The Studio

*This volume is one of a series devoted to the art and technology
of photography. The books present pictures by outstanding
photographers of today and the past, relate the history
of photography and provide practical instruction in the use of
equipment and materials.*

LIFE LIBRARY OF PHOTOGRAPHY

The Studio

Revised Edition

BY THE EDITORS OF TIME-LIFE BOOKS

TIME-LIFE BOOKS, ALEXANDRIA, VIRGINIA

For information about any Time-Life book,
please write:
Reader Information
Time-Life Books
541 North Fairbanks Court
Chicago, Illinois 60611

TIME-LIFE is a trademark of
Time Incorporated U.S.A.

Library of Congress Cataloguing in Publication Data
Main entry under title:
The Studio.
 (Life library of photography)
 Bibliography: p.
 Includes index.
 1. Photography—Studios and dark rooms.
2. Fashion photography. 3. Photography—Portraits.
4. Photography, Table-top. I. Time-Life Books.
II. Series.
TR550.S79 1982 770'.28 82-6011
ISBN 0-8094-4416-X (retail ed.) AACR2
ISBN 0-8094-4417-8 (lib. bdg.)
ISBN 0-8094-4418-6

ON THE COVER: In a candid shot by photographer Arthur Elgort, a studio assistant tests the lighting as the model tries out a pose for a spread in *Vogue*. Known for free-and-easy fashion photographs that fairly dance off the page *(pages 130-131)*, Elgort likes to relax his models by taking pictures while the technicians make last-minute adjustments. Often he will present albums of these warm-up candids— studio photographs in their own right—to his friends and colleagues.

Contents

Photography can be approached from either of two directions. One approach is the way of the photojournalist, the quick-eyed observer who catches life on the wing as it flies past the camera lens, capturing the spontaneous picture that will make the newspaper's front page—or the family album.

Studio photographers travel an entirely different route. Painstaking craftsmen, they plan a picture as carefully as an architect designs a house, and often take days to arrange the composition and adjust the lighting before clicking the shutter. Rather than reporting events from the sidelines, they stage their own and exercise total control.

To gain this control and increase their flexibility, amateurs who are beginning studio photography may wish to acquire a whole roomful of paraphernalia—floodlights, spotlights, reflectors, tripods, electronic flash units and view cameras of various sizes. They may also wish, as professionals do, to operate like the designer of a theatrical production, constructing entire sets. Professional studios are sometimes large and elaborate, with barn-sized rooms, carloads of expensive equipment and big staffs of photo assistants, set builders, wardrobe mistresses and stylists.

But an expensive establishment is really unnecessary for most studio work, and amateurs can set up their own studios with nothing more than a camera, a room, a few lights, and perhaps a roll of seamless photographic paper for a backdrop. And by borrowing a few techniques from professionals, they can even come close to their goal: a kind of photographic perfection that is reachable only through the unique ability of the studio photographer to manipulate every step of the picture-taking process.

The Editors

The Photographer in Control 1

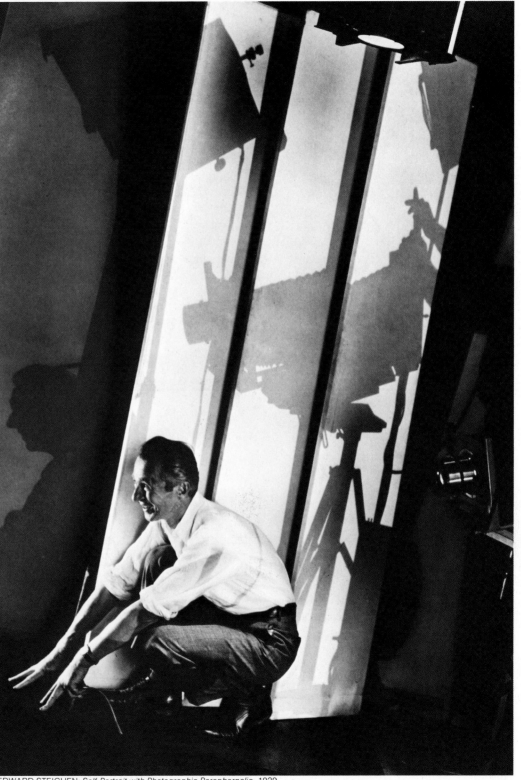

EDWARD STEICHEN: *Self-Portrait with Photographic Paraphernalia*, 1929

Making, Not Taking, Pictures

Studio photographers are among the highest-paid and most influential figures in all of photography. When their pictures are published in magazines such as *Vogue* and *Harper's Bazaar,* the course of the international fashion industry may be changed. Success or failure in their advertising photographs directly affects the fortunes of the product or services they are helping to sell. An arresting portrait of a celebrity not only may become the public's most enduring image of that person but may subtly alter the way the rest of us look at ourselves. Not all studio photographers inhabit such a rarefied atmosphere, of course. Many of them work out of quiet neighborhood studios, taking family portraits and recording birthdays, weddings and other events that are close to the hearts of their clients. But all studio photographers share the common distinction of exercising total control—for better or for worse—over the picture.

As the name implies, studio photography was born and raised in the studio. Working at first with the available light coming through the studio skylights, and later with increasingly sophisticated artificial light sources, the photographer could operate, ultimately, in any kind of weather. Today, studio photography has a paradoxical dimension. No longer is it confined to the studio itself: Now photographers also take their studios with them, and the whole world has become their stage.

Philippe Halsman, one of the finest portrait photographers in the business, offered perhaps the most concise definition of studio photography: *"making, not taking, a picture."* No disparagement of picture "takers" was intended. The French master photographer Henri Cartier-Bresson, for one, *takes* pictures. According to Halsman, Cartier-Bresson "never interferes in the action he photographs, and his unobtrusiveness is so unique that it has created the legend that, at the moment of picture taking, Cartier becomes invisible." No one would ever accuse studio photographers of being invisible. They are everywhere, arranging every element—from lighting to pose to props—as much as is humanly possible. While a Cartier-Bresson steals scenes from the life that swirls around him, studio photographers consciously create scenes to suit the images they have already envisioned.

Two of the most eminent practitioners in the field are Richard Avedon and Irving Penn. If their photographic styles could each be characterized in one word, Penn's would be "stillness," Avedon's "motion." Both began work in the years following World War II and quickly established themselves in three phases of studio photography: portraiture, fashion and advertising. Penn eventually extended his mastery to the still life as well.

Avedon brought to studio photography a restless, adventuresome style. An early fashion shot that revealed his flair for the unusual showed Dorian Leigh, one of the leading models of the day, laughing as she threw her arms

around the winner of a bicycle race in France. The photograph caused an uproar in the fashion business: In 1950 it was not the custom to show a model in such a human act. Avedon went on from there, achieving a series of new sensations, often touched with humor. He put a model on roller skates and sent her cruising down the streets of Paris. He placed a sleekly dressed woman in front of a pair of lumbering elephants with wrinkled hides. On other assignments Avedon showed the model with tears in her eyes or smiling at her husband or pushing a baby carriage. The shock of such natural-looking vignettes was absorbed by the fashion world, and the style found a popularity that lingered into the 1970s.

Like all studio photographers, Avedon jealously guards his independence and his right to control everything in his pictures. When he was still comparatively unknown, *Life* commissioned him to shoot a series of street pictures of New York City. Knowing that it could immeasurably enhance his career, Avedon accepted the assignment—but found he could not complete it. "I didn't like invading the privacy of perfect strangers," he explained. "It seemed such an aggressive thing to do." More to the point, he added, "I have to control what I shoot, and I found that I couldn't control Times Square."

Avedon's refuge has always been the studio, which isolates people from their environment and allows the photographer to create another world for the camera. Television studios also lend themselves to this kind of manipulation, and in recent years Avedon has tried his hand in this field as well—with typically controversial results. His ads featuring teen-age model Brooke Shields in a tight-fitting pair of Calvin Klein jeans drew heavy fire for being too suggestive. But Avedon has also photographed less provocative TV and print ads for Famolare shoes, and has served as creative consultant for Christian Dior television commercials.

Avedon was introduced to fashion photography early: His father operated a women's-wear shop, and there were always fashion magazines around the house (the young Avedon kept a scrapbook of the magazine pictures he particularly liked). He wanted to become a poet, but when he dropped out of a Bronx high school at the age of 17, he got a job as an errand boy at a small photography concern. When he enlisted in the Merchant Marine in 1942, his father gave him a Rolleiflex as a going-away present. He spent the war years taking identification pictures of Merchant Marine personnel and doing more challenging photography on his own time. Upon leaving the service, Avedon went to work photographing models at Bonwit Teller, the New York specialty store. After a year, he compiled a portfolio of his best pictures and applied for a job at *Harper's Bazaar*.

The art director at the magazine—a Russian immigrant named Alexey Brodovitch—was impressed by a particular photograph in Avedon's portfolio:

13

a slightly out-of-focus study of two brothers that Avedon had snapped during his Merchant Marine hitch. In that blurred picture Brodovitch saw something that appealed to his romantic nature. Avedon had caught the sense of people actually moving, not frozen for the lens. This "mistake" would become his photographic signature. It would lead him into a new, poetic world—and the subjective, startling work that he began to turn out gave studio photography a creative push forward.

Brodovitch himself would exert a profound influence on modern fashion photography. At one time he taught Irving Penn, and in addition to discovering Avedon, he worked with Avedon's protégé Hiro, who has become one of studio photography's most prominent names. A trained artist, Brodovitch possessed a gift for aphorisms that contained worthwhile lessons for any serious student of photography. "Start working without a camera," he said on one occasion. "Cut out a window in a piece of cardboard and observe, discover and decide what to snap." Perhaps most important to a young photographer like Avedon was this advice: "Develop a statement of your own. Shout, don't whisper."

The energy and probing vision so evident in Avedon's fashion and commercial photography extend significantly into his portraiture—but the effect is entirely different. "Years ago, when Dick fought with other photographers for space, he purposely made his work startling," says writer Harold Brodkey, who has followed Avedon's work closely. "Now, instead of jumping out at you, the work pulls you into it." Against a background of seamless white paper or a blank white wall, Avedon's subjects stand facing the photographer and his boxy 8 x 10 Deardorff camera. Avedon gives them no instructions for pose or dress. "Dick has told me that a lot of what he does now is to let the sitter photograph himself," Brodkey says. "He's there to catch you if you're willing to be caught." Subjects who are willing to be caught by Avedon have ranged from celebrities such as Igor Stravinsky, the Duke and Duchess of Windsor and William F. Buckley to a little-known Kansas murderer, a female impersonator and a New York City caterer. During a portrait session, Avedon engages his sitters, concentrates on them, involves them in the process. "Sometimes the force of it grows so strong that sounds in the studio go unheard," Avedon says. "Time stops. We share a brief, intense intimacy. But it's unearned. It has no past, no future."

Neither critics nor subjects have been unanimous in their praise for Avedon's portrait work. Although Brodkey describes Avedon's portrait of him as "not the way I look, but the way I am," author Truman Capote deemed his own portrait "unflattering," and *The New York Times* said the picture of the Windsors portrayed them as "haggard with guilt and dissipation." Avedon finds these objections irrelevant. "Whether or not people like my portraits of them

isn't the point," he says. "Each of my portraits is more a portrait of myself than of someone else—a portrait of what I know, what I feel, what I'm afraid of." Avedon displays a similar attitude toward a major recent project, a series of photographs of working people in the American West: "When it all comes together," he says, "you'll have a portrait of America. My portrait of America."

In contrast to the romantic vivacity of Avedon's fashion work and the sometimes harsh look of his portraits, the photography of Irving Penn is suffused with a consistently cool, introspective beauty. His tranquillity and urbanity are aptly expressed in a photograph of a stylish model picking a piece of tobacco from her tongue with a perfectly manicured nail, or a shot of the contents spilled from a woman's handbag: a gold pill case, scattered tranquilizers, a cigarette holder, a pencil for jotting down appointments.

Born in Plainfield, New Jersey, Penn has been called by one critic "the last and greatest Victorian photographer." He studied design at the Philadelphia Museum School of Art under Brodovitch, who taught there in the 1930s. After a few odd jobs in New York, Penn fled to Mexico to do what he had dreamed of doing—become a painter. The results were far from what he had hoped. Realizing that as a painter he would never be more than mediocre, he made the important decision to give up. Ever practical, he destroyed his paintings by dropping them into a bathtub and scrubbing the paint from them. Later he used the fine linen canvases as tablecloths.

Penn returned to New York City in 1943 and went to work in the art department at *Vogue*. His job was to suggest covers for the magazine's photographers, but most of the suggestions were rejected: The photographers wanted to think up their own covers. Before long, *Vogue's* new art director, Alexander Liberman, proposed that Penn shoot covers himself. Penn did, photographing his first one with a borrowed camera. The picture was a stark, eye-stopping still life of a brown leather bag, a scarf and gloves, some lemons and oranges and a huge topaz. It appeared on October 1, 1943, the first of more than 150 covers he would do for *Vogue*.

Liberman's encouragement of the budding photographer continued when Penn came back to *Vogue* after World War II (he had joined the American Field Service in 1944 and had served on ambulance duty with the British Army in Italy and India). Penn embarked on a series of stunning portraits, including studies of Picasso, Colette, the American artist John Marin and the distinguished jurist Learned Hand. As he has done throughout his career, Penn used only the even illumination of northern light. In addition, he took a charming series of studio pictures of tradespeople and everyday workers—chauffeurs, postal workers, plumbers—in New York, Paris and London. The pictures were Liberman's idea, and he gave Penn both the staff and financial support to

make them. "The relationship between me and Liberman is the most significant single circumstance in my professional life," Penn has said. "My *Vogue* images are always the ones he chose. I find that once he picks a photograph I never look at the contacts again. As far as I'm concerned, the collaboration has been perfect."

Although Penn wanted to continue his work with the daylight studio image, Liberman encouraged him to search even farther afield for arresting faces to shoot. For several years, Penn set out periodically to explore new territory — Nepal, New Guinea, Peru, Dahomey — taking with him an elaborate portable studio. As he explains it, "I'm not a photojournalist and am not especially interested in the kind of photographs that result from showing people in their natural surroundings." Believing that people "become not as they really are" when confronted with a camera, Penn carefully posed the people he visited in the neutral environment of his traveling studio *(pages 94-98)*. "Here the subject and I relate more easily to each other as one human being to another than as a tourist to a native," he says. "Also, in a studio, I'm able to control the posing, the play of light and shadow, and thus to enjoy the photographic subtleties that mean so much to me."

Whether the subject is a New Guinea highlander or a New York high-fashion model, Penn's photographs consistently reflect his credo: Show "the very still, the very quiet." Through more than three decades, his austere, uncluttered style has been so influential and so widely imitated that today few photographers even realize that the ideas they are copying originated with him. For a brief period, Penn devised a wide variety of compositions for his portraits of celebrities by placing the sitter in a corner, photographing the seated half-figure, and cropping the head on his ground-glass screen in order to create "a disturbing tension." Although these eccentric ways of picturing his subjects have attracted many imitators, Penn explains that he originally stuck his celebrities in corners because he did not "feel able to cope with them. You see, I used the corner as a prop for myself, as a protection." He discovered afterward that the studio itself made the problem easier: "By putting them in my studio they had less to depend on in holding on to their public facades."

Penn sets about the task of making pictures with near-frightening dedication. During a portrait sitting, a reverential hush falls over the studio. Conversations are minimal, instructions are issued in whispers, the phones are cut off. The silence begets some tension, and more than one sitter has felt overwhelmed by it. Only the clicking of the shutter breaks the silence. The tension is not relieved until Penn has the picture he feels he wants. A few of his famous sitters end up intensely disliking the picture. But, like Avedon, Penn is unperturbed. "No subject minds a boring picture," he says. "They mind a picture that has gotten to the soft core."

Penn the innovative portraitist was also a pioneer in the use of color film, turning out scores of color images on assignment for *Vogue*. Yet, through the years, Penn has done all his personal photography in black and white, and the effort he lavishes on his platinum prints is considerable. Even when the subjects are as unlikely as dirty, shredded cigarette butts, Penn prints the image larger than life, in velvety grays. He explains, "There is a particular joy for me that these pictures aren't manufactured objects, that I coat every piece of paper myself, that each is handmade." Penn's commitment to painstaking printmaking has been steady, beginning with a series of nude studies started in 1949. "I spent nights and weekends for one year making these photographs," he said. But when he finished the more than 100 silver prints, he put them away in a box for 30 years. "I was afraid to show them—afraid they might shock the public."

When "Earthly Bodies"—76 of these early nudes—was finally exhibited in 1980, one critic wrote that the show "confirms the fact that Penn may be the most focused and single-minded photographer of our time." For his part, Penn has defined himself as "the least specialized of all photographers. I need a balanced diet." Noting that advertising photographers have to be enormously flexible, he says, "One of the reasons that photographers such as Avedon and Hiro are so good is that they've tried everything—the blurred pictures, sequences, the intense strobe—and moved on." □

The Craft of Portraiture

By their insistence on total control over their works, studio photographers confine themselves to pictures of people and things in a delimited setting. But the restriction is more apparent than real, for subjects can be as varied as portraits, pets, dresses, furniture and almost every commercial product made. Of these the most common is the portrait.

Two of the finest practitioners are Yousuf Karsh of Ottawa and Arnold Newman of New York, and both do extensive research on each sitter to learn how to reveal his character. But no research was necessary for Karsh to know that the longtime head of the United Mine Workers of America, John L. Lewis *(right)*, was a crusty, strong-willed man. Lewis substantiated this reputation at once. Striding into his Washington office after Karsh had set up his lights, Lewis sat before the camera with his hat still on, glowered and ordered, "Shoot!" Karsh soothed Lewis into removing his hat and relaxing somewhat. But the roughhewn nature of the former coal miner is clear in the portrait.

Newman had an easier time with the Japanese sculptor-architect Isamu Noguchi. He trained his 4 x 5 view camera on his subject's upper torso to make the head and body seem part of an abstract work by the sculptor. Newman frequently uses background props related to his subjects and makes long exposures (of a second or more) to permit small apertures that give great depth of field, bringing a close association between man and prop. His subjects rarely move and blur the pictures, for he talks until he puts them at ease. How does Newman know when a subject is at ease? "When a kind of sleepiness overcomes him," he says.

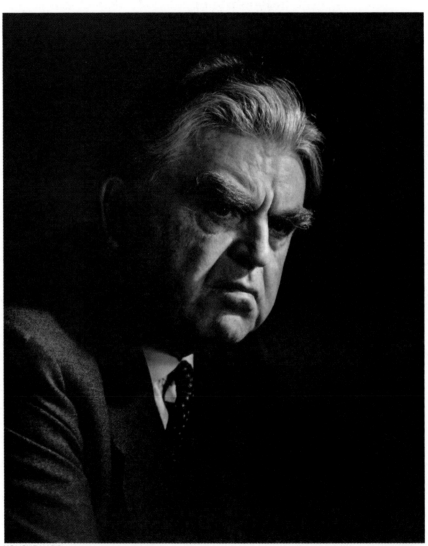

YOUSUF KARSH: *John L. Lewis, 1944*

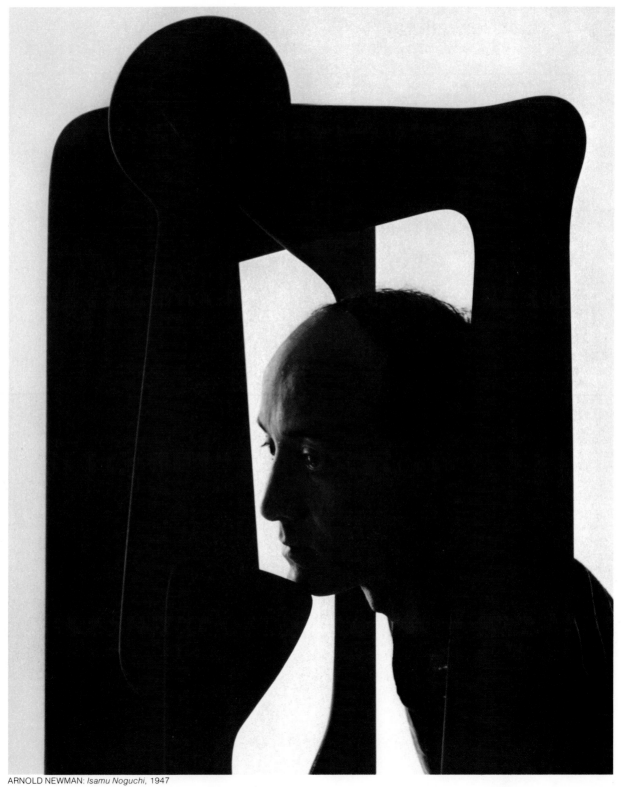

ARNOLD NEWMAN: *Isamu Noguchi*, 1947

In making these two images of Sophia Loren, placed together to create a multiple portrait, Richard Avedon purposely blurred the images to achieve a romantic effect. The wind-tossed hair, closed or lowered eyelids and imprecise facial characteristics all contribute a sensuous dimension that a sharper picture might have lost.

Avedon achieves such an expressive quality by an approach that might seem self-defeating. "My photographs don't go below the surface," he has stated. "They're readings of what's on the surface. I have great faith in surfaces. A good one is full of clues. But whenever I become absorbed in the beauty of a face, in the excellence of a single feature, I feel I've lost what's really there."

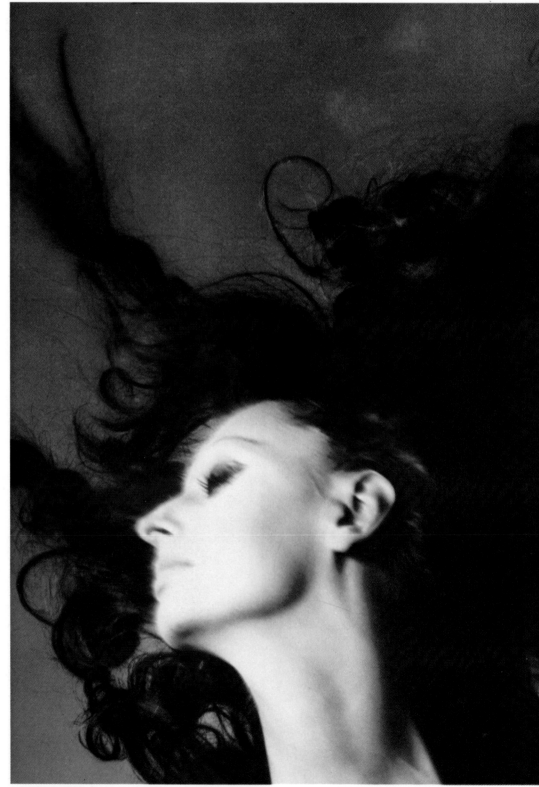

To make this romanticized dual portrait of Sophia Loren, Richard Avedon used a Rolleiflex with strobe attachment. He achieved the wind-whipped look by having Loren bend her head forward, then toss it back as an electric fan sent a breeze through her hair. She repeated this motion about 50 times as Avedon froze the movement with the strobe. From all his shots, these two were pasted together in a photomontage, which was rephotographed to make a negative for prints.

RICHARD AVEDON: *Sophia Loren,* 1970

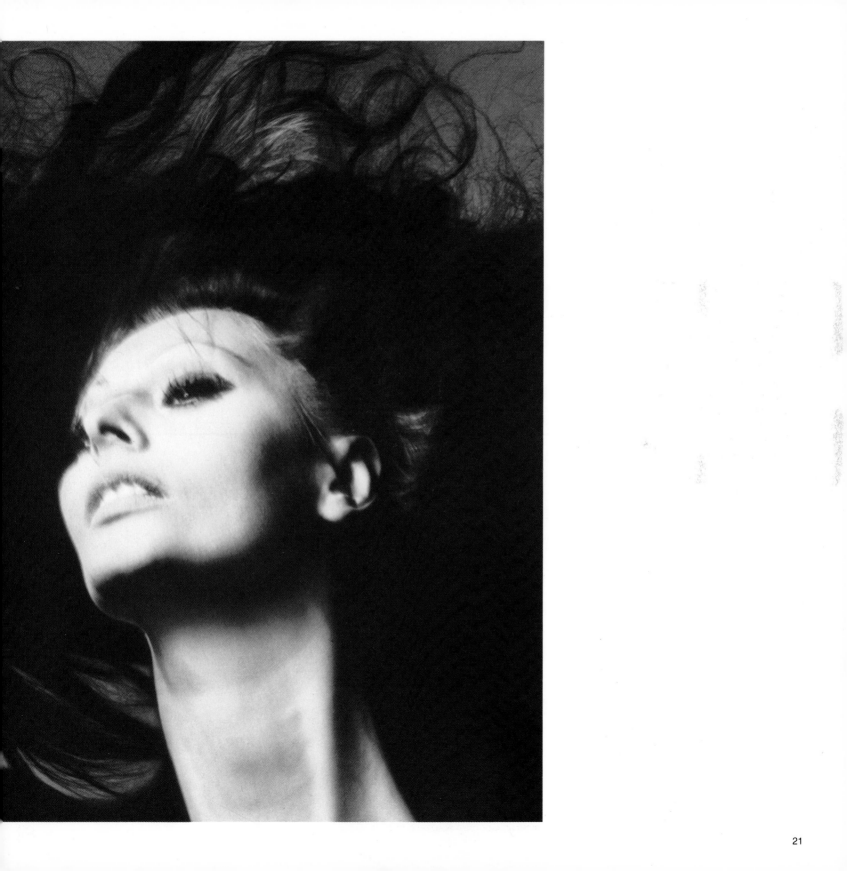

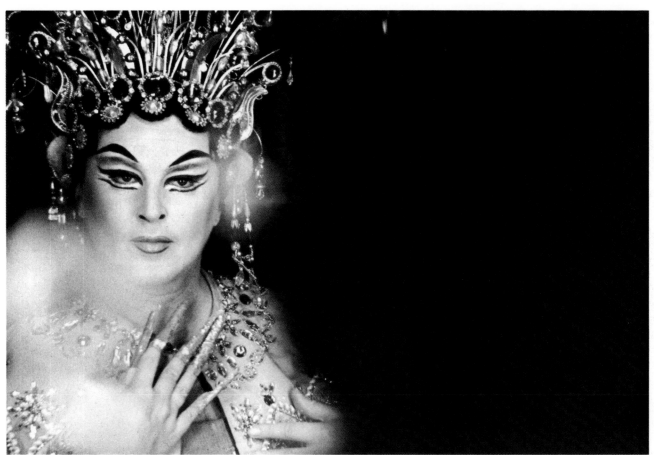

RODDY McDOWALL: *Birgit Nilsson,* 1966

Some of the most successful portraits of celebrities are made by photographers who have an intimate knowledge of the entertainment world. Roddy Mc-Dowall, who made the portrait of opera soprano Birgit Nilsson above, was a child movie star in England; he grew up to become an actor and film director. His ability to convey the characteristics and personality of performers often springs from his friendships with them.

He has said that actors, like children and pets, photograph best when they are in a familiar setting — playing a role in which they are at ease.

Barbara Morgan, in making a series of portraits of the eminent dancer Martha Graham *(opposite),* watched performances and studied the dance for five years. Her pictures were not taken during performances but came from studio sessions with Miss Graham.

So shy of the camera is opera star Birgit Nilsson that to make this portrait Roddy McDowall decided to catch her reflection in a dressing-room mirror so that she would not tense up facing a lens. He used the lens-shift adjustment on his view camera (Chapter 5) to avoid picking up the camera's reflection as well.

In an acrobatically graceful motion, Martha ▶ *Graham portrays a tragic moment from a dance. Her body merges horizontally with a black band on the studio wall, but her arched left leg and full, sweeping skirt provide an uplifting sense of motion. The picture was made with a 4 x 5 Speed Graphic at 1/800 second, using multiple flash.*

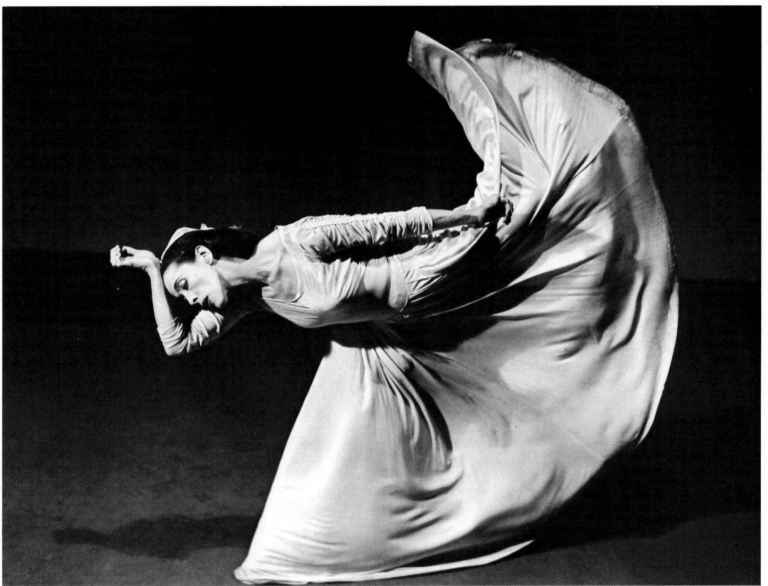

BARBARA MORGAN: *Martha Graham in "Letter to the World,"* 1940

Making a portrait is never simple, since there are so many variables to take into account—but sometimes a photographer wants to make extra trouble for himself. A good example is Philippe Halsman's famous portrait of the eccentric surrealist artist Salvador Dali *(opposite)*. The picture was so complicated it took 26 attempts to get; some of the noble failures are seen at right. The inspiration for the photograph was a painting by Dali (on the large easel) of the Greek legend of Leda and the swan. Everything in the painting, which shows Zeus approaching Leda in the form of a swan, hangs in space in accordance with Dali's perception of the world as one great conglomeration of atoms, each hovering around its nucleus.

Halsman and the artist, who were old friends, mulled over a lot of ideas for a photograph that would dramatically display Dali in his suspended world. Dali even suggested stuffing a duck with dynamite and exploding it as he jumped at his easel. Halsman vetoed that plan as dangerous, cruel and probably illegal. In time it was resolved that cats and water, hanging in space as Dali leaped in the background, would convey the desired surrealist mood. The easels were suspended by wires from the studio ceiling and Mrs. Halsman held the chair aloft. Three assistants threw the cats from right to left while another hurled water out of a bucket from the opposite direction. The entire shooting took about six hours. At the picture session, Dali jumped at a blank easel. On the print of the last shot *(opposite)*, he painted on the blank easel a fitting subject—a person suffering through a feline nightmare.

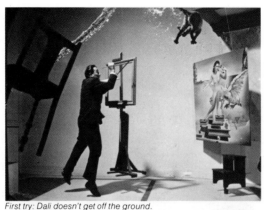
First try: Dali doesn't get off the ground.

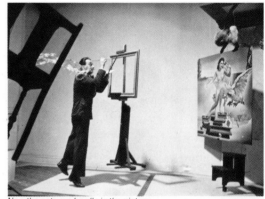
Now the cats are hardly in the picture.

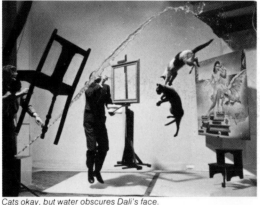
Cats okay, but water obscures Dali's face.

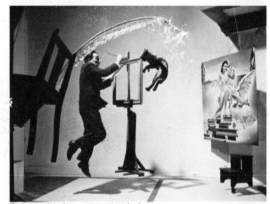
One cat showing—two cats missing.

Fine—except a secretary accidentally walks by.

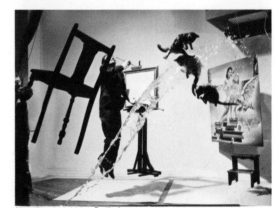
Now the chair hides Dali's face.

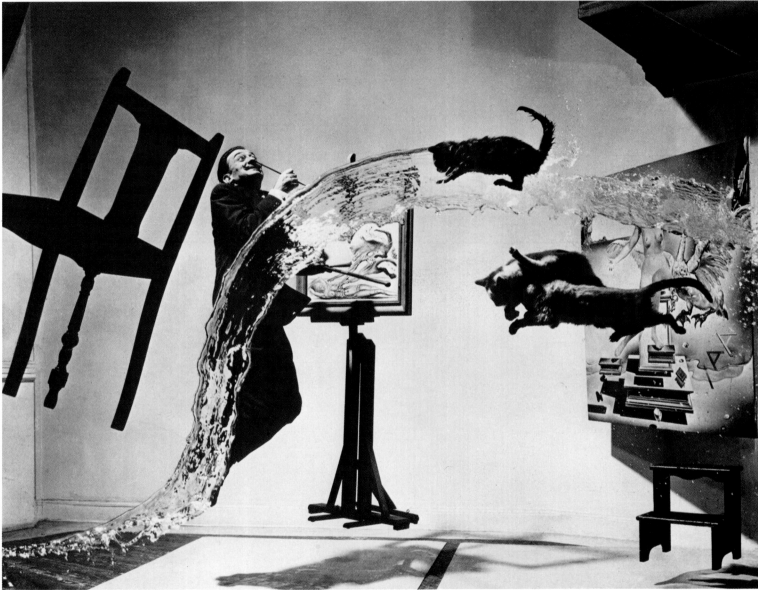

PHILIPPE HALSMAN: *Dali Atomicus*, 1948

A portrait arising from an intimate interaction between photographer and subject can be a window on both their personalities. In certain cases it can also afford a glimpse of an entire culture, whether the subjects are ordinary people or instantly recognized celebrities.

Gregory Heisler produced his bizarrely colorful portrait of an Australian miner *(right)* as part of "A Day in the Life of Australia"—a project that sent more than 100 photographers fanning out across the island continent to record its special character. When the miner walked into an isolated canteen in the outback, he looked, said Heisler, "like he had been dipped in rust."

Rolling Stone photographer Annie Leibovitz will often use playful manipulation of a star's public image to express her own insights into the person's character. "I like taking pictures of people who are famous," she says. "I'm recording images, not a reality." Leibovitz is willing to go to great lengths to assemble props, costumes and settings for her portraits. Some of her subjects must be carefully coaxed and cultivated, but there are others—such as comedian Steve Martin *(opposite)*—who readily play along with her image making.

Photographer Gregory Heisler made this portrait of a dust-covered iron-ore driller in an Australian outback canteen, using the canteen's movie screen for the background and a silver umbrella to diffuse his light. The driller, who had driven 125 miles for a midnight beer, was "very fierce-looking." But he proved to be quite happy to pose.

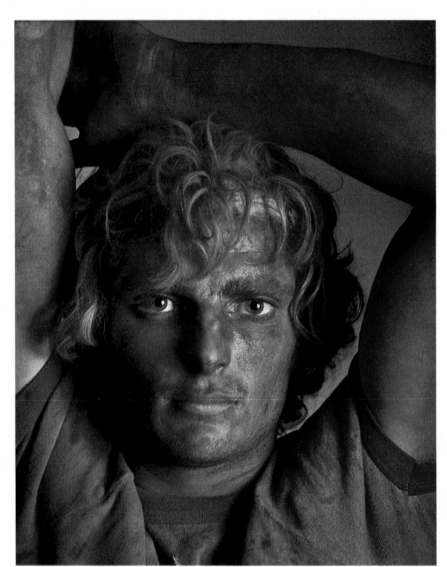

GREGORY HEISLER: *Roger Gardiner,* 1981

With comedian Steve Martin's cooperation, Annie ▶ Leibovitz devised a portrait that mirrors the contradictory appeal of his style—intellectual on the one hand, rude and goofy on the other. Streaked with black paint to match the stark abstract from his own art collection, Martin wears a costume similar to the one he wore in the movie Pennies from Heaven.

ANNIE LEIBOVITZ: *Steve Martin*, 1981

For decades, Main Street studio photographers took pictures of children in stiff, predictable poses. Now, however, photographers try to show the essence of the child's nature through the use of a stylized pose that lifts the subject out of ordinary time *(right)*, or through the contrasting technique of startling informality and candor *(opposite)*.

To bring out the best in children, portraits are often made in a relaxed atmosphere—at home or in other familiar surroundings. The studio of photographer Starr Ockenga, who often uses friends and family members as models, is simply her living room with the furniture shoved out of the way. In whatever setting the photographer chooses, the object is to make pictures that penetrate beyond the clichés adults often bring to their perceptions of childhood. □

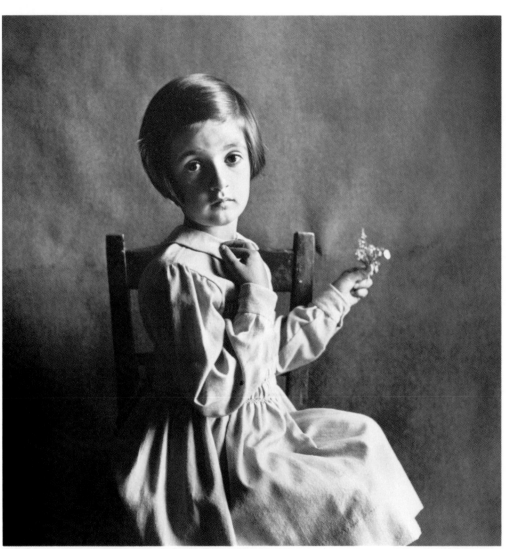

IRVING PENN: *A Florentine Child, Elisabetta Cristina Giuffrida-Ruggeri,* 1948

A pose and mood reminiscent of Renaissance portraits characterize this study of a little Italian girl at her home in Florence. One of a series on Italians done for Vogue after World War II, the picture captures in its quiet charm the timeless innocence of children the world over.

This portrait of the photographer's 14-year-old son captures an adolescent's characteristic combination of vulnerability and defiance. Asked to pose in his mother's sunlight-flooded home studio, the boy took a shower before presenting himself for the shooting. His plastered-down hair and the black eye he sports suggest teen-age rebellion even as his pose indicates a willing cooperation with the photographer.

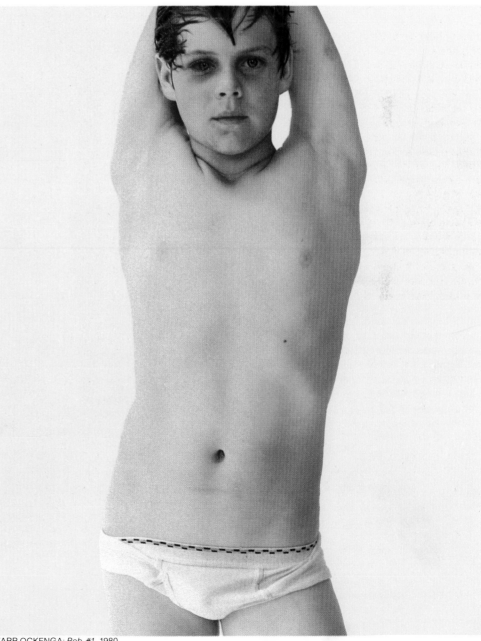

STARR OCKENGA: *Rob #1*, 1980

Fashion Indoors and Out

Few studio photographers have greater need of inventiveness than those who picture fashions. To catch the eye and incite desire, fashion photographers will stretch their control over their images to its limit. Sometimes the garment alone dominates the picture: The model's face and personality are deemphasized, and the appropriate mood is achieved with precise lighting and an unadorned background. Or the photographer may create a fantasy world: The clothing becomes a costume; the model is cast in an implied role; and surprising, compelling, perhaps even unsettling juxtapositions rivet attention and stir the imagination.

Art Kane says the animal symbols in his fashion shots are there "to say something about the nature of the woman in the picture as a human being." He frequently chooses empty apartments as studios for his fantasy scenes, explaining that he likes the quality of light in such an environment. The picture opposite was staged in the photographer's own Manhattan apartment before the furniture had been moved in. (The doorman helping to unpack the props fled in fear when he spied the serpent.)

Fashion photographers have put together equally fantastic tableaux out-of-doors—having entire city blocks sealed off to serve as their studios, or posing models in Paris designs atop the Eiffel Tower and on bridge railings over the Seine. Specific styles and approaches to high-fashion photography have changed through the years, keeping pace with evolving social attitudes toward clothing, art, sex and the role of women. But the demand for original, arresting fashion images has remained constant.

GUY BOURDIN: *Classic Gown*, 1970

A lighting scheme was tailor-made to show off this gown by emphasizing the contrast between the slim, clinging gown and its huge, billowing sleeves. Only one light source was used—an electronic flash bounced off an umbrella reflector. Illuminating the model from the side, it made a picture that transcends fashion to become a stately study of the human form.

A pensive woman in a revealing, petal-skirted chiffon evening dress sits beside a live boa constrictor on the floor of an empty apartment. One of a series of fashion shots whose motif was "the inner life of the young woman of Manhattan," the eerie scene was meant to convey the loneliness that photographer Art Kane sees menacing the outwardly elegant, yet essentially isolated, New York career woman.

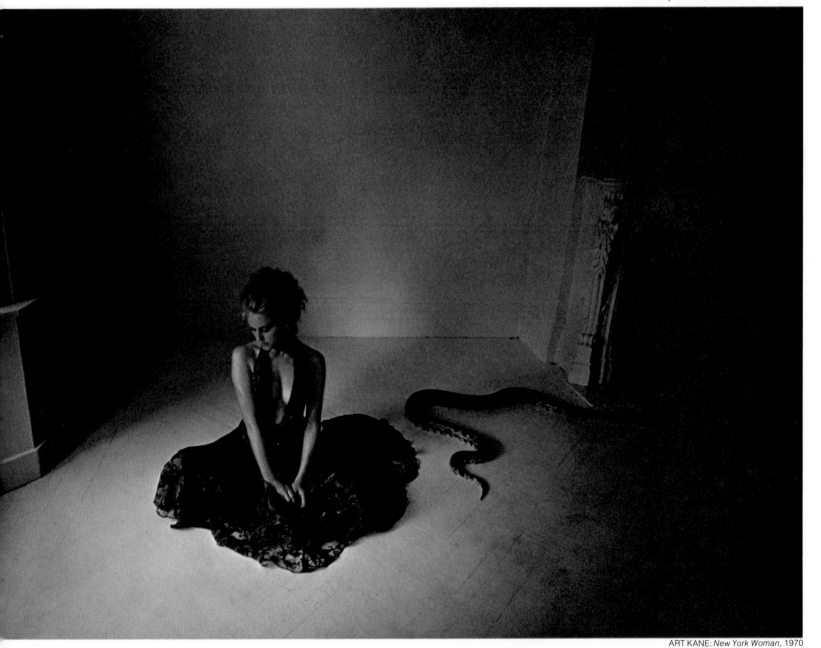

ART KANE: *New York Woman*, 1970

The fashion photographer who shoots indoors with a sophisticated array of lights and the one who takes the studio out into a sunlit plaza must resolve different sets of technical concerns. In the end, however, both have the same responsibility: to pull dozens of independent elements together into a photograph that gives the desired effect. Paradoxically, the photographer's control of the process depends on a willingness to cede some of that control to the model.

Among the fashion photographers who are aware of—and embrace—this paradox are Peter Knapp and Oliviero Toscani. "I call myself an 'imperfectionist,' " says Knapp, who dislikes studied results and tries to avoid posing his models. For the picture at right, he fired a steady stream of orders to keep the model moving in a search for "all the little accidents that may happen." Toscani, who likens his craft to that of a film director, always explains exactly what he wants his models to do—knowing that each will interpret his instructions differently. "Everyone puts her own energy into the photo," he says. But this spontaneity is welcome. "I pose a precise question," says Toscani, "but I want a natural answer."

PETER KNAPP: *Begonia,* 1981

The model's pert expression, the child's toy she is holding, and the naïve grace—almost gawkiness—of the fleeting attitude caught by the camera combine with cheerful colors to produce the youthful look desired for a spring fashion spread. Four flashes illuminated the ceiling and background, and a fifth bounced off an umbrella at the model. Not particularly fond of the outfit she wore, Peter Knapp strove just for an unself-conscious picture of his subject, whose name was Begonia.

To create a composition that would match the ▶ liveliness of the gaily striped patterns and free-and-easy designs he was shooting, Oliviero Toscani had his seven models line up with the late-morning sun behind them, link hands and jump from the rim of a fountain at the Place de la Concorde in Paris. The young women's vivacity and sportive glee reflect Toscani's feeling that fashion photography has evolved from a display of wealth through a display of style to today's playful mockery of style.

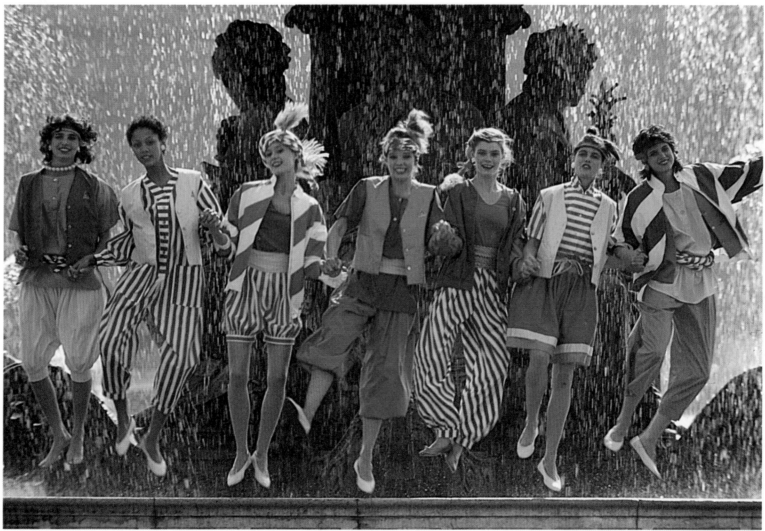

OLIVIERO TOSCANI: *Place de la Concorde*, 1981

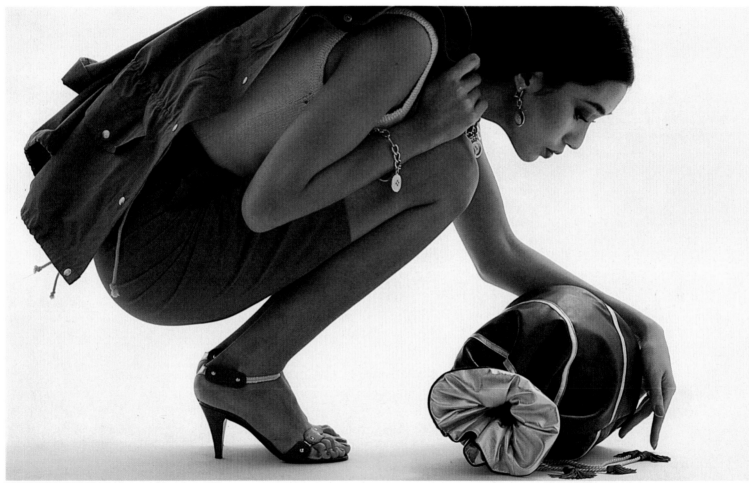

GEORGES TOURDJMAN: *Exotism and Orientalism,* 1981

Photographing fashion accessories frequently calls for ingenuity to avoid having such relatively small items as tote bags, sandals or jewelry overwhelmed by the beauty of the model or by other elements of the composition. For the photograph above, Georges Tourdjman hit on the solution of asking the model to crouch. This had the effect of making her appear smaller while the accessories seemed larger. At the same time, the pose uses the woman's delicate grace to enhance the products being presented.

Another useful tool for photographing accessories is humor. In Henry Wolf's picture on the opposite page, the large emerald pendant not only is at the physical center of the composition but is the focus of a small comedy spontaneously played out for the camera. A masterly demonstration of what Wolf calls a "designed accident," the shot was saluted by *American Photographer* as being one of "The Ten Best Pages of 1981." □

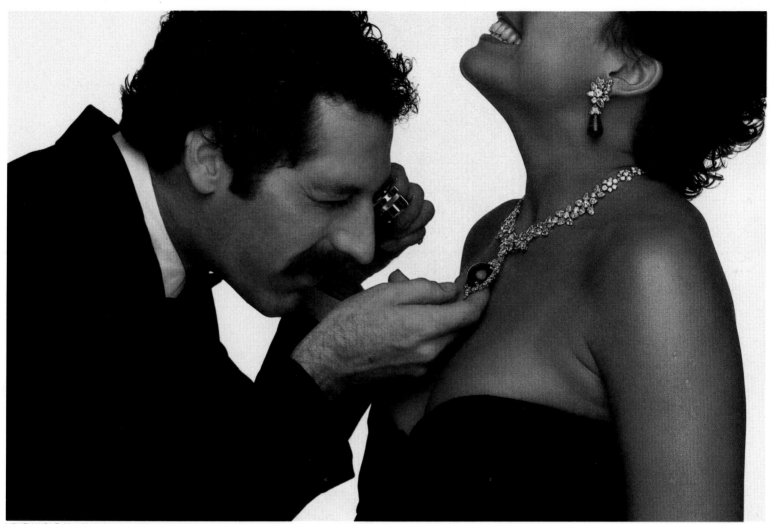

HENRY WOLF: *New York Jeweler*, 1981

Like a small pet the model had stopped to stroke, the drawstring bag (opposite) becomes a special focus of attention in this whimsical fashion layout by Georges Tourdjman, who composed the picture so that none of the accessories would be lost in the "gutter," or middle fold in a magazine. To create the diffuse light of a cloudy day, Tourdjman used a white background and bounced his strobes off two umbrellas and two reflecting panels.

Lighthearted humor softens the implied lechery of a pose that resulted from spontaneous horseplay in the studio: New York jeweler Stanley Silberstein mistakenly squinted through the wrong end of the loupe, making the enormous emerald appear tiny and provoking a hearty laugh from Irish noblewoman Clare Beresford. Judicious framing enhanced Beresford's sparkling grin as well as the diamonds and emeralds that adorn her.

Art from Everyday Edibles

A still-life photographer's virtuosity in the studio can change the mundane into the extraordinary, producing studies of texture and design that hover between abstract and representational art. Still lifes of food are a frequent advertising assignment for the commercial photographer, whose first imperative is to make the subject appetizing and attractive. But beyond that is the challenge of exciting new interest in an everyday edible item.

One way to make a familiar object new is to alter its scale, shrinking or enlarging it until it becomes momentarily strange to the viewer, who needs to look twice to recognize it fully. Peering under the cap and into the interior of the mushroom *(opposite),* photographer John Neubauer calls attention to textures that would normally go unremarked. To achieve what he calls "a larger than life, exaggerated view" was an exacting exercise in photographic precision: "The closer you get to a small subject," Neubauer remarks, "the more critical things look—the lighting has to be perfect."

Guy Powers' overhead view of a seafood and salad repast *(right)* draws back to disclose a pattern instead of zooming in for a minute examination of texture. Even if each plate of food is counted as only one item, there are more than 40 separate objects on the table. In order to get his lens as far as possible from this profusion of details, Powers positioned his 8 x 10 camera on a platform suspended from the 16-foot-high ceiling of his studio. Then, because it would have been difficult to view the table with the camera aimed straight down, he hung a mirror from the ceiling at a 45° angle and shot the table's reflection in it. The result is an image of formal simplicity that still allows appreciation of its intricate design. □

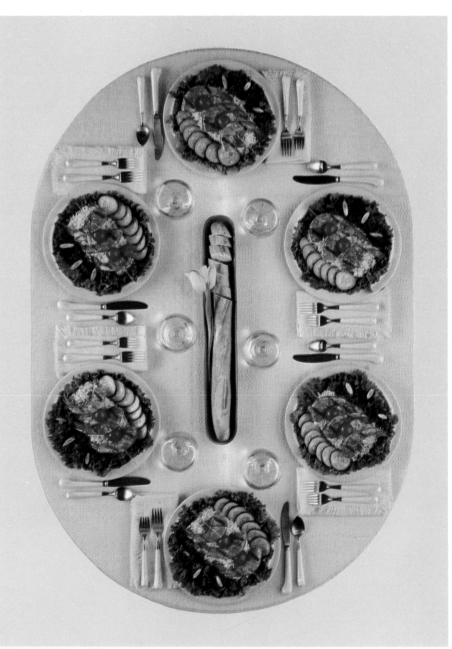

GUY POWERS: *Table,* 1982

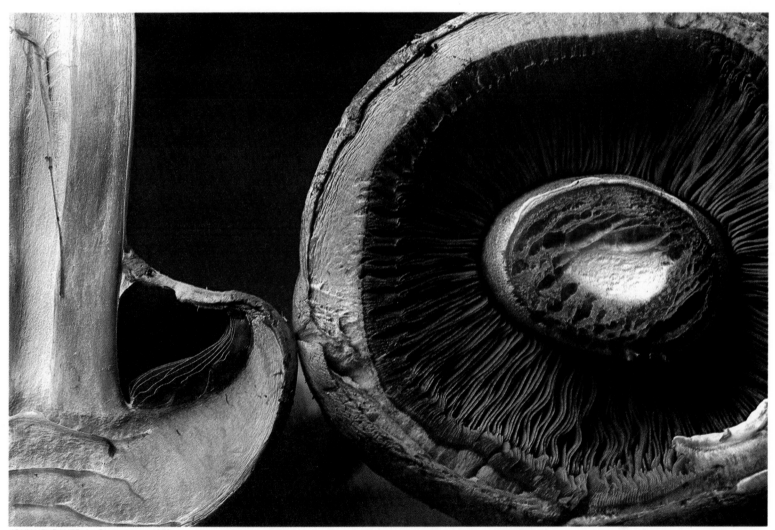

JOHN NEUBAUER: *Le Champignon,* 1979

◀ Any one of the meals pictured at left—each a carefully arranged plate of rice, cucumbers and jumbo shrimp—would have made a delectable still life in itself. But Guy Powers' goal was to render a plethora of detail into a unified whole. Using a Polaroid to calculate exposure, Powers lighted the subject with eight strobes, bouncing the light off the studio's curved cyc wall on one side and off a wall of seamless paper on the other.

Seeking a unique way to present an everyday object, John Neubauer used a macro lens to make this calendar photo of two mushrooms. Lighting was his major concern: "You can't go in with the light from the front with such a small subject," he says. Instead, he illuminated the subject with a single strobe aimed straight down from about three feet away, producing a simple graphic design that emphasizes the mushrooms' form and texture.

Focusing on the Product

In the 19th Century, commercial enterprises relied entirely on art work for their advertisements and promotional publications. Today they go primarily to the studio photographer, whose camera is used to stimulate buyer interest in even the most humble utilitarian objects.

Like the simple bathroom fixtures photographed by Gary Perweiler on the opposite page, a still-life subject can be presented as plainly as it is seen in the course of the day's routine. Or, like the cosmetics arranged by Ernie Friedlander in front of an Oriental fan *(right),* a subject can be rendered exotic by the addition of a dramatic prop. In either case, the making of a successful commercial still life demands close adherence to the basic rules of studio photography: Pay keen attention to detail, arrange objects with concern for composition and, above all, take maximum pains with lighting.

Friedlander's detailed set-up illustrates the care and precision that go into his efforts to "sculpt with light." Not only does his lighting accentuate each pleat in the fan, but it also serves to emphasize the smooth surfaces and rounded edges of the compact case and the lipstick dispenser. Finally, the red-and-black color scheme hints at mystery and romance— two frequently employed enticements in advertising photography.

Against a black-velvet backdrop, a silver-edged fan lends an air of Oriental intrigue to a simple lipstick and compact. Ernie Friedlander placed the objects on a mirror-like surface of black plexiglass and lighted the composition from above with a single box strobe. He used fill cards to highlight the front of the compact and the side of the lipstick, and a small mirror to light the lid of the lipstick.

ERNIE FRIEDLANDER: *Lipstick Still Life,* 1981

Gary Perweiler, who likes to "posterize" things, found the drain stopper and hot-water-faucet handle at right a lighting challenge, for the composition presented three different reflective surfaces: gleaming metal, flat white rubber and the transparent brightness of water droplets. Shooting from six inches away with a wide-angle lens and using a diffusing bank strobe and a dull silver fill card, he got the effect he was after.

GARY PERWEILER: *Mt. Vernon*, 1976

The dual nature of the photographer's art—the merging of esthetic sensibility and technical skill—is nowhere more evident than in industrial photographs of high-tech products and machinery. Facing the often cold and distant look of technology, the photographer is required to find a way to make it more inviting.

Tom Weigand, who often photographs metallic subjects and has been praised for his innovative studio technique, maintains that a modern photographer should be able to achieve all his effects using only a single, carefully controlled light source. Holding himself to this stringent rule, he creates remarkable pictures of such unpromising subjects as the pair of berylium copper strips at right, which he shot for a manufacturer of the copper alloy. Weigand made the picture with one 2,000-watt strobe in a "soft box" aimed straight down from 18 inches away.

Gabriele Basilico, an architect and frequent photographer of architectural subjects, found another solution to the problem of extracting fresh, attractive images from the intimidating world of technology and science. Photographing a sophisticated desk-top teleprinter for the Olivetti corporation's annual report, he selected a delicate, almost ethereal detail to contrast with the blocky solidity of the machine itself. By focusing on this detail *(opposite)* — a rack for the roll of paper on which the machine prints copies of its transmissions—Basilico tried for a close-up that "loses the purely technical character" of a highly technical subject.

To achieve this graceful abstract, Tom Weigand clamped a pair of berylium copper strips together at both ends and twisted them into a curve. The reddish glow on the metal is the reflection of an unseen piece of red gelatin filter material taped inside the right-hand strip. Using an ultraviolet filter on a 210mm lens, he made the exposure at f/32 at 1/125 second.

TOM WEIGAND: *Berylium Copper Strip,* 1981

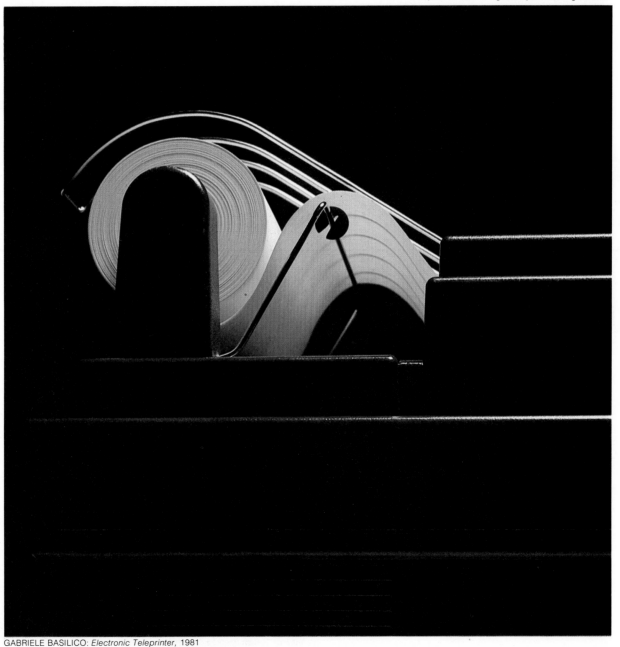

GABRIELE BASILICO: *Electronic Teleprinter,* 1981

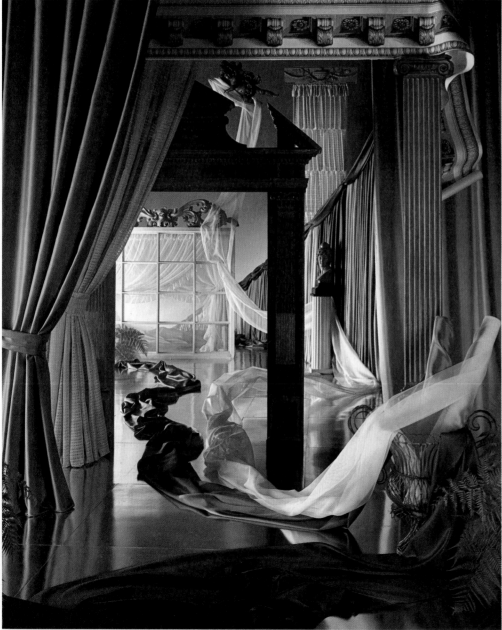

Whereas the photographs on the two preceding pages fill the frame with a single close-up image, a promotional assignment for Burlington Industries confronted photographer Lionel Freedman with the different and complex task of displaying a wide selection of the company's fabrics in one picture. In his large New York studio, Freedman set about creating a surreal room of his own imagining—a room festooned with a greater range of fabrics than was likely to be found in real life. He gave the picture a dreamlike quality by using indirect lighting and by unfurling bolts of cloth across the highly polished floor. At the sides of the room he gathered fabrics in hangings as a restrained counterpoint to the wandering strips in the center.

LIONEL FREEDMAN: *Fabric Display*, 1960

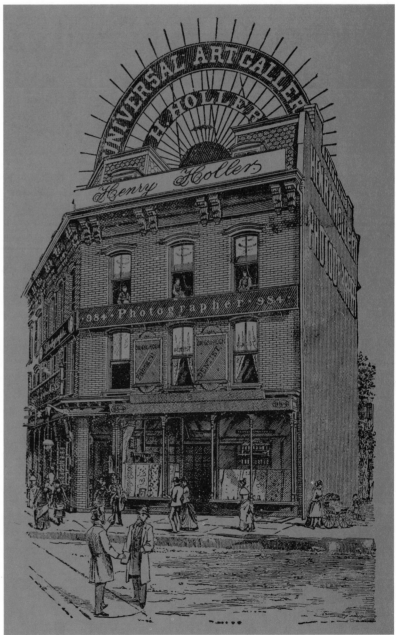

H. Holler's Photography Studio, Brooklyn, New York, 1891

Techniques Past and Present

From the very beginning, photography has been a studio art. The oldest surviving daguerreotype, made by Louis Daguerre in 1837, is a still life with plaster cupids and a wine bottle artfully arranged in a corner of the inventor's studio. An impressionistic murkiness pervades the picture, the result of dim interior lighting and the slow reaction time of the first cameras and plates. Nonetheless it is an admirable example of studio photography.

One of the first to be impressed was the American inventor Samuel F. B. Morse. He met Daguerre in Paris in 1839 and was so enthralled by the Frenchman's studio interiors that he declared them to be "Rembrandt perfected." He resolved to bring Daguerre's process to America, and in doing so opened up one of this country's first photography studios.

Morse's principal interest was in making portraits. Besides being the inventor of the telegraph, he was one of the nation's leading portrait painters, and professor of art at New York University. Photography fascinated him because it promised to be a fast and accurate way to make portrait studies for his canvases. With a chemistry professor at N.Y.U., John W. Draper, who was interested in the scientific problems of photography, Morse built a glassed-in studio on the roof of the university building in 1840. Shortly afterward he opened a second studio, a veritable "palace for the sun," on the top floor of a nearby commercial building, and went into business, taking daguerreotype portraits and teaching photography, while waiting for the United States government to grant him recognition and money for his telegraph.

Like Morse, almost all the early studio photographers were portraitists. And all of them faced the same perplexing problem: how to bring enough light into the studio to make an exposure. Indoor exposure times for the early daguerreotypes were so protracted—a half hour or more—that portrait photography seemed at first impossible. How could any sitter keep still for so long a period? Daguerre himself said it could never be done, but inventive photographers were already working out ways to reduce exposure times by using faster lenses and concentrated light sources. Strong light, in fact, was a prerequisite. Most portrait photographers, like Morse, solved the lighting problem by building studios with glass roofs and directing the exterior light onto the subject's face with mirrors. There were some ingenious variations on this basic scheme. Alexander S. Wolcott, who opened a studio on New York's Broadway in March 1840, several months before Morse opened his, brought in sunlight through the window. He used a system of gigantic reflectors cantilevered over the sidewalk to catch the sun's rays and focus them onto the subject. To protect the sitter's eyes from glare, the light was filtered through a rack of glass bottles filled with blue dye.

Daguerreotype portrait studios were an immediate popular success. Everyone wanted his features immortalized by this miraculous new process.

"Daguerrean galleries," as they were called, sprang up in every city. By 1853 there were 86 in New York City alone, and an estimated 1,000 New Yorkers made their living by working in them. The Commonwealth of Massachusetts reported in 1855 that it had 134 professional daguerreotype artists, and that during the year they had made 403,626 pictures. The studios ranged from rudimentary to lavish. In frontier communities in the West, the local photographer might set up his camera in a single room over the barber shop. Some big-city daguerreotype studios were as richly appointed as opera houses, with commodious waiting rooms, an abundance of side rooms where the portraits were taken and labs where they were developed. One of the most fashionable was opened by Mathew B. Brady, later of Civil War fame, in New York in 1853. It profoundly impressed the reporter from Humphrey's *Daguerrean Journal,* who wrote: "The walls are covered with satin and gold paper. The ceiling frescoed, and in the center is suspended a six-light gilt and enamelled chandelier. . . . The golden cornices and festooned damasks indicate that Art dictated their arrangement."

Whether modest or magnificent, all the early studios shared some basic similarities. Usually they were installed on the building's top floor, with a skylight to bring daylight indoors. The subject ordinarily sat in a chair facing squarely into the camera, which was set on a tripod. To keep his head steady during exposure, he held it against a heavy wrought-iron stand with a headrest complete with clamp at the top. An adjustable mirror filled in the shadowed side of his face. Behind him was a plain cloth backdrop.

In the late 1850s the discovery of the more sensitive wet-plate, positive-negative system of photography simplified the lighting problem, but not studio décor. The simple tan or gray backdrops of earlier decades gave way to lavish painted canvases, depicting lush gardens with grapevines twining over Grecian columns, or to fancy interiors with paneled walls, staircases and marble statuary. The single chair was increased to a roomful of plush ottomans flanked by tables and balustrades, against which the subject would posture imperiously or loll seductively, depending on mood and sex.

Until well into the 20th Century, studio photography continued to mean portrait photography. But in the 1920s, the character of professional studios began to change. The increasing use of photographs in advertising meant that studios began to cater to the needs of industrial firms and fashion houses. Portrait studios remained, of course, making everything from passport photos to wedding pictures. But most of the big new studios adapted their operation to the needs of commercial clients. Some concentrated on fashion or food, some on creating ingenious illusions to promote various industries or products. And so the major studios remain today—specialized, technically sophisticated purveyors of images to commerce and industry.

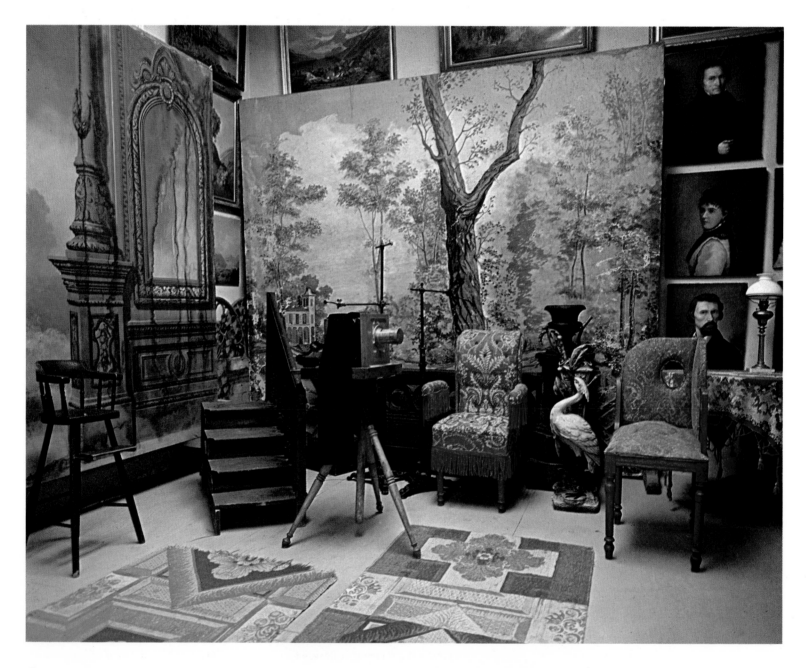

◀ *A 19th Century elegance characterizes a semi-restoration of Peter Britt's Photo Gallery in Jacksonville, Oregon, with its painted canvas backdrops, two posing chairs and various props, including a flight of steps, a ceramic egret and an urn on an octagonal pedestal. Behind the view camera on its tripod are two wrought-iron headrests.*

Boxlike wooden view cameras (above, left) were brought to Oregon from supply houses in San Francisco. One lens, with its heavy brass casing, weighed 30 pounds. Besides being a photographer, Britt was a skilled portrait painter, and examples of his art, with works by others, share the walls with his photographs. In the picture at right, above, a posing chair has been arranged against a backdrop to suggest palatial grandeur. The hole in the chair was needed for photographing babies. The mother would kneel out of sight behind the chair and hold the baby through the hole.

In Victorian America, every town worth its name boasted a photography studio. The local photographer was both resident portraitist and chronicler of town life. Every self-respecting citizen would sit importantly for his picture. Brides would pose in their wedding dresses, and young married couples would bring their first baby. On request, the photographer would lug his view camera outside for a shot on location. He would pose the fire department beside its hook and ladder, the dry-goods merchant next to his calicoes and denims, and a family in front of its new house.

The photographer of Jacksonville, Oregon, Peter Britt, arrived in town in 1852, one year after a gold strike had sent the town booming. Trained as both a portrait painter and a photographer, he set up shop with a single box camera in a log cabin he built himself. Soon people from all over southern Oregon were flocking to his studio—miners celebrating a strike, bankers in top hats, Indians, soldiers, and settlers with their families. Britt expanded to new quarters, equipped with the elegant props shown here, which are now preserved in the Jacksonville Museum.

Tintypes on Short Order

As photographic portrait galleries grew ever more lavish—and more expensive —a new kind of studio emerged that catered to the taste and pocketbook of the average worker. It was devoted exclusively to the production of portraits on tintype, a fast, cheap cousin of the daguerreotype, in which the picture was made directly on a dark metal plate that had been coated with a light-sensitive emulsion. Because of the dark metallic background, the developed image gave the illusion of being a positive rather than a negative. Like modern Polaroid instant pictures, tintypes could be taken, developed and handed over to the customer in a matter of minutes.

Tintype studios persisted until well into the 1930s, before they finally succumbed to the more sophisticated camera techniques of modern times. But at least one still exists. At the Henry Ford Museum in Greenfield Village, a town in Dearborn, Michigan, reconstructed from America's past, the tintype studio shown here has been set up in a small frame house. Visitors may still pose in front of the tintype camera as their grandparents did before them, and have their images recorded for posterity on tin.

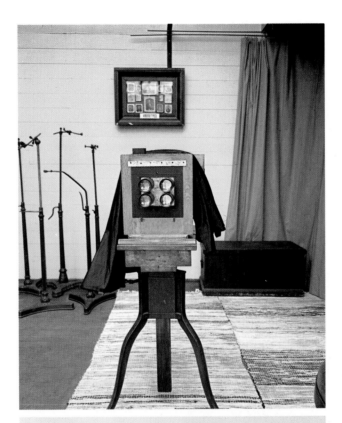

Tintype studios, like this reconstruction at Greenfield ▶ Village, were simple and functional. A monochrome background drapery hangs behind the posing chairs, an abbreviated armchair stands in the center, and a stool with a backrest is at right. The camera with its viewing cloth rests on a tripod in the center, and iron headrests are grouped by the left wall. A glass roof and floor-to-ceiling window admit daylight.

Tintype cameras, like the one at right, above, often had multiple lenses for taking several pictures at once. Since tintypes could not be printed, the only way to get a copy of a picture was to make another exposure. After the tintypes were snapped, they were developed and hung out to dry on stands like the ones at right. The entire process, from plate preparation and exposure to final portrait, took only five to 10 minutes.

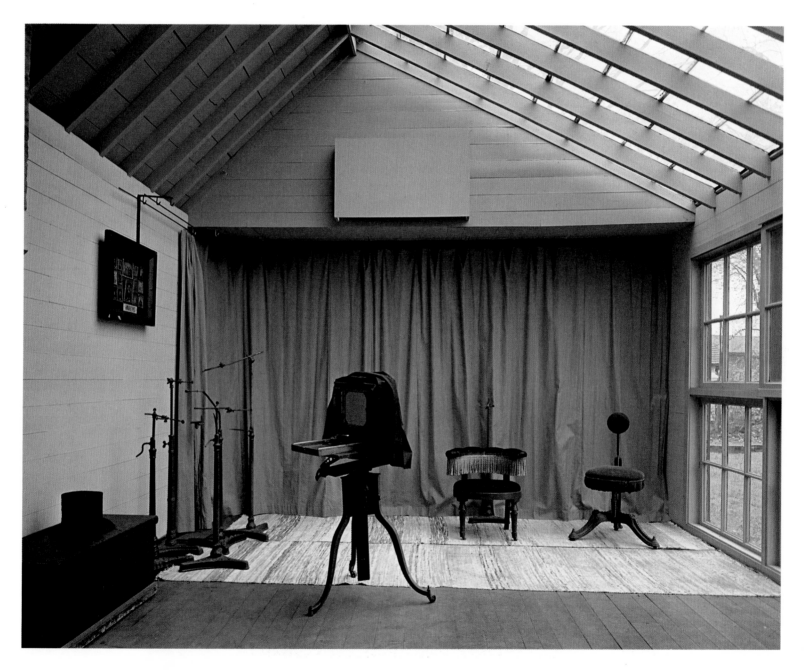

Splendor in the Big City

One of the most sumptuous of all the late-Victorian portrait studios was a gallery opened in New York City at the turn of the century. The studio's proprietor was a retired army officer, Colonel Theodore C. Marceau, who had already established a string of fashionable photo studios in Cincinnati, Los Angeles and San Francisco. In moving to the nation's largest city, Marceau resolved to outdo himself, and his competitors, in stylish extravagance.

Although most of the city's portrait galleries were located in low-rent lofts along Broadway, Marceau splurged on a Fifth Avenue ground-floor storefront. He then spent on furnishings and equipment what a photography journal of the day called "an amount unheard of in the establishment of photo studios."

There were reception chambers and waiting rooms, and a special dressing room with an ornate marble make-up table where women could change into their best lace and damask evening gowns before posing decorously *(right)* in front of the camera. A fad for Middle Eastern art was sweeping New York society at that time, and Marceau embellished his waiting room with Turkish draperies, carpets and ottomans.

Competing photographers scoffed at Marceau's presumption and prophesied his speedy bankruptcy. Marceau, however, not only survived, but captured a large part of the carriage trade. The bulk of his business was the result of a practice followed by fashionable women: At Christmas they gave framed pictures of themselves as presents. The number of sittings might rise to as many as 50 a day between Thanksgiving and Christmas.

The customer would be taken first to a dressing room to arrange her gown and hair, then to a studio that was about 25 feet square and workman-like in appearance, with camera, flood lamps or skylight, and the usual posing chairs and painted background panels. The photographer would take four or five poses, and the customer would return a day or so later to choose the one she liked best.

Marceau's prices were high—as much as $20 for one sitting and a dozen 5 x 7 sepia prints. But to a style-conscious society, nothing would do but a portrait from the city's fanciest gallery.

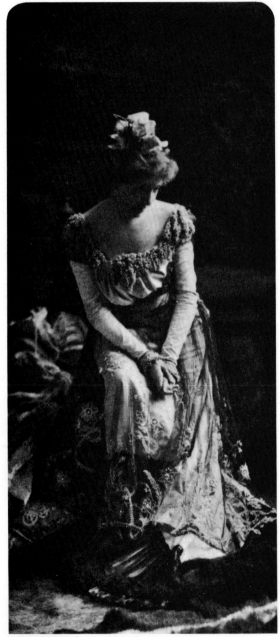

T. C. MARCEAU: *Portrait of a Lady,* date unknown

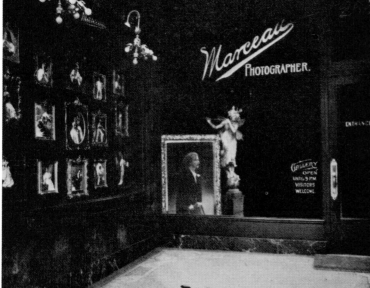

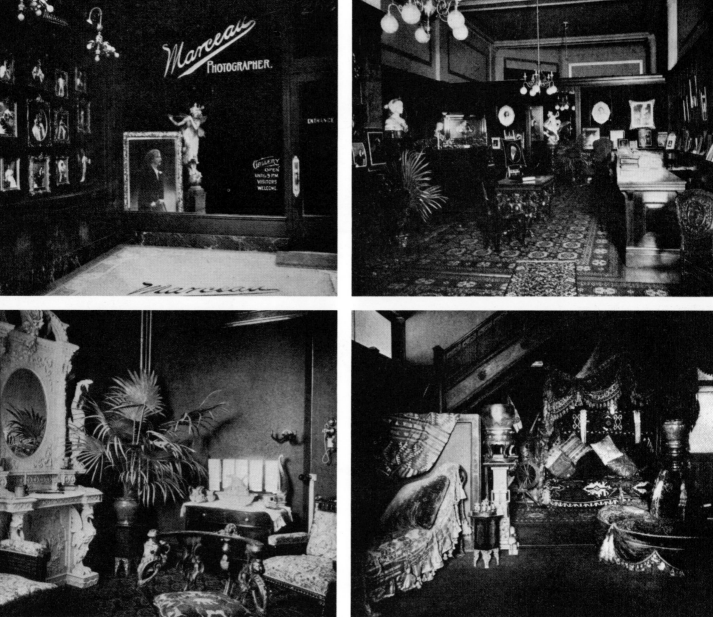

Tricks of the Trade from Hollywood

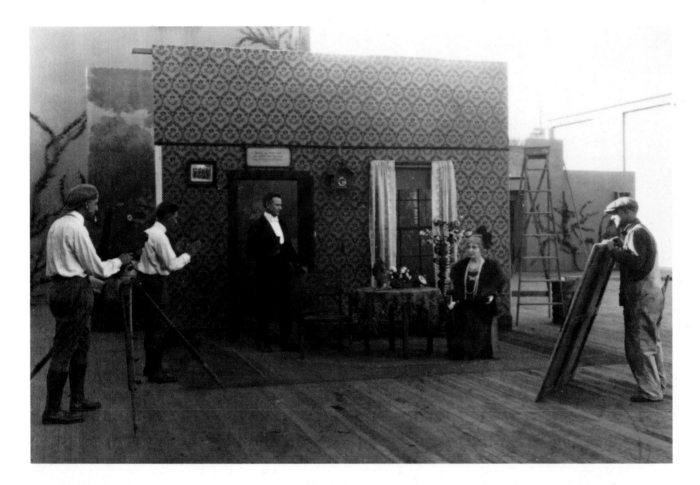

Simple or lavish, the Victorian studios never moved beyond the production of stylized portraits. But in the early 1900s a new national obsession — motion pictures — began to work dramatic changes in both the subject matter and the techniques of studio photography.

The movies seemed at first an unlikely source of photographic expertise. The earliest ones were murky one-reel shorts that flickered uneasily for five or

10 minutes before expiring. They were shot in flat, natural light, usually in jerry-built, open-air studios. But as directors grew more skilled, they began dressing up their product with lighting techniques, set designs and stage effects borrowed from the Broadway theater. Eventually these innovations, perfected on movie lots in Hollywood and on the East Coast, became part of the standard vocabulary of studios everywhere.

Increased realism in set design was the movies' first big contribution to studio techniques. The Jesse Lasky Feature Play Company, which from 1913 to 1915 made film adaptations of Broadway hits (above), used sets as detailed and convincing as any found behind a theater's proscenium. Innovations in lighting had to wait until the development of flood lamps. Lasky usually filmed in bright sunshine, building his sets outdoors on his Hollywood lot. Even when movie companies went inside, they splurged on huge greenhouses with glass roofs to let in the sun — like the Lubin Studio in Philadelphia (opposite), which was apparently light enough and large enough to stage three different scenes at once.

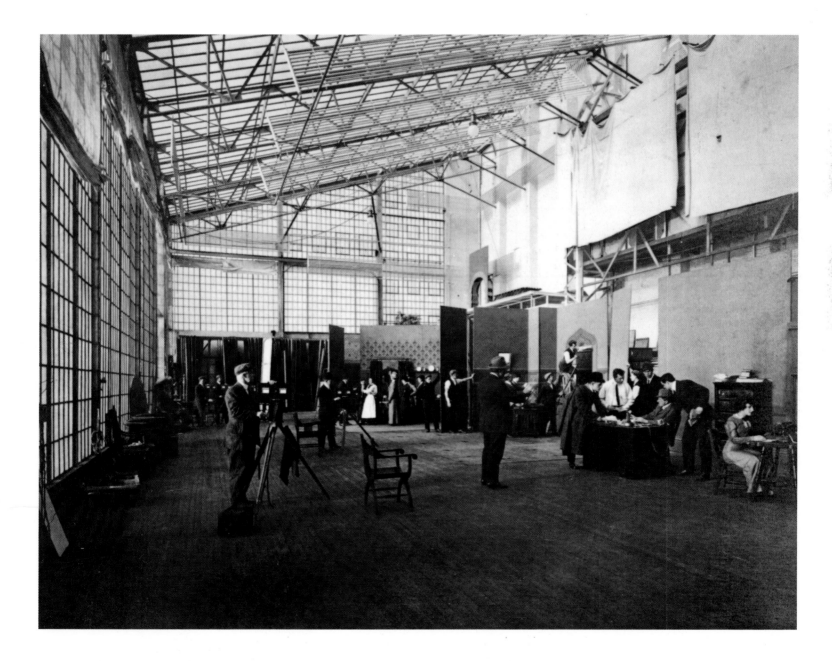

Learning to use the flood lamp was the movies' single most important breakthrough in studio techniques. It freed photographers from the flat, monotonous illumination that usually results from relying exclusively on daylight and opened up endless possibilities for creating dramatic effects.

Hollywood studios were surprisingly slow in converting to artificial light. Though the inventive Billy Bitzer, cameraman for the famous director D. W. Griffith, had used electric lighting as early as 1899—rigging some 400 arc lamps to film the Jeffries-Sharkey boxing match in New York City—Hollywood stayed with natural light until well after 1910. The main reason was economic. Sunshine was free, and in the halcyon climate of Southern California it hardly ever stopped for bad weather. But in 1915, Cecil B. De Mille began trying to duplicate the dramatic lighting effects he had learned while working at the Belasco Theater on Broadway.

De Mille first used velvet draperies and metallic reflectors to shade and direct the sunlight, but quickly switched to arc flood lamps. The results were moody and dramatic, and some scenes were so dim that De Mille's producer, Samuel Goldwyn, complained that "you couldn't see the actors' faces half the time." De Mille retorted by calling his new technique "Rembrandt lighting," which inspired Goldwyn to jack up the price of his films to movie houses. But the new lighting techniques did indeed provide an artistic and emotional impact that would have been impossible with natural light. They also gave cameramen the kind of control over their subject—even in uniformly illuminated scenes such as the one opposite—that has been an indispensable part of studio photography ever since.

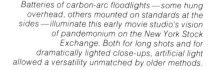
Batteries of carbon-arc floodlights—some hung overhead, others mounted on standards at the sides—illuminate this early movie studio's vision of pandemonium on the New York Stock Exchange. Both for long shots and for dramatically lighted close-ups, artificial light allowed a versatility unmatched by older methods.

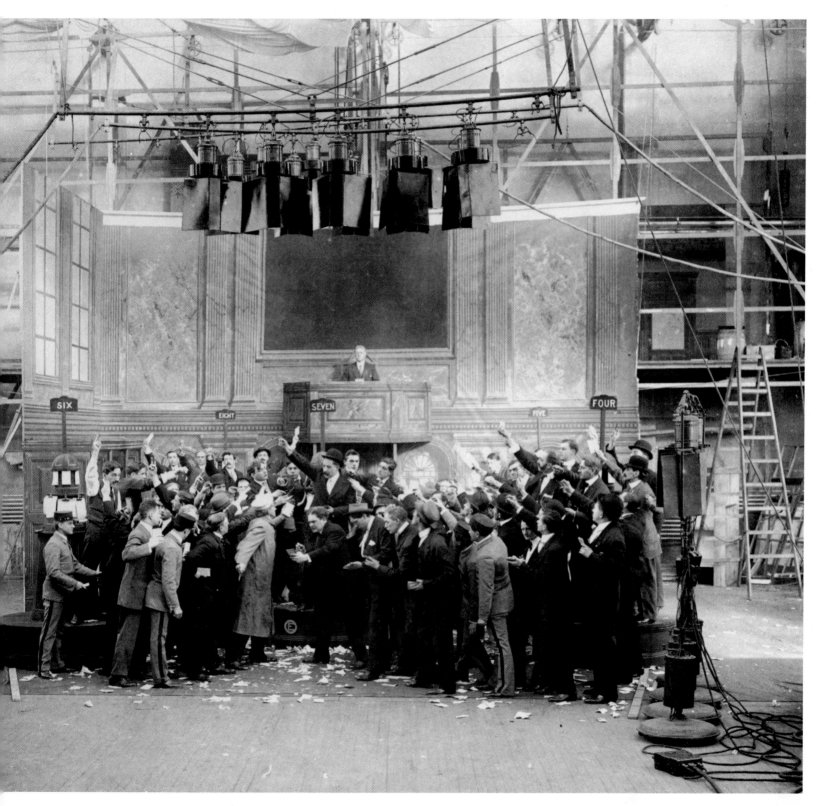

57

Pictures for the Sunday Millions

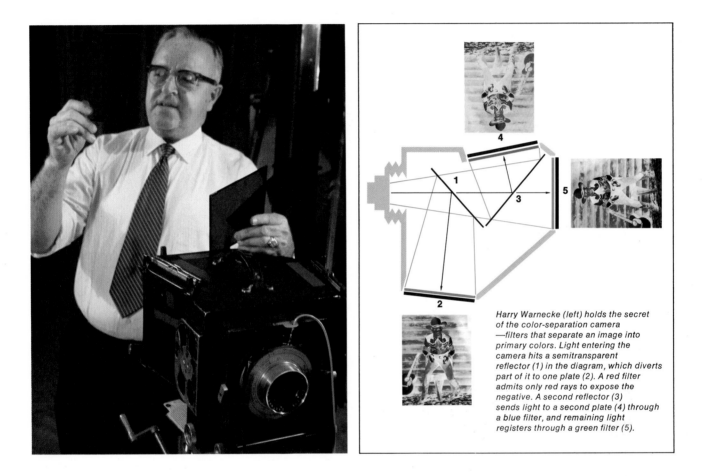

Harry Warnecke *(left)* holds the secret of the color-separation camera —filters that separate an image into primary colors. Light entering the camera hits a semitransparent reflector (1) in the diagram, which diverts part of it to one plate (2). A red filter admits only red rays to expose the negative. A second reflector (3) sends light to a second plate (4) through a blue filter, and remaining light registers through a green filter (5).

One of the first studios set up specifically for color photography was, paradoxically, established by a newspaper at a time when modern color film was still to be invented and ordinary newspaper letterpresses did not reproduce color photos satisfactorily. The driving force behind the idea was Harry Warnecke *(above)*, a staff photographer for the New York *Daily News*, who had been experimenting with color on his own. He knew that color could be reproduced with the rotogravure printing process, which the *News* was already using to put out a Sunday picture section that included color advertisements. He convinced his bosses that a cover photograph in full color would be a worthwhile attraction.

The *News* backed Warnecke generously. He even designed a camera of his own—a big "one-shot" device *(diagramed above)* that simultaneously exposed three plates with black-and-white emulsion through three separate filters to make red, blue and green separations required for color reproduction. Using this and other specialized gear, Warnecke provided a steady supply of color pictures. And long before color snapshots were common, bathing beauties and movie stars *(opposite)* appeared in color in the *Sunday News*.

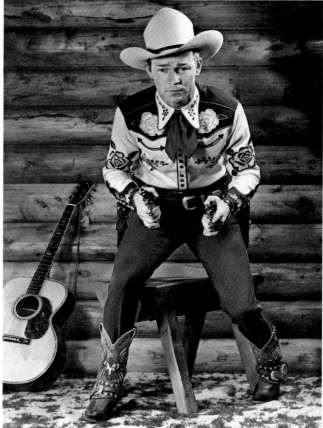

Hundreds of celebrities had their pictures snapped by Harry Warnecke's color-separation camera in the New York Daily News color studio (left), where the photographer himself adjusts the cranelike tripod that holds his bulky camera. The log-cabin backdrop at the rear lent verisimilitude to the portrait of cowboy star Roy Rogers, taken in 1943. Photographers at the News studio built their own sets and created their own special effects, including a "snowstorm" of untoasted corn flakes sprinkled from a hand-cranked drum.

Creating a World on a Tabletop

No studio sleight of hand is more likely to arouse a viewer's curiosity about how an image was made than the successful use of a miniature setting. One of the masters of this tabletop art is French-born Michel Tcherevkoff, whose photographs—and the imaginative set-ups he used to make them—are shown here and on the following pages.

Tcherevkoff's photographs are noted for a sleek, space-age surrealism, and his sunny, meticulously kept loft in lower Manhattan has become a mecca for art directors seeking eye-arresting effects. Coming up with a design rarely takes Tcherevkoff more than a couple of days; but he may spend a week or more executing it—with the help of professional modelmakers and artists to build props and paint scenic backdrops.

Tcherevkoff creates the illusion of spaciousness in his scenes by playing with perspective. In the picture opposite, the highway seems to stretch into the distance because the lines were laid out to converge rapidly as they moved away from the camera. In most shots, Tcherevkoff also uses a wide-angle lens to enhance the impression of a sweeping vista and great depth.

Deft control of lights—and especially of the shadows they create—contributes to the seamless cunning of Tcherevkoff's Lilliputian constructions. But the ultimate key to his success is attention to detail. He makes sure that his models look authentic and that their surfaces are appropriately reflective or light-absorbent.

The shooting itself usually takes less than a day, and Tcherevkoff often invites his clients over for the occasion. He says, "I work hard, put on a good show—and make sure to set out a wonderful lunch."

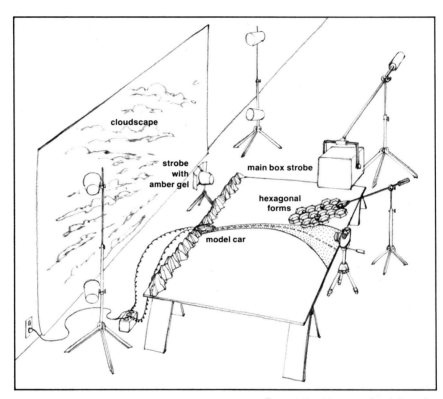

cloudscape

strobe with amber gel

main box strobe

hexagonal forms

model car

To create the picture opposite, photographer Michel Tcherevkoff used the set-up shown in the sketch above. The sawhorse-supported surface was a piece of gleaming black plastic laminate lined at the back with scale-model plaster mountains. A painted cloudscape was hung in the background. The highway—dramatically tapered to give the appearance of receding into the distance—was cut from a sheet of fine-grained black sandpaper and marked into lanes with lengths of tape. The model of hexagonal shapes was suspended from a boom above the scene. In addition to the main box strobe overhead and four background strobes, another strobe covered with an amber gel (a cellophane-like paper) simulated the setting sun.

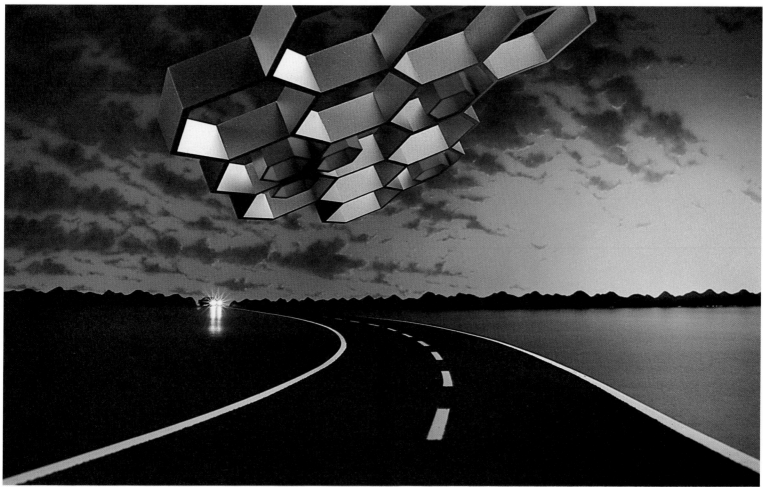

MICHEL TCHEREVKOFF: *AT&T Landscape*, 1981

In a fantasy scene designed to dramatize a new system of automobile telephone communications, mysterious hexagonal forms hover over a highway at sunset as a lone car approaches. Tcherevkoff used tiny quartz lights to simulate the car's headlights.

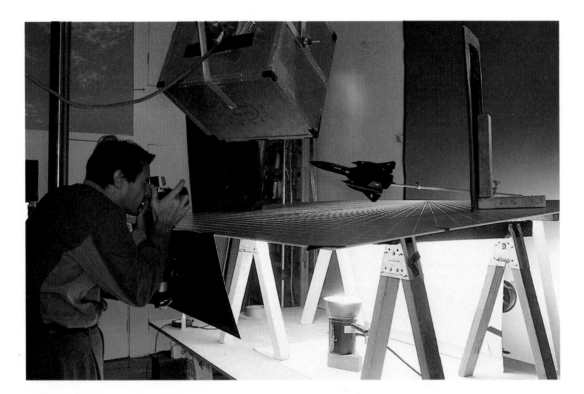

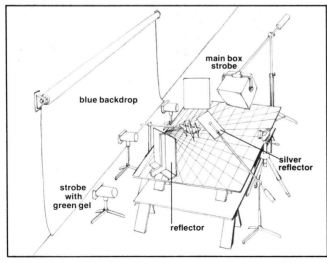

To create the glowing network of lines in the picture opposite, photographer Michel Tcherevkoff (above) used a sheet of white translucent acrylic coated with dark blue paint. He scraped off some of the paint to form a pattern of increasingly smaller squares that give the illusion of distance. The sheet was then laid across sawhorses (left) above a strobe covered with green gel while three similarly covered strobes lighted the blue paper backdrop. The model jet plane, illuminated by the main box strobe and three reflectors, was made from an ordinary hobbyist's kit. The jet's left wing artfully conceals the boom arm supporting it.

blue backdrop

main box strobe

silver reflector

strobe with green gel

reflector

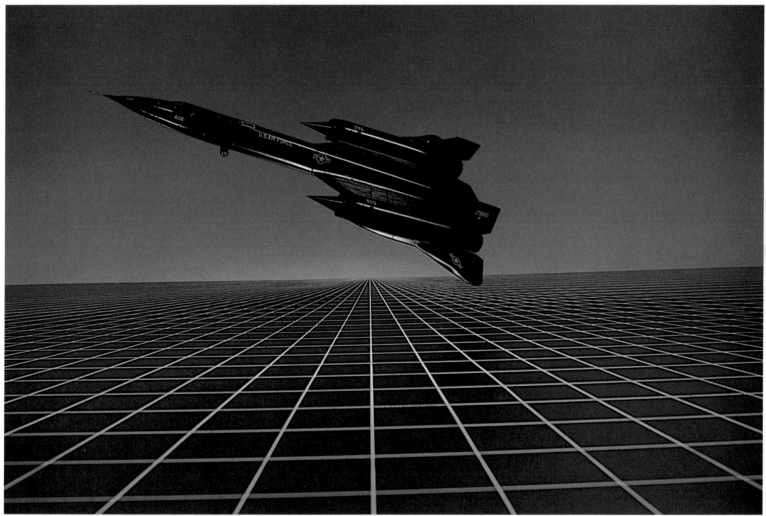

MICHEL TCHEREVKOFF: *The SR-71*, 1981

An SR-71 reconnaissance plane banks against a rich blue twilight sky above a luminous, futuristic grid that seems to extend forever in this scene created for a company that makes light metals for aircraft and satellites. Tcherevkoff hired a model builder to assemble and paint the miniature copy of the jet.

Fine Points of Food Photography

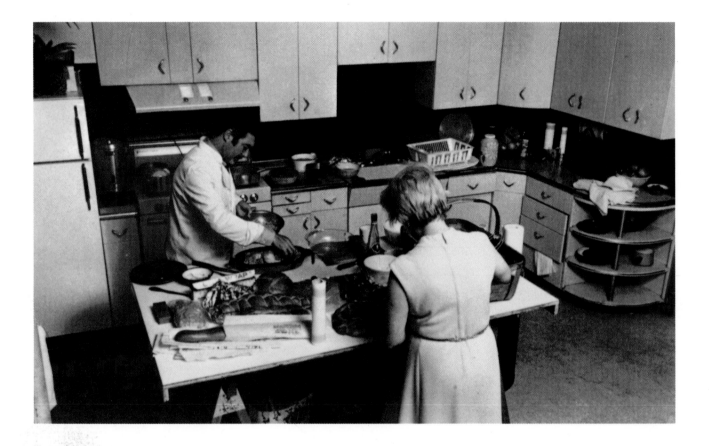

With new advances in set design, color and lighting techniques, studio photography had, by the 1950s, arrived at a versatility unimaginable to the early portraitists. Drawing from an increasingly sophisticated bag of photographic tricks, studio photographers gained the ability to conjure up a seemingly endless variety of special effects. They also acquired an entirely new breed of client—big business. Most large studios today work for large corporations, creating illustrations for magazine and book publishers and turning out photos for advertising agencies. This in turn has resulted in a new kind of specialization to meet the needs of commercial clients.

One of the most important studio specialties today is food photography. More money—upward of $3 billion a year—is spent advertising foods and beverages than any other kind of product. Food photography is thus the main business of many studios, which must have special kitchen facilities to handle it. One such studio, shown here and on the following pages, was established in 1963 by Rudy Muller on the ground floor of a converted printing plant in New York City. In addition to a generously appointed kitchen *(above),* it has a carpentry shop for building sets and a shooting area of some 3,000 square feet. Like most studios, it is equipped to take pictures of nonspecialized subjects. But a full 70 per cent of its billings come from photographing food.

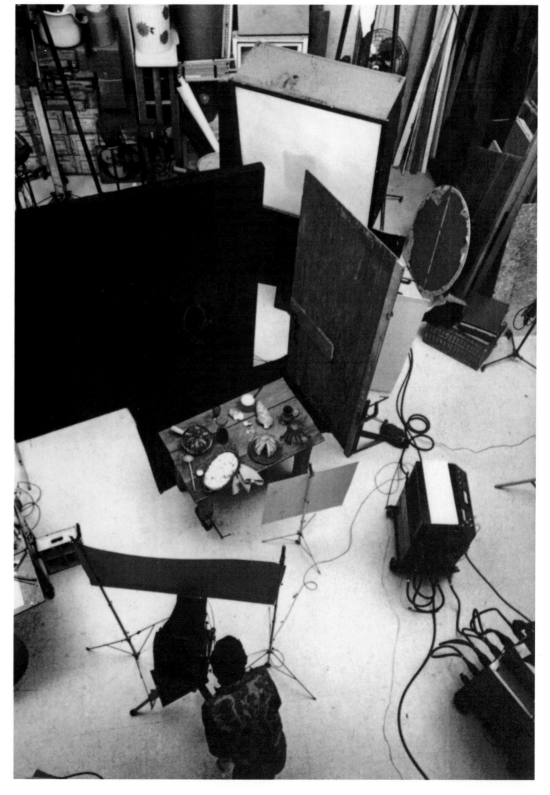

In Rudy Muller's studio kitchen, a chef prepares a casserole of Flemish chicken that will be photographed as part of an assignment for *American Home* magazine. The magazine's food editor, Frances Crawford, busies herself over loaves of braided French bread. The chef, Jacques Jaffry, is employed by the client. Although Muller supplies the kitchen, the client does the cooking.

Using an 8 x 10 view camera, Rudy Muller photographs, for *American Home*, a still life of assorted culinary delights, including the casserole being prepared on the opposite page. To give the picture a hearty, rustic look, the dishes are arranged on a plank table and an old barn door serves as one of the two background flats. The picture will be backlighted. The light source is a large boxlike strobe unit at the rear, which is aimed through the space between the two flats. Cardboard reflectors in front of the table and above the camera fill in foreground shadows, and the two bulky floor batteries attached to cables at the right provide power for the strobe.

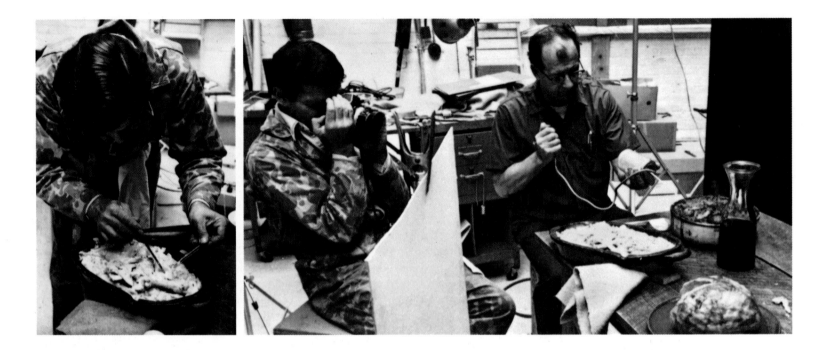

"Planning a still photograph is like putting together a movie," says Rudy Muller. "You have to put up a set, assemble the right props, and if you're using live models you have to find a cast." No casting was needed for the *American Home* assignment, which was simply to illustrate three traditional country recipes from Europe that would provide hot, one-dish meals for winter. Nonetheless, it took two days to set up the picture and photograph it.

The first step was a conference with the magazine's food editor and art director to plan the approach and decide on a set and props. Muller then built the set with the help of two assistants, while his stylist rummaged among the city's antique and gourmet-ware shops for appropriate plates, casserole dishes, pitchers and glassware. The next morning, a chef arrived from *American Home* to cook the food, which included a French *cassoulet* of beans and meat, Flemish-style chicken with cream and vegetables, and a stuffed cabbage. To make sure that the food would look fresh and appetizing during the entire shooting session, each dish was prepared in duplicate; when the first set of dishes became cold, it was replaced with the second set, which had been kept warm in the oven. As soon as the food was ready, it was arranged attractively on a table, the lighting was adjusted, and the shooting began. Muller photographed steadily for two hours, using both a 35mm reflex and an 8 x 10 view camera, and finally produced the picture on the opposite page.

Before shooting, Muller rearranges pieces of Flemish-style chicken in an earthenware casserole (above, left) to make them more photogenic. He then photographs the assembled dishes with a 35mm camera (center), searching for unusual angles and depth-of-field effects. To create the illusion of steam rising from the casseroles, an assistant gets ready to pump fumes of a concentrated acid into the air above them. The acid reacts with the air to produce a steamlike vapor.

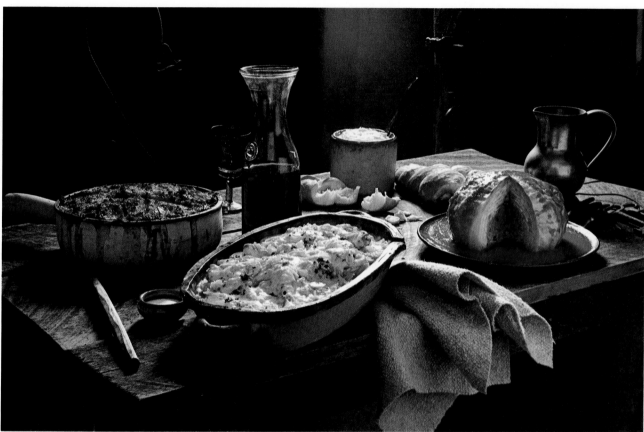

RUDY MULLER: *One-Dish Meals,* 1970

The photograph picked to run in the magazine
gives a hearty, down-home look to this array of
sturdy provincial dishes, each one a meal in
itself. The cassoulet is in the casserole at left,
the chicken in the earthenware baking dish in
the center, and the stuffed cabbage with tomato
sauce on the plate at right. The wine carafe,
butter pot and lusterware pitcher were chosen to
enhance the effect of a country kitchen.

Staging a Rustic Tableau

As an instrument for creating complex, story-telling images, the studio photographer's camera challenges the illustrator's pen. Among the photographers who are known for this narrative approach is Hollywood-based Reid Miles, whose intricate vignettes have become hallmarks of several major advertising campaigns. In them, Miles evokes the small-town feel of Middle America with a whimsical mix of nostalgia and humor that often emulates the styles of Norman Rockwell and other period illustrators.

One of Miles's chief assets is Hollywood itself. The movie-making community not only has an abundant supply of skilled designers, stylists and other set workers, it also boasts a large number of prop-rental shops filled with authentic remnants of decades past. In addition, Hollywood offers an enormous selection of character actors whose larger-than-life personae are perfectly suited to Miles's broadly comic roles.

Miles—who claims with a smile that he turned to the camera because he could not draw—pays minute attention to staging the tableau and refining its details. (The set at right took four days to build.) He especially devotes time to coaching the actors in the exaggerated expressions and postures needed to turn them into caricatures. The result of his orchestration is a humorously overblown scene packed with such realistic details that it rivals the most intricate drawing.

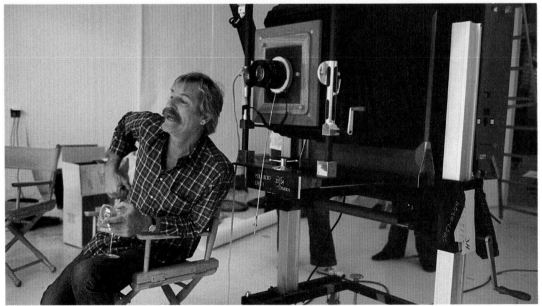

Inside Reid Miles's Hollywood studio, two assistants (above, right) give the finishing touches to a set carefully designed to epitomize a rustic general store. Miles himself (right) gives directions on light-placement from his chair next to a huge view camera that gives a 20 x 24-inch image on instant film; the final shooting is usually done with a 35mm camera.

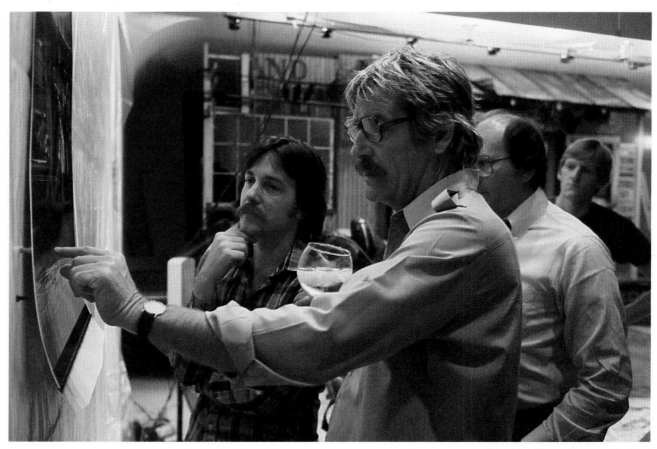

Two actors look on as Miles and an assistant examine one of the giant instant-film shots. Miles uses the shots first to check the appearance of the set alone; on the day of the shoot he uses them to study the effect with the actors in place.

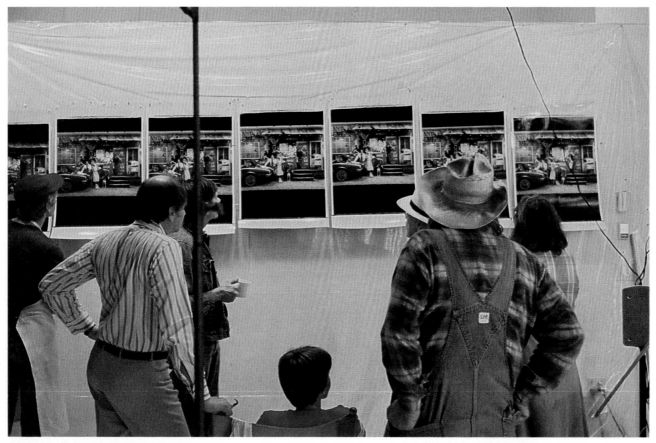

During a break in the shooting, the actors gather
to look at the growing array of instant shots. Miles
sometimes employs the shots to study major
changes in composition, but more often he uses
them to check variations in the actors' animated
facial expressions and exaggerated postures.

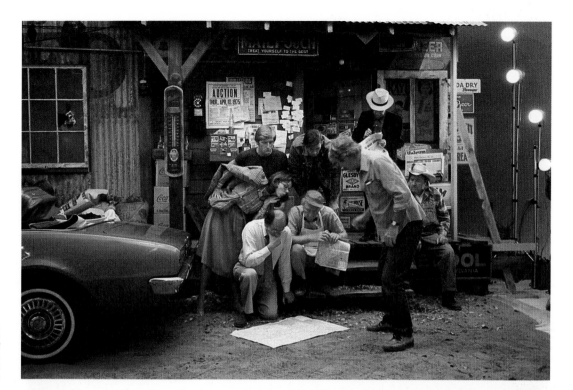

Trying one approach to the theme of cityfolk lost in the country, Miles positions the actors to see how the scene would look with the map spread on the ground and the actors hovering over it. He abandoned this version without taking a picture because it forced the actors to look down, obscuring their expressions.

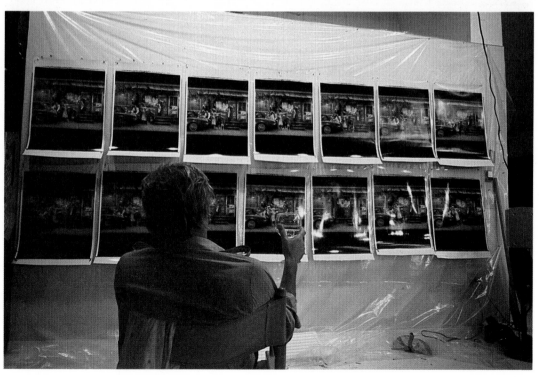

Before the final shoot, Miles takes a few minutes to contemplate the 14 best instant pictures of the 40 taken. He will shoot several versions of the same basic scene, and at this point in the day's work he must decide which arrangements he wants to use.

The final version selected for Reid Miles's portfolio captures the reactions of a city couple and their son to the contradictory directions they receive from a colorful assortment of rural characters. The set supports and studio ceiling seen at the edges of the picture are normally cropped in reproduction; Miles shoots the extra margin to be sure he has the entire scene within his frame.

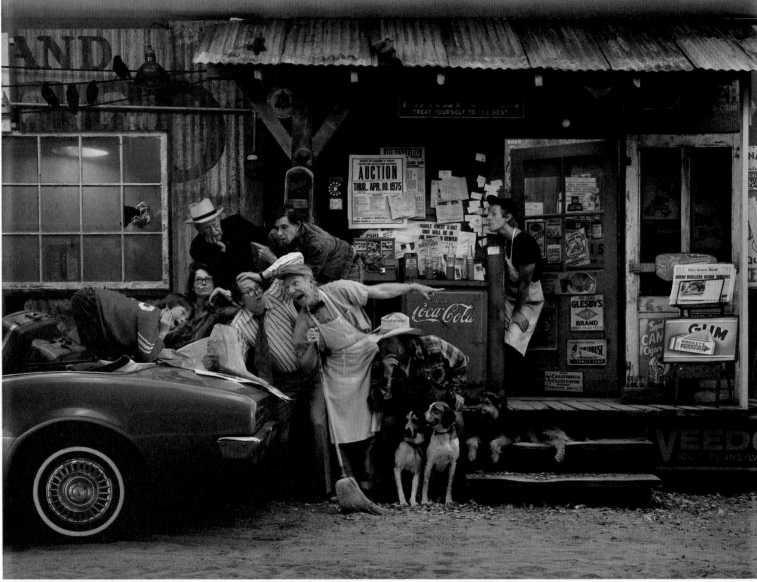

REID MILES: *City Slickers*, 1981

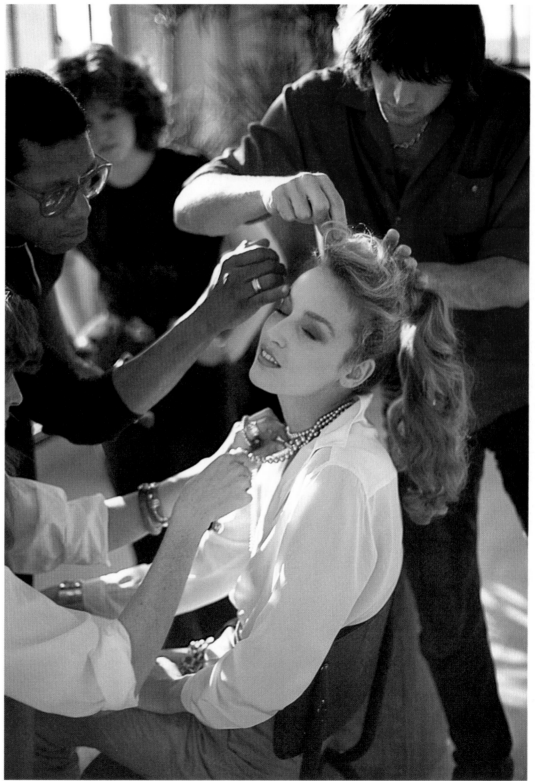

ARTHUR ELGORT: *Stylists Behind the High Style*, 1981

Taming the Whirlwind with Teamwork

Big City Productions. The studio's exaggerated name reflects the style that has made the reputation of its founder and senior photographer, Steve Steigman. It occupies the middle three floors of an old five-story loft building on East 19th Street in Manhattan. Steigman, whose successful career enabled him to buy the building, lives above his shop on the fifth floor, and rents out the ground floor to a competitor. The tempo at Big City is very big city — a controlled whirlwind from eight in the morning to eight at night — and nowhere is the action more frenetic than in the high-ceilinged studio on the second floor, where Steigman shoots his complex, cartoon-like vignettes.

On a set designed to look like backstage in a theater, six models, all male, are lined up in front of a star-emblazoned door. They are laden with gifts, obviously waiting to vie for the favor of an unseen leading lady. At the head of the line is a young man carrying daisies. Red-haired, slight and impish, he is the epitome of the pipsqueak upstart. Each of the others also caricatures a classic type: suave man-about-town, rich businessman, debonaire diplomat, lanky Texas oil tycoon, and a portly, middle-aged man with a neatly trimmed mustache, who could pass for anyone's uncle.

Steigman, looking through the viewfinder of a 35mm SLR, speaks with rapid-fire urgency. "Hand higher, Rich," he tells the young man. "Higher. Higher. That's it! Now, head to the left a little. Just a little. Now, everybody else bend to the left like a banana. More. A little more. Willie, wide eyes rolled toward the door." The diplomat expands his eyes until they look like hard-boiled eggs. When another model doesn't get the pose right from verbal instructions, Steigman, wiry and bursting with energy, bounds onto the set to demonstrate. A smoke machine whirs into action and two of Steigman's assistants wave large cardboard sheets to diffuse the smoke in a fine haze that suggests a dusty backstage atmosphere. A third assistant hovers over Steigman at the camera; his job is to keep track of exposure settings, film frames and strobes.

Steigman takes a Polaroid test shot of the scene and shows it to the advertising agency art director who is present for the shoot. They compare it with the art director's rough sketch of how the scene should look. As they confer, the stylist — a specialist in charge of props and the models' appearance — rushes over to powder the sweaty bald pate of one model and brush an errant lock of hair on another. When she starts to smooth the lapel of the young man at the head of the line, Steigman stops her abruptly. "Leave him. He's supposed to be a schlemiel." The photographer takes another look through the viewfinder and decides that a wall phone in the background should be moved. All three assistants converge on the prop: Screwdrivers flash, a drill whines and the phone is moved in less than two minutes. With six models on the set, there is no time to lose; each is costing the client $150 per hour.

"Ready, guys," Steigman shouts as he jumps behind the camera. "Rich—

sweet expression. More syrupy. You're in l-o-v-e." His voice flutters as he draws out the word. "Everybody else—surprise. A little more upset. Like this: 'Humph,' 'Humph.' That's it. That's it. Beautiful." Steigman's delivery becomes a staccato incantation, every phrase punctuated by a blinding burst from the strobes. "Hold it. Hold it. H-o-l-d i-t. Surprise. Humph. Humph. Rich, more oohhh, you're star struck. Good. Good. Hold it. Hold it. Champagne bottle in the back a little higher. Perfect. Bracket. One. Two. Hold it. Three. That's a beautiful shot. Just a couple more . . ."

A change in camera angle causes a cardboard mask overhead to intrude on the scene; a ladder appears and the offending edge is quickly folded up and taped out of the way. The art director suggests changing the young man's daisies for a single rose; the stylist makes the switch from her supply of extra props. The pulsing cadence of directions and strobe bursts begins again.

There are dozens of commercial photographic studios that operate like Big City Productions, doing a general business that includes television commercials. All of them are engaged in complex assignments that require close co-operation among the many specialists who make up the studio team. As the versatile studio photographer Irving Penn once remarked, running a studio is like flying a plane. Both jobs involve very expensive, delicate pieces of 20th Century equipment. Like airplane captains, studio photographers must rely on their crews to carry out their orders and anticipate their wishes.

The number of people on the team can vary greatly. Big City is unusual in that it has a full-time staff of 16—including three bookkeepers to cope with the $12 million in annual billings—and can offer its clients two very different styles of photography (most commercial studios limit themselves to one style or another, or to some specialty of subject matter, such as food or fashion). The reason for the duality is simple: Ad agencies often propose layouts that require both a staged illustration and a product shot. At Big City, both pictures will receive equal attention, for two floors above Steigman's theatrical setup is a still-life studio, the domain of his colleague and former star assistant, Steve Bronstein, who specializes in sleek, view-camera product shots.

In Bronstein's workplace, white walls and orderly rows of equipment give the room the clinical calm of a research laboratory. A radio plays soft rock in the background, and on a workbench is a large cage containing two doves—leftover props that were adopted as pets. As an agency art director paces the room, Bronstein stands on a ladder with his head buried under the black focusing cloth of an 8 x 10 view camera. He gives precise directions to an assistant who is on his hands and knees under a makeshift table, adjusting the placement of a strobe that will shine through the table's translucent plastic surface. Bronstein often photographs tricky subjects such as liquor bottles and silverware, but today's is unusually difficult: a flawless, $50,000 three-carat dia-

mond. The gem is smaller than the tip of a little finger, and the slightest shift in a strobe's position radically alters the way its facets transmit and reflect light.

After hours of preparation, the tiny subject is nearly overwhelmed by equipment. With the camera's bellows fully extended to more than three feet, the lens is practically touching the diamond. A huge box strobe hangs only inches overhead, side and back strobes create highlights, and a tiny reflector dangles from the end of a long boom. The under-table light adds a finishing touch to the background by creating a halo around the stone's crest. Now Bronstein tackles the difficult feat of giving the precious jewel sparkle without losing the crisp detail that the view camera provides. "In simple product shots," he explains, "subtlety of design and lighting is sometimes about all you can offer." After trying several approaches, Bronstein comes up with a complex double exposure that produces a constellation of shimmering stars. The art director is delighted, and Bronstein—with more than 30 Polaroid test shots already stacked up—is at last ready to record the subject on 8 x 10 film.

If the pace in Bronstein's studio is less hectic than in Steigman's, it is no less intense. For both photographers, meticulous tinkering and an enormous amount of concentration go into each session. Throughout the exacting process, an assistant works hand in glove with the photographer—shifting lights, loading film into the camera, adjusting exposure settings, keeping tabs on the test shots and real film they have taken.

Nearly all assistants are aspiring photographers who are willing to work long hours—13-hour days are not uncommon—for relatively low pay in order to learn the profession from the inside. Among the jobs they must master are the building of sets and other practical arts of illusion making. Apple boxes, for example—small platforms 18 inches on a side and three, six or 12 inches high—can be used to boost furniture or models in a shot (as long as the camera's field of view does not include the floor). Plain muslin stretched over plywood panels, stapled along the edges and painted with ordinary latex will look like a plaster wall. Add a baseboard, put a carpet in front, hang a picture—and the room is complete. If a brick wall is needed, as in Steigman's backstage shot, fake-brick facing is stapled to the panels and washed with a dilute solution of white tempura paint for a more natural look. Door and window units complete with frames fit easily between panels, and the whole contraption is kept erect by "pole cats"—2 x 3-inch uprights with spring-loaded caps that allow them to be wedged between floor and ceiling. Steigman's senior assistant, Dennis Kitchen, swears by the usefulness of the hot-glue gun, a handheld, plug-in applicator that melts sticks of waxy glue, extruding a stream of it when a trigger is pulled. The fast-hardening adhesive is strong enough to attach molding to a wall or a knob to a door, but a brisk yank will remove either.

During slack periods, the assistants perform ordinary housekeeping chores

that keep the studio in shape—painting a wall, cleaning the refrigerator, vacuuming the dressing area. The senior assistants must be almost fanatical about returning every piece of equipment to its place after a shoot. Sawhorses and apple boxes are stacked neatly in one corner along with the spring-loaded poles; in another corner, rolls of seamless backdrop paper in cardboard tubes are stored in a tray that holds them upright. Tripods, light stands, ladders, handtrucks and brooms all have their hooks on the wall. Tools, tape rolls and cardboard sheets, sorted by size, all fit in roll-around carts. Plywood panels go into storage, cameras and other equipment are locked away. After a year or two, most assistants move on to apprenticeships with other photographers until—like several of Steigman's former aides—they open studios of their own.

On the floor between Steigman's and Bronstein's studios is the nerve-center of the Big City Productions: the offices of studio manager Sue Moseson. Three buttons are lighted on her phone and two staff members are waiting to see her as she coolly attends to the innumerable details that keep the business side of Big City running smoothly. During a momentary lull, one of the company's two sales representatives joins Moseson to work out a cost estimate—a written statement that tells an ad agency how much it will have to pay for a picture it wants the studio to shoot. The sales representatives' job is to drum up business by showing samples of Steigman's and Bronstein's work and touting the studio's ability to meet an ad agency's tight schedule. Allowing one day for set construction and other business matters, each photographer can schedule four days of shooting a week. When only a plain seamless-paper backdrop is required, Steigman can put models through their paces at four or more sessions per day; his record is 12.

Moseson and the sales representative have prepared this particular cost estimate based on a sketch that was made by the advertising agency's art director and on the detailed discussion the sales rep had with the agency. The sketch shows five businessmen around a conference table against a backdrop that suggests a large corporation's board room in a glass-enclosed skyscraper. The cost of renting each prop—table, chairs, business suits—is carefully calculated; even the price of pads, pens and ashtrays to go on the table is added in. For the background, Moseson and the sales representative figure the cost of getting a painted canvas of the sky from a theatrical-backdrop service, as well as the charges for borrowing and trucking four sheets of plate glass to simulate windows. Finally, they calculate that the stylist and three studio assistants will each spend two days on the project and that Steigman will spend three hours shooting; they add in the value of the time. For the agency's information, the estimate also notes the cost of five models, even though the agency will be billed directly by the models' agents. If the agency and its client

approve the estimate, Big City will shoot the scene in about two weeks.

After conferring with a staff member and taking a call about the delivery of a prop, Moseson makes a call herself. "I need a house," she says into the phone, "a regular suburban development type house. One with a little back porch with a little roof over it. The roof is very important." She is speaking to the owner of a location service—an agency that has on file thousands of locales that the owners will rent for a shoot. She has already talked to three other services, including one named This Must Be the Place. If there is the faintest hint of frustration in her usually cheery voice, it is because two portfolios labeled "Porches" have arrived by messenger and not one of the scores of Polaroid snapshots in them shows anything nearly as ordinary as the porch she needs for tomorrow.

Before resorting to a location service, Moseson first checks the studio's own file of locations it has used in the past and others that have been scouted as potential shooting sites. When an unusual location is needed, Moseson will send studio assistants to likely settings to take study shots. The pictures are filed, along with notes about lighting conditions, even if the location is not used, since Moseson never knows what the next request will be. Among the photographs in her files are book-lined Victorian rooms (found when Big City staffers were looking for a setting that could pass for Edgar Allan Poe's library) and unused railroad tracks (once needed for a scene showing a beautiful model tied to them). Because the cost of traveling with models who are being paid by the hour is expensive, Moseson always tries to find a site as close to the studio as possible. For New York photographers and location services, favorite sources of typical American homes are the suburban New Jersey communities that lie just across the Hudson River. However, when a shot demands it—and the client is willing to foot the bill—Steigman and his crew will travel as far as is necessary. To make a picture of a woman being scooped up by an authentic turn-of-the-century steam shovel, they went to a gravel pit in the hills of North Carolina, where exhaustive research had turned up one of the last of the monstrous machines. Steigman shot a sweeping overview of the scene while he was suspended from the basket of a cherry picker.

Finding locations is but a small part of a studio manager's job. Among other tasks, Moseson coordinates photographers' schedules with clients' deadlines, arranges for delivery of props and set construction materials, finds temporary studio help and keeps track of each job's budget. The key to success in her pivotal position lies not only in getting everyone and everything to the right place at the right time but in doing this calmly and diplomatically despite last-minute glitches and emergencies real or imagined. Moseson's calm demeanor allows her to keep one ear on the conversations going on around her—the source of up to half of the information she needs to operate. Everyone assumes that the studio manager knows everything that is going on. She usually does.

The conversations that Moseson monitors take place in a sunken seating area just in front of her desk. Commonly referred to as the Pit, it contains a large, low table with two phones, and it is where staff members go to make calls, do paper work or hold a meeting. Big City's two stylists spend a great deal of time on the phones in the Pit. Aside from taking care of models and props during a shoot, a stylist's prime task is to seek out props. Some of these can be borrowed from the half dozen or so property houses in New York that cater to theaters and movie companies as well as photographers, but more often the stylist turns to her most valuable possession: the source book she herself has compiled. Under alphabetized headings such as Clocks, Fans, Military Uniforms and Office Furniture (Antiques has by far the most entries), the book lists businesses and people that a stylist knows, first- or second-hand, to be reliable sources. A few telephone calls followed by a quick inspection trip will usually turn up even a seemingly obscure prop, such as an old maritime sextant.

Sometimes, though, the search can be more arduous. The most unusual heading in Jayne Boyle's source book is Foam. It dates from a shoot for which she needed to have a washing machine wildly bubble over with suds. Although it is simple enough to do this with an overdose of soap, Boyle needed a way to do it quickly and repeatedly in a controlled manner while the photographer was shooting. After dozens of calls, she found the answer—a firefighting device known as a high-expansion foam machine. She rented one from the fire department in Morristown, New Jersey.

Another heading in Boyle's book is Grass. It lists sources in Florida and California that will fly sod to a winter-bound New York so that a summery lawn scene can be set up in the studio. Her book also lists a place where she can buy dry ice at six in the morning to keep ice cream frozen or beer cans frosty on a location shoot, or to create billowy smoke in the studio. Listed under Jewelry is the name of an artisan who will craft an earring using colors that echo the client's product. A stylist's resourcefulness is usually backed up with a considerable collection of tricks of the trade—especially when it comes to fitting clothes to a model quickly. The secret is to err on the large side: Baggy jackets and pants look perfectly tailored when large clothespin-like spring clamps are used to pinch up excess fabric in the back, out of the camera's view. Too-long trouser legs are hemmed by turning the extra length into the leg, pressing it with an iron and then securing it with tape. An oversized hat or shoe is made to fit by stuffing it with crumpled tissue paper.

Like photographic assistants, stylists usually work on staff until they have learned the ins and outs of their craft. Then they too go out on their own. Many smaller studios hire freelance stylists to work a day or two at a time, and an experienced stylist can command a healthy daily fee.

Although they are in many ways still apprentices, Big City's staff stylists and photographic assistants are able to handle more than 90 per cent of the studio's prop and set needs. Sometimes, however, an outside specialist is needed, particularly for still lifes of food. An expert in the preparation of food for photography is known as a home economist. At Big City she uses the complete kitchen at the rear of the still-life studio to put finishing touches on the dishes she has concocted for the shoot. Usually she makes multiples of everything in case one dish dries out or wilts. Another professional brought in on occasion is a set designer, who builds settings too structurally complex to be handled by the assistants. The outsider that Big City calls upon most often, however, is a model maker. The stock in trade of most model makers is such items as miniature buildings with windows that light up, plastic ice cubes that not only do not melt but look more authentic than real ones, and bottles pouring out a seeming-liquid that is really molded plastic.

Over the years, some of these adept craftsmen have built other clever deceptions for Big City: a scale replica of the famous English landmark Stonehenge; a fully detailed, scale reproduction of the interior of an airplane's fuselage; and a copy of an escalator one quarter life size. One model maker crafted diminutive ornaments and lights to make a liquor bottle look like a Christmas tree. Another constructed a model of Earth as it looks from space so that a brass mail slot could be attached to it (for an ad promoting a service offered worldwide by mail). Still another artisan created an oversized and somewhat misshapen light bulb; it was positioned above a model's head to suggest a bright idea that went amiss.

While the photographers at Big City routinely turn over many tasks to others in and out of the studio, there is one job that Steigman prefers not to delegate: casting human models. Their appearance and the personalities they project constitute a much too vital part of his photographs, especially the zanier tableaux. Surprisingly, he has no use at all for the catalogues that are issued by model agencies or the composites of shots of themselves that models hand out. "They've put on a mask in those," he says, "I like to see the mask off." In order to observe a model unhampered by preconceptions, he prefers to work with what he calls a "mug shot" — a passport-style head shot snapped on instant film by one of his assistants. The picture is put on an index card along with the model's age, clothing size and agency. Steigman then sorts such cards into two broad — and distinctly personal — categories: "Favorites" and "Others." Each of these categories is subdivided by age and sex — for example, "Boys 13-18" or "Women 60-70." The 2,000 or more photographs in Steigman's Favorites files are the ones he commonly flips through when he is searching for characters. He selects two or three he likes for each role, in order of preference, and usually the advertising agency goes along with his choices.

From time to time he browses through the Others file to see whether he has overlooked a potential Favorite.

Although the models in Steigman's vignettes look at times like outrageous exaggerations, he has no trouble finding such unusual-looking subjects. Every Monday morning the studio has an hour set aside for taking mug shots of all comers, and the stream of people is steady. Occasionally, a special casting session is held for a specific shoot or to get new faces. Once, when Steigman felt his collection was getting stale, he placed an ad on a local radio station. The studio was inundated with more than 2,000 applicants, and about 25 ultimately ended up being hired. What Steigman looks for in a model is not simply a physical type. The ones that end up in his Favorites file, he says, project an attitude that he likes, often a liveliness expressed by a sparkle in the eye. When he spots people he likes on the street or in a restaurant, he has no reservations about going up to them, giving them his card and asking them to drop by for the Monday morning mug-shot session. One such find who has since modeled for Steigman is a bartender from around the corner.

Steigman has also become expert at finding animal models. Besides using animal talent agencies, which keep endless files of lovable mutts, haughty felines and sassy parrots, he knows the two sources of elephants in the New York City area. One, the Bronx Zoo, let him bring models and a seamless-paper backdrop to the zoo during off hours and set up a scene with a tame pachyderm that usually gives rides to children. That seasoned pro performed beautifully; but Steigman often finds animals unable to live up to their trainers' promises when surrounded by strangers and facing repeated blinding strobe flashes. His most harrowing experience came when he was shooting a camping scene in a specially rented studio; a bear reared up to its full seven-foot height and ran right over the camera and out the door.

A typical day at Big City begins to wind down about 7 p.m. In Bronstein's still-life studio, the senior assistant sets up an elaborate arrangement of television sets for the next day's shoot. His counterpart downstairs double-checks equipment he will pick up at five-thirty the next morning for a location shot; in the dressing area nearby, the stylist makes a survey of the props they will take along. On the floor in between, the studio manager makes a last call to a modeling agency to set the time the models will be picked up at the studio to go to the location. She then returns to working out a new estimate with a sales representative. Steigman and Bronstein have settled into the Pit with the other sales representative to discuss accounts. They are interrupted twice, once by the vacuum of an assistant finishing his daily clean-up of the area, and again by the nuzzling wet nose of Steigman's golden retriever, Timber, who has slept almost continuously through the long day's whirl, and now seems disturbed by the unnatural calm descending over the studio. *Don Earnest* □

On the Subject's Home Grounds

For most studio photographers, the great test comes when they discover that the picture they want to make cannot be shot on their home ground—that, despite the availability of stylists, props, models and all the requisite equipment, they must go on a pilgrimage, taking studio to subject. There, on location, they must achieve the technical perfection of studio work.

At times, the reasons for taking the studio on location are obvious. Heads of state seldom can find the time to visit a photographer's studio: To take the picture opposite, Arnold Newman, who is based in New York, had to set up the essentials of a studio in the Oval Office of the President in Washington.

At other times, the reasons for going on location with the studio are more subtle. It is possible—if complicated—to create in the studio a surprisingly realistic wheat field *(pages 188-190).* But many abstract photographic ideas are difficult to execute except on location. To best express the drama of 2,000 years of Christianity, Newman went to Jerusalem and set up a studio in a street at dawn *(overleaf).* Many other studio photographers have made the brief trip from Manhattan to Brooklyn—or spent months traveling across the world—in search of atmospheric locales essential to their pictures.

Whether they travel with elaborate setups, taking a specially designed tent as did Irving Penn *(pages 94-98),* or with a minimum of gear as did Louise Dahl-Wolfe *(pages 88-89),* studio photographers on location carry a vital, indiscernible piece of equipment: their own minds. Therein, as Newman says, lies their purpose: to "get, or try to get, the kind of picture you imagined before you left."

When Arnold Newman was asked to make a portrait of President Lyndon B. Johnson in 1963, he took his studio equipment to the Oval Office in the White House. Newman was given 90 minutes to arrange his equipment, but only 15 minutes for the actual shooting. The photographer covered the windows with cloths to block unwanted light, mounted two view cameras—a 4 x 5 and an 8 x 10—and arranged his lights and reflectors, using an assistant as a stand-in. While making his picture (opposite), Newman coaxed the President into the poses and facial expressions he wanted, as a Secret Service man watched in the background.

Crowded into a narrow ancient street —and guarded against Arab snipers by Israeli soldiers —Newman set up religious articles before his view camera for the picture opposite. Since it was shot at dawn, the natural light was bolstered by floodlights and spotlights with reflectors.

Summing up the spirit of Christianity, a plain ▶ Cross borrowed from a nearby church rests against a wall of the Via Dolorosa. The pennon with the Cross on its flagstaff's tip and the weapons represent the Christian Crusaders who fought to drive the Moslems from Jerusalem.

Shortly after the Six-Day War of 1967 between Arab and Israeli forces, in which Jerusalem fell to Israel, *Holiday Magazine* assigned Arnold Newman to make photographs symbolizing the three great religions—Christianity, Judaism and Islam—whose histories are bound to the Holy City. Newman and his editor realized that such pictures could be taken only on location, in Jerusalem.

Before setting out, Newman blocked out each photograph in his mind and selected the props he would need. Once in Jerusalem, he decided to take the Christianity picture on the Via Dolorosa, the narrow street along which, according to tradition, Christ carried the Cross on his way to the Crucifixion. The site is that of the Fifth Station of the Cross, where Simon of Cyrene stepped forward to help Jesus carry the Cross. For the picture *(opposite),* the King James Bible was opened to Matthew 27:32, where the story of Simon is told. □

ARNOLD NEWMAN: *Christianity, the Fifth Station of the Cross*, 1967

Working out of a Suitcase

When the noted fashion photographer Louise Dahl-Wolfe undertook a quest for unusual locales in the years following World War II, the better to display high-style clothes, she resolved to remain a studio photographer but at the same time to travel light—without boxes of props or elaborate equipment. She had to depend upon her own ability to exploit natural lighting and upon finding props on the spot in order to produce studio-quality pictures. She succeeded brilliantly, returning from exotic places with exquisite pictures. By artfully incorporating the local architecture and handiwork *(opposite)* into her photographs, Dahl-Wolfe demonstrated that the studio is defined by the photographer's mind—which has control of the subject matter whether in Marrakech or on Madison Avenue. □

Ready to depart an estate in Hammamet, Tunisia, where she shot fashion pictures for Harper's Bazaar, Louise Dahl-Wolfe (above, far right) used a self-timer to trip the shutter for this picture of her troupe and herself. Her model, Natalie, stands at the group's left—and the car roof bears cases containing dresses and her view camera.

In the shade of a Tunisian tree, Natalie wears ▶ *cuffed shorts and blouse of rayon faille—an image of cool sophistication created by careful use of natural light. The exotic props—two pairs of love birds in filigreed cages—were obtained locally.*

LOUISE DAHL-WOLFE: *Sportswear in Tunisia,* 1950

Instant Setting in an Empty Flat

Rudy Muller is a New York photographer and former antiques dealer noted for his appropriate choices of props. He often wins commissions because his imaginative studio sets give an added dimension of realism to the message an advertiser wishes to convey. If an outdoor setting or a tight schedule makes building a set impractical, Muller finds a scene to match his idea and simply takes the studio on location.

For a 24-page newspaper advertising supplement planned by a wine and liquor importer, Muller conceived nine different parties at which the products might be used. To establish a mood of youthful gaiety for a "moving-in" party *(overleaf)*, he chose an empty flat in Brooklyn's Park Slope district. Old town houses there were drawing an influx of New Yorkers who liked the high ceilings, bay windows and cavernous rooms—attractions that Muller saw as well suited to his own purposes. He rented the flat for a day, made it a studio, set the scene, shot the pictures and was out by nightfall.

Forethought is the key to this kind of operation; once on location the photographer must be self-sufficient. Muller's studio equipment—cameras, lights, extension cords, stands, tool kit and ladders—filled a station wagon. A second station wagon, timed to arrive an hour later, carried the props for the party scene—food, tableware, barrels, packing crates and the client's wines.

One of Muller's assistants (nearer the camera) lends a hand to a moving man in the photographer's Manhattan studio as they prepare to pack for the trip to Brooklyn. Everything needed to set up a studio-on-location had been previously assembled; careful tallies of equipment were made at both ends of the journey.

A stepladder and big cardboard reflectors are among the first items to be lugged up to the apartment chosen for location shooting. Muller's crew transformed the bare living room into a studio, swept and dusted, and staged the scene he imagined for a young couple's moving-in party.

Muller (in doorway, rear) approves the hostess gown the model will wear at the moving-in party he is staging in the empty apartment. The models had arrived on location right on schedule, about two and a half hours after the first load of equipment came. By that time the studio was essentially set up: Lights, reflectors and cameras had been placed by Muller's assistant; the party scene was ready for the last touches.

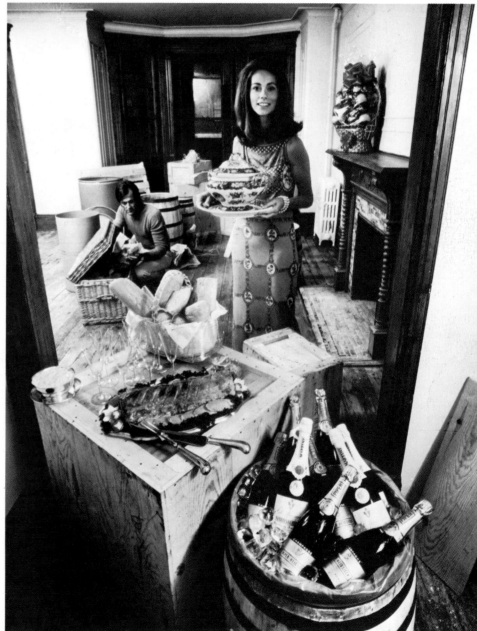

With her dress carefully hung up, the model crouches in front of a mirror previous tenants had left in the apartment bathroom, perfecting her make-up in preparation for the final shot.

Muller hand-held his Nikon F for the photograph at right. "Host" and "hostess" are almost ready for their guests. The dinner — onion soup, roast smoked pork loin, hot French bread, fruit and cheeses, which the man is unpacking — will be served with champagne and Italian wines. Muller artfully placed a fruit basket on the mantel to hide an ugly light fixture. The antique tureen, crystal stemware, Revere bowl and pistol-grip carvers imply the comfortable background of a young couple who offer barrels and crates as tables and seats at their moving-in party — but have the taste to serve the advertiser's wines.

RUDY MULLER: *We-Just-Moved-In Party,* 1970

Irving Penn's Neutral Ground

In making a long series of documentary portrait essays that took him to remote parts of the world, Irving Penn chose to work in what he called "neutral ground," where subjects, removed from their natural surroundings, lower their guard and offer a true aspect of themselves to the photographer and camera. This means using a studio. Penn discovered the value of such neutral ground in 1945 during a Christmas visit to Cuzco, Peru. There he rented a local photographer's portrait studio where, in three days, he made a number of photographs that Edward Steichen said "richly render the timelessness and human dignity of a people." *Vogue* later assigned Penn to carry out a series of location-shot studio studies of little-known cultures.

For most of these assignments Penn hired studios. In Spain and Crete he improvised, using the bare walls of farmhouses and garages as his backgrounds and employing the Mediterranean light the way he would floods and spots. But in 1967, when his search for authentic locations and unspoiled peoples led him to the indigenous cultures of Dahomey on Africa's West Coast *(page 96)*, he knew he could not count even on improvised studios; it would be necessary to take one with him. He devised a portable studio he "could bring to the subject, rather than vice versa." This ultimate studio-on-location *(opposite)* accompanied Penn on all his later documentary expeditions, allowing him the desired control of conditions for his pictures.

Penn also brought personal assets to the job of photographing exotic peoples. A man of natural reserve and formality, he still was able to penetrate language and cultural barriers to elicit an equally serious response from his sitters, who became his rapt partners, rather than uninvolved subjects of snapshots.

"I have tried to find universal and timeless qualities . . . rather than to record accidental or transitory situations," Penn said when he described his aims. " At the same time, I also am always sustained by awareness of the documentary and historical value of these records . . . because tomorrow or next year much of what I photographed will be changed or gone forever."

New Guineans gather to watch Penn at work in his portable studio, set up among thatched huts on a fairground. While the studio was being erected an onlooker remarked, "Short fella house him come up long fella," as the frame of fitted pipes and joints rose swiftly into a structure 11 feet high over a 10 x 18-foot floor. Two men can set up the tent, which is light enough to ride on a jeep roof because its frame is aluminum and its covering is nylon. The light is controlled by adjusting the flaps and by the mobile reflector canted in the foreground. Penn's commitment to the studio setting does not extend to such standard studio gear as the view camera. His expedition pictures were shot with 2¼ x 2¼ twin-lens reflexes; he packed five of them and several sets of auxiliary close-up lenses.

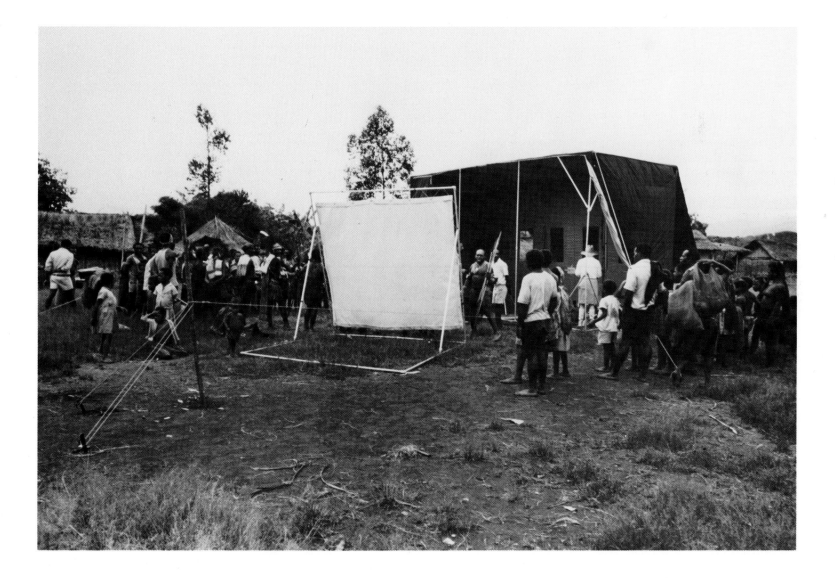

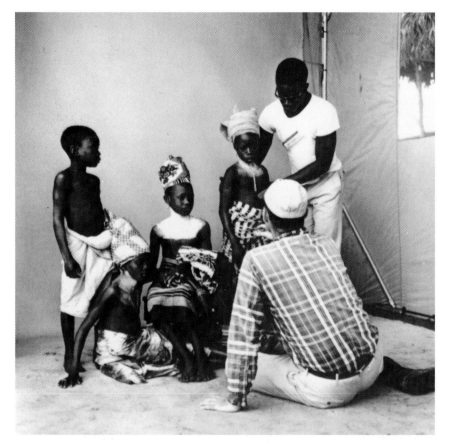

Seated on the floor inside his portable studio, Penn positions Aizo children for a picture (left). The bare tent contains nothing familiar — not even a grass blade for toes to pluck — to distract his sitters. While an assistant interprets his instructions, the youngsters' attention is riveted on Penn; they are spellbound by his intense concentration. With similar single-mindedness he also arranged Aizo women, opposite, in a pattern of graceful feminine self-assurance and Asaro tribesmen (overleaf) in threatening poses that recall their ancient traditions of warfare.

Women of Dahomey tribes like the Aizo, whose ancestors lived near the slave-trade port of Whydah, have long worn a behavioral disguise to protect their privacy from Europeans: They put on false airs of playful gaiety when outsiders are around. Penn overcame this psychological barrier, inimical to his plan to find the real nature of his subjects, by initiating a courteous, formal exchange of greetings and compliments.

Impressed by Penn's diplomacy, the villagers dropped their masks. They became, as Penn put it, "completely available," ready to take a personal part in the magical world within his studio. On its neutral ground they emerged as their real selves, human beings possessed of innate dignity *(opposite)*.

An observance of protocol and the isolation of the studio helped Penn in New Guinea, too. Once, encountering a delay on a trip to photograph the tribesmen of an isolated village, he had a formal apology for his lateness sent ahead to the highlanders who expected him. Evidently touched by this gesture, they willingly posed for him when he showed up. In one portrait *(page 98)* the tribesmen, mud-daubed to honor an old victory, affect frightening attitudes through posture and by means of their ceremonial masks.

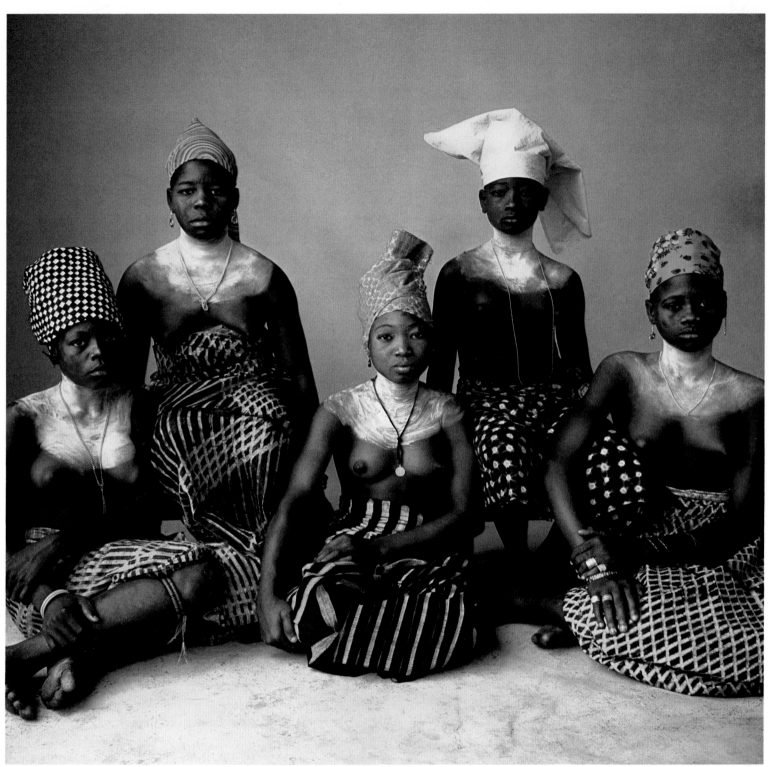

IRVING PENN: *Dahomey, Five Girls,* 1967

IRVING PENN: *Asaro Mudmen, New Guinea*, 1970

Focusing on Fashion **4**

EDWARD STEICHEN: *An early fashion photograph of a dress by designer Paul Poiret, Paris, 1911*

The High Art of Picturing Style

Fashion photography, the most glamorous specialty of the studio, is something of a paradox. The pictures, at their best, are technically expert and in some cases so beautiful that they are cherished among the finest examples of photographic art. Yet fashion photography is as ephemeral as a whim. The subject matter is severely limited: It consists, amid whatever props, of a model wearing the latest clothes. The photographer's problem is somehow to bring freshness and variety to pictures that, as Edward Steichen *(pages 106-107)* has said, "tell the same story year after year." It is not a simple problem.

As for the purpose of fashion photography, it may seem to be a straightforward job of selling, but in fact it is quite complex. It is the same many-faceted purpose served by fashion magazines themselves: to enter the dream world of "beautiful people"—the modish and sophisticated, nice-smelling and certainly well-off—and to report back to more ordinary folk what these trend-setters are wearing, how they are eating, what they are reading, where they are congregating. The purpose goes deeper, using this "in" world to influence the way the rest of us live—and in the process, to create an atmosphere that will induce us to buy what is advertised in the magazines.

The fashion photographer has several accomplices: the dress or accessory designer, the manufacturer and—since all photographs are meant for publication—a fashion editor and an art director. They help, but it is the photographer's own imagination, more than technical proficiency, that counts most. Combined with innate taste, imagination enables a photographer to do the job as defined by Cecil Beaton *(pages 110-111):* "The dressmaker provides the dress, but the photographer must make the woman in that dress appear in a manner that will give all other women a feeling of covetousness."

What often makes women—and men—covetous of a given fashion is the sight of someone inhabiting the desirable world of well-heeled luxury. Some of the most successful photographers of the 1920s and 1930s were aided in creating such a world pictorially by their own real-life familiarity with it. There was Beaton, son of a British timber merchant, who attended prestigious schools (Harrow and Cambridge) and moved from there into the top strata of London society, where he indulged twin tastes for party-going and dressing up: He once eschewed conventional dress to appear in a different fancy-costume disguise every day for 10 days. There was the pioneer Gayne de Meyer *(pages 104-105),* whose wife reportedly was the illegitimate daughter of Edward VII and who had a Venetian palace, a London town house and a home in the south of England, all rumored to be provided by his royal connection. De Meyer was a stoutish, cane-sporting exotic: He slept under a blanket of mink and protected his blue-dyed hair with a net while working in the studio. There was George Hoyningen-Huene *(pages 108-109);* he rarely used his title of baron and cultivated left-wing friends, but he also kept a picture of his father, a

Baltic nobleman, in full regalia preceding the Czar in the 1896 coronation procession in Moscow. Huene had a fabled temperament: When he was working for *Vogue,* the magazine's art director, Mehemed Fehmy Agha, acting on orders, took him to lunch one day and gently suggested that he "behave." Huene upset the table, food and all, right into Agha's lap, ran to the restaurant's telephone and called *Harper's Bazaar,* which hired him on the spot.

(Agha, a colorful personality in his own right, was the Ukrainian-born son of a Turkish landowner and tobacco grower. A witty raconteur, he was credited with finally laying to rest certain fashion-photograpy clichés from the De Meyer days by deriding them in a 1939 memo to *Vogue* President Condé Nast: "To be alluring, a model must clutch her hips; to be glamorous, she must lean over backwards; to be dramatic, she must clutch a drape.")

Since Agha's time, the grand style of the founders of fashion photography has given way to a more casual, informal approach. Beginning with Martin Munkacsi *(pages 112-113),* fashion photography has frequently ventured out of doors. Pioneering women photographers such as Toni Frissell *(pages 114-115)* and Louise Dahl-Wolfe *(pages 116-117)* introduced a new naturalism and intimacy into the genre, affecting the work of even such upholders of the old studio traditions as Irving Penn *(pages 120-121).* During the swinging '60s, nudity, kinky sex and intimations of violence came into fashion photography, along with the far-out fantasy of photographers like Richard Avedon *(pages 122-123).* But with the onset of more sobering economic times in the 1970s, a new generation of photographers emerged—many of them women—whose approach to fashion was more everyday and informal. They often worked on location with a minimum of equipment; but even in the studio they strove for a less stylized, more down-to-earth approach that owed much to street photography and photojournalism and brought fashion at least partway down from its pedestal into real life.

The problems inherent in fashion photography—the narrowness of its subject matter, its make-believe milieu, its commercial aspect, the plethora of patrons whom it must please—have stimulated some of the world's most gifted photographers in the three quarters of a century in which it has developed into a specialty. Often their work can be identified at a glance: The pictures on the following pages bear their creators' signatures as surely as if the photographers had written their names on the negatives. In meeting their own exacting standards, these men and women have also established fashion photography—whatever its humble origins as the appendage of an industry—as an art in its own right.

De Meyer: Mannered Chic

Prior to World War I the clothes shown in fashion magazines were most often sketched with pen and ink. But in 1913 Condé Nast, then the new publisher of *Vogue* magazine, asked a dilettante photographer whose work he liked to try his hand at photographing fashions. The man was Gayne De Meyer, a Parisian of German ancestry who called himself a baron although his claim to the title was dubious. De Meyer became the pioneer who founded the profession of fashion photography. His success was based on his familiarity with the fashionable world of his time and his ability to interpret it pictorially, and on the ethereal quality of his photographs—which effect he got by veiling his lens with silk gauze and using soft backlighting.

When he died in modest circumstances in Los Angeles in 1946, De Meyer's style had long been passé. It had been superseded by a series of newer trends in fashion photography set by a small group of talented men and women. Each presented a very personal image of the world of fashion—and in doing so molded fashion itself and influenced all studio photography.

This study of a woman in a gold lamé costume was made by De Meyer in Europe, a few years before he came to the United States. Although not strictly a fashion photograph, it was the kind of deliberately blurred image of a richly gowned, glamorous female that led Condé Nast to hire De Meyer to photograph fashion for Vogue.

DE MEYER: *Woman with Cup*, c. 1910

De Meyer almost invariably posed his models standing with one hand firmly on hip, a stance that presumably spelled chic to the baron. At top left the actress Jeanne Eagels in an evening gown and, below, a male model showing off the latest in morning coats both strike the classic De Meyer attitude. At lower left the model's outfit is overwhelmed by her surroundings; De Meyer was also an interior decorator who often created luxurious settings for his fashion shots. Some of Vogue's wealthier readers were so taken with these ornate and exotic backgrounds that they commissioned him to create salons for their town houses.

DE MEYER: *Jeanne Eagels*, 1921

DE MEYER: *Woman with Oriental Plant*, date unknown

DE MEYER: *Male Fashion*, date unknown

Steichen: Master of Lighting

Edward Steichen concluded that when a woman saw a picture of a dress she should get "a very good idea of how it was put together and what it looked like." His decision to take photographs that would make crystal clear the fabric, cut and details of a costume resulted in a forthright style that broke with his predecessors' fussy romanticism.

It also led Steichen to embark on a long and intensive experimentation with lighting. He had been taking fashion photographs as early as 1911, and yet by 1923, when he was doing fashion photography for *Vogue,* he had never made indoor pictures with artificial light. Confronted by the studio electrician's insistence that he use a dozen klieg arc lamps to photograph his first dress for *Vogue,* Steichen took a four-ply thickness of bed sheets and draped it over the entire battery to make the light from the arc lamps appear to be natural illumination. (His action moved the electrician to observe, "That guy knows his stuff.") But Steichen soon realized that electric light would be invaluable in giving variety as well as clarity to fashion pictures and began adding lights one at a time until, by the end of his years with *Vogue,* there were, in his own words, "lights going all over the place."

In the photograph at right, one of a series Steichen made beginning in 1924, he used a celebrated model, Marion Morehouse (later wife of the poet e.e. cummings), but set her against a plain background and in a simple composition that focused attention on her dress. Even when he used an absurd prop like the horse on the opposite page, Steichen aimed so many lights at the models, the horse and the reflecting white-tile backdrop that the emphasis was still on the lines of the white fashions themselves.

EDWARD STEICHEN: *Marion Morehouse,* 1927

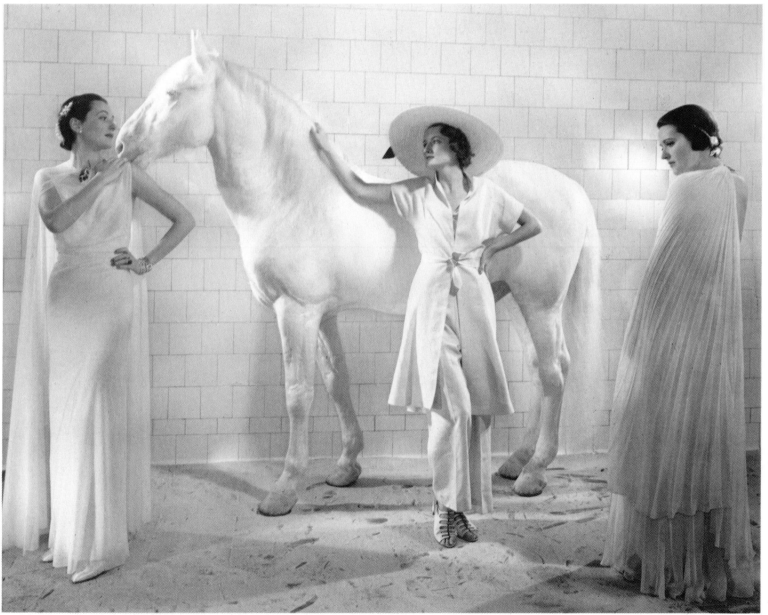

EDWARD STEICHEN: *White Fashions*, 1935

Hoyningen-Huene: The Classic Ideal

During more than two decades as a fashion photographer, George Hoyningen-Huene refined a style that combined a personal fascination with femininity and a reverence for the art of ancient Western civilization. The son of a Baltic baron and his American wife, Huene (rhymes with "learner") had received a classical esthetic education growing up in the pre-Revolutionary Russian court of Czar Nicholas II. It was a world, as he said in later life, where "men were men and women were women—modern people seem so androgynous to me." To capture the feminine mystique he recalled from his childhood, Huene worked patiently with his models, encouraging them until he had "made them conscious of their femininity . . . and they looked as if they were about to be kissed."

The quality that he strove to bring out in photography had been best portrayed, he felt, by the ancient Greek sculptors' idealizations of female serenity. In his own most characteristic pictures, there was a sense of statuesque monumentality, humanized by the model's air of sweet tranquillity. She seemed a flesh-and-blood Grecian deity—an irresistible image that women sought to make their own by wearing clothes like those that hung so gracefully on Huene's poised figures.

"Texture, line, simplicity—these were the things he liked, the classic truth," said Katharine Hepburn of her friend Huene when he died in 1968. Here he emphasized texture and line by covering the pillars flanking the model with sheet metal and bouncing front spotlights off them, thus dramatizing the shimmering satin-lamé material of the simply cut robe.

GEORGE HOYNINGEN-HUENE: *Housecoat by Chanel*, 1931

The plaster torso in the background of this picture of a clinging crepe gown is almost a Huene trademark. His follower Cecil Beaton (overleaf) noted that Huene's absorption in classic art led him "to bring a whole new collection of properties to his studio: women were posed against Corinthian columns, casts of Hellenic horses, heads of Greek gods."

GEORGE HOYNINGEN-HUENE: *Evening Gown*, 1934

Beaton: Borrowing from the Stage

CECIL BEATON: *Evening Gown,* 1934

The fashion photography of Cecil Beaton foretold the renown he was later to gain as a stage and screen designer (of sets and costumes for the play *Coco* and the movie *My Fair Lady,* among others). His photographs, executed mostly in the 1930s, are stage productions in microcosm, featuring sets designed by Beaton (who also frequently painted them) and lighting that mimicked the spotlights of the Broadway and Piccadilly shows of the period. But, despite the theatricality, Beaton pursued the realistic tradition: The clothes and the accessories were always as much stage center as the model.

Often the model was a well-known actress. Beaton was one of the first photographers to sense that stage and screen stars were desirable mannequins—their strong personalities enhanced the clothes they wore, and their well-publicized glamor aided in popularizing fashions.

A fast worker—he averaged 60 exposures during a two-hour sitting—Beaton was at the time somewhat self-consciously uninterested in technical procedure. He once said that he was "ashamed at being so inept at the technical side of the game," but he also rather enjoyed the amazed reaction of his listeners when he let it be known that he had taken his first pictures for *Vogue* with a hand-held, pocket-sized, folding Kodak No. 3A that was precariously set on a rickety old tripod.

Beaton staged the tableau at left by placing three models behind a back-lighted, translucent screen of white muslin to produce the shadow silhouettes of a flower woman (left) and two beaux offering violets to a puppet-goddess of the haut monde arrayed in a costly formal gown.

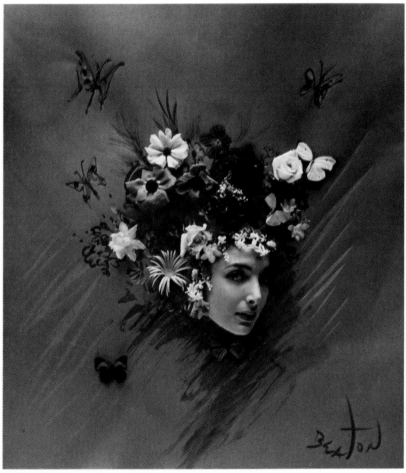

CECIL BEATON: *Spring Fashion*, 1949

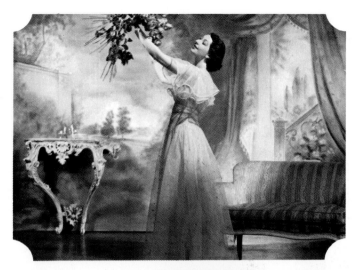

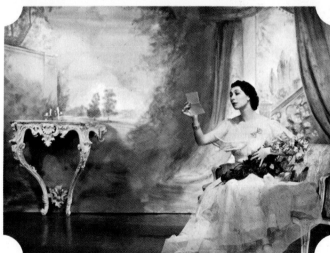

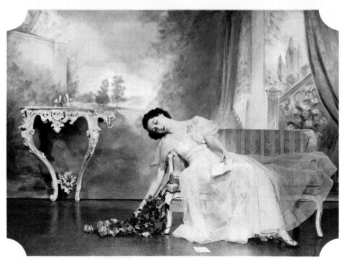

A favorite Beaton device was to "embower"
his models in mixed real and artificial flowers.
Above, he used it to create a Vogue cover
by having the model put her head through
a hole in a canvas that he had decorated.

Beaton produced a series of "playlets"; this
one (right) starred the comedienne Ilka Chase as
a jilted woman. Presumably the unhappy ending did
not deter women from buying the Henri Bendel gown
and Tiffany jewelry she was wearing.

CECIL BEATON: *The Florist's Box*, 1937

Munkacsi: The Drama of the Outdoors

MARTIN MUNKACSI: *Beach Fashion*, 1936

When Martin Munkacsi arrived in the United States in 1934, he had been the highest-paid news photographer both in his native Hungary and later in Germany. Engaged at *Harper's Bazaar* by a new editor who gave him a free hand, though she knew he had not done fashion work, Munkacsi startled competitors with his first picture.

For a bathing-suit feature he took his model out of the studio to a windy Long Island beach, and insisted that she run toward him. Such action poses had never been used for fashion, and Munkacsi's pictures were tartly dismissed by *Vogue's* chief editor as "farm girls jumping over fences." Yet the image he created of the American woman swinging into splendid action out of doors became an enduring rival to the pampered creature who had adorned earlier fashion photography.

Her boldly striped beach coat billowing behind her, Munkacsi's model strides into the wind—a good illustration of his advice, published in Harper's Bazaar in 1935: "Never pose your subjects. Let them move about naturally. Don't let the girl stop to put her hair to rights."

A brave model perched on a parapet of a ▶ *futuristic building at the 1939 New York World's Fair holds on to the wall with one hand as Munkacsi records his arresting view of a winter outfit (right). He once persuaded a reluctant model to sit on the back of a live camel by taunting her with the epithet "Supercoward!"*

MARTIN MUNKACSI: *For the Winter Season,* 1939

Frissell: Playclothes in Faraway Places

Photographing fashion out of doors became a dominant trend during the late 1930s and into the 1940s as more and more women entered the active world outside the home. The sportswoman was a new female idol; and to keep her free and easy, the fashion industry brought out bigger and better lines of sportswear and playclothes. The outstanding photographer of outdoor wear was a young society woman named Toni Frissell, who preferred to shoot on location because she was "never mechanically minded" enough to feel at ease among the lights and equipment of the studio. But she had received good training on how to take pictures out of doors from her brother Varick, who had been a newsreel cameraman before his early death.

In addition to her native talent, Frissell brought two other advantages to the growing fad for sporty fashion photography: An ardent sportswoman herself (on an assignment, she once worked out with the United States Olympic ski team), she knew how to pose her athletic models convincingly, and how best to display the functional nature of their riding habits or tennis dresses. Moreover, as a fully accredited Manhattan social registerite, she was able to take her models into exclusive watering places of the rich, such as Bailey's Beach in Newport or Cypress Point in California *(opposite)*. When subscribers to *Vogue* or *Harper's Bazaar* examined a playdress pictured in such settings, the urge to acquire it presumably was strengthened.

TONI FRISSELL: *Bikini*, 1946

Offering her face to the sun and the wind, a model in a characteristic Frissell pose shows off what was described as "the summer uniform of the land," a shirtwaist dress. The setting is a beach resort at Del Monte, California, where the sports-loving rich disported themselves amid surrealistic cypress trees and barking seals.

◄ An alert Harper's Bazaar editor, spotting her first bikini on the French Riviera in 1946, sensed its imminent popularity and assigned Toni Frissell to picture it. Frissell transported a model and a bikini to fashionable Montego Bay, Jamaica, and arranged the model on the pier at an hour when the sunlight would cast shadows long and dramatic enough to emphasize the contours of her body. Result: the first picture of a bikini to be seen in a U.S. magazine.

TONI FRISSELL: *Shirtwaist*, 1938

Dahl-Wolfe used Kodachrome film in an 8 x 10 view camera to record the delicate hues of this photograph. To set off the old-fashioned charm of the lace-trimmed nightgown that is the focal point of the picture, she employed the Victorian setting of her own New Jersey bedroom. A decorator like Gayne de Meyer (pages 104-105), Dahl-Wolfe followed the studio photographer's tradition, not only choosing film and arranging lighting, but selecting all the props for her set.

LOUISE DAHL-WOLFE: *My Bedroom*, 1942

Dahl-Wolfe: A Sense of Color and Setting

LOUISE DAHL-WOLFE: *Sun Fashion*, 1952

Louise Dahl-Wolfe was a decorator and painter turned photographer, with an intense interest in color that led her to pioneer its use in fashion pictures. In the 1930s, when she started taking fashion pictures, black-and-white was thought to be preferable for this medium because even slight deviations from the true colors of the fashions could cause the photograph to be rejected. Kodachrome, the first modern color film, became available after 1935, but it could not always be counted on to produce true colors, either indoors or out.

Dahl-Wolfe worked under strong klieg lights in the studio, using huge one-shot cameras *(page 58)*. She trained herself with diligence, absorbing all she could from camera technicians and engravers, and by the time she retired from the field in 1962, she had contributed such "firsts" as the photograph on the opposite page. It is perhaps the earliest color fashion photograph to use interior natural light, a difficult achievement during this period of still-erratic film.

After World War II, Dahl-Wolfe helped introduce another innovation by taking her models to little-known spots almost anywhere on earth and photographing them against such exotic settings as the ruins of ancient civilizations *(left)*. The effect was to add another dimension to the image of the outdoor woman Munkacsi and Frissell had glorified, by making her a citizen of the world.

Photographer and model traveled to the Maya ruins in Mexico's Yucatán peninsula to make this picture of smartly matched shorts and top posed against a stone where human sacrifices had been offered to propitiate the gods.

117

Horst: Highlights and Silhouettes

German-born H. P. Horst, known professionally simply as Horst, created techniques of lighting that were, in the words of *Vogue* art director Mehemed Fehmy Agha, ''what the lighting of sculpture in museums should be: three-dimensional and dramatic.'' To get the three-dimensional effect, Horst placed light sources above and diagonal to the model to slant a pattern of light and shadow downward across each side of her figure, creating dramatically accented shots like that of the noted couturière ''Coco'' Chanel at right. (Another of Horst's many lighting methods was less popular with fashion editors: For his so-called black compositions —pictures subtly featuring highlighted models and black backgrounds—he used so few lights that the editors complained at times that the dress was ''shrouded in deepest mystery.'')

Horst himself feels that the chief problem for a studio photographer is that ''almost everybody is camera shy.'' This forces him to study his own feelings and responses about the sitter to decide on the best way to photograph her. He was not satisfied with his first take of Chanel. He asked her to pose a second time and, while trying to think of the kind of surroundings that would induce ease on her part, remembered a couch he had seen that had belonged to Marie Antoinette; here, Chanel gracefully reclines on it.

HORST: *Gabrielle (Coco) Chanel*, 1937

The great dress designer Chanel was photographed in *Vogue's* Paris studio wearing one of her own creations, a jersey afternoon dress. Horst made it a side-view study to bring out the graceful beauty of her profile and used small frontal light sources focused on the sitter's head to frame her against the background shadows. This picture was the personal favorite of the designer, who died in 1971.

Outdoors as well as indoors, Horst uses light to ▶ create the effect he wants. This advertising photograph was taken on a rooftop in Paris in the late afternoon. The model is silhouetted against the sky to show the lacy transparency of her tunic and fan, which repeat the shell-like shape of the garden chair. To bring out the details of the skirt, Horst aimed one 600-watt photo floodlight directly at the model, and placed reflectors on either side.

HORST: *Rooftop in Paris*, 1981

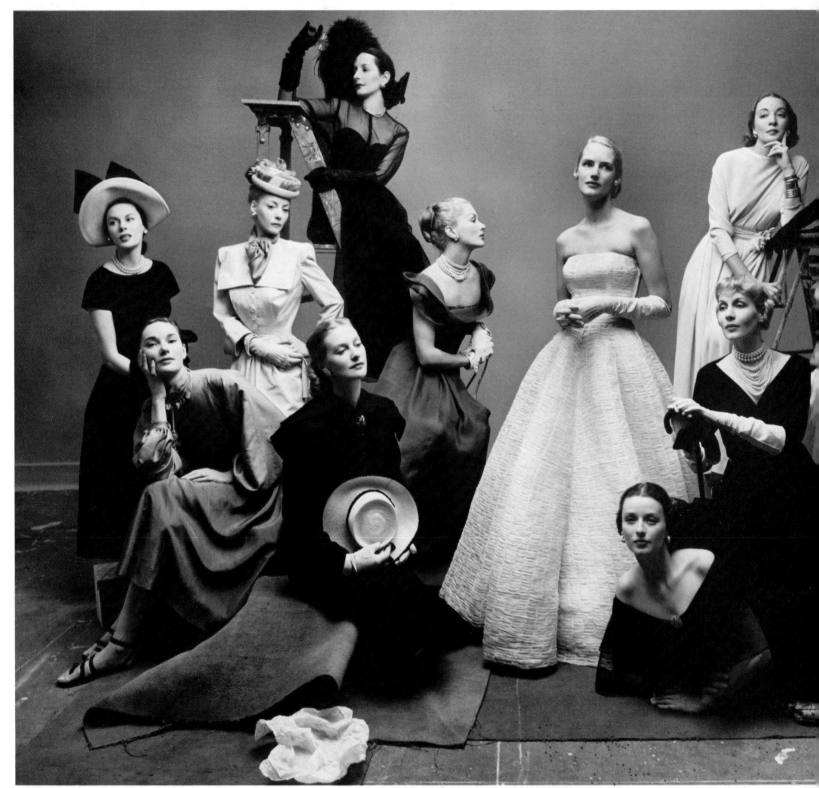

IRVING PENN: *Twelve Most Photographed Models*, 1947

Penn: Cool Elegance

IRVING PENN: *Girl in Black and White*, 1950

Penn's picture of Jean Patchet, a famous model of the 1950s, was the first black and white specially commissioned to replace the color illustrations Vogue had used on its cover since 1909. The symmetry is broken only by the model's sidelong glance. To help get the contrasts Penn wanted, she used black lipstick, improvised from mascara.

◄ *Penn's tribute to his co-workers, the intricately posed group portrait (left) of the top models of the 1940s, reflects personal quirks: He preferred that his models wear gloves—here eight of the 12 do so—and, at least, no nail polish. Lisa Fonssagrives (seated, in profile, sixth from left), whom he met at this sitting, later became Mrs. Penn.*

No fashion photographer ever worked harder to bring out the distinctive quality of each of his models than Irving Penn. As the dean of fashion photography in the years after World War II, Penn began his fashion sittings early in the morning. Sometimes, however, it was 5 o'clock in the afternoon before he was satisfied with any of his painfully arrived-at pictures. Once the mannequin was made up and dressed, Penn would ask her to stand against a plain background; then he would study her until he found some trait that he felt might reveal the concept of woman and costume. Such sessions could be grueling for both photographer and model, but they resulted in some memorable images of serenely beautiful young women displaying striking outfits with timeless unconcern *(left)*.

Times changed—and, over two decades, so did Penn. Many of his pictures had been black and whites, severe in mood and strong in form. But as the world of fashion became lighter in feeling, his own style shifted. Now it conveyed more humor, a sense of what he calls "electric prettiness" captured in colorful clothes worn by delectable, smiling—better yet, laughing—models.

Sometimes Penn supercharges the electric prettiness into incandescence. To get this intensity into pictures, he works rapidly, with complete concentration and with no waste motion. The model spends seven eighths of her time in the hands of hairdresser, stylist, make-up artist, and only one eighth in front of Penn's camera while electronic flashes pop at disconcerting speed. She has no time to get tired of posing—and if all goes well, the pictures come out flower fresh.

121

Avedon: Emphasizing the Bizarre

Richard Avedon's fashion photographs often exploit the excitement generated by headline-making events, personalities or trends. For *Vogue's* coverage of the 1962 Paris collections, he photographed a 10-page spoof of the scrambling courtship of movie stars Elizabeth Taylor and Richard Burton, who were then dashing around Europe pursued by an avid press corps. Dressed in the new fashions, Suzy Parker, the decade's most famous model, played the role of Miss Taylor; the actor-director Mike Nichols was the male lead.

Avedon has an instinct for matching the model to the moment. In the mid-1960s, when blacks were beginning to appear in television commercials and in fashion pictures, he was first to work with the overwhelmingly exotic, six-foot-two Donyale Luna *(left),* who rapidly became the most photographed black model in fashion. And in 1968, struck by the oddly wide-set features of a society teenager named Penelope Tree *(opposite),* Avedon persuaded her to pose for him. Modeling African, gypsy, American-Indian, space-suit styles that were worn by the young as the decade closed, Tree became an image of the liberated generation.

Looking ultimately avant-garde, model Donyale Luna (left) carried off the futuristic design of what Vogue described as a "mini-modern-gladiator dress," made of squares of aluminum hinged together. She wore sandals with thigh-high thongs to complete the outfit.

Penelope Tree's broad cheekbones are encased ▶ in the silver bands of an African-inspired mask (opposite). Avedon achieved the startled-fawn look of this picture by panning his camera across his model's face as a strobe flashed at 1/20,000 second, slightly blurring her features.

RICHARD AVEDON: *Dress by Paco Rabane,* 1967

RICHARD AVEDON: *Mask by Emanuel Ungaro*, 1968

Newton: Shock

The clashing colors, the dramatic lighting and the sensational story-telling effects of Helmut Newton's photographs are typical of the school of fashion photography that began to emerge in the 1960s. Into the world of the fashionable lady the new photographers introduced intimations of sex, violence and romantic mystery.

A Berlin-born and Paris-based Australian, Newton is noted for his often shocking use of nudity and for his almost journalistic use of flash lighting and action. Though he frequently shoots on location and uses his models like a movie director, he brings to location photography the eye of an experienced studio man who understands how to exploit artificial light in conjunction with natural light or even to make advantageous use of the accidents of natural light.

Newton's directions to the model are usually simple. For the photograph at right, he merely told the model to walk fast and open her eyes wide. A fashion editor specified the dress the model was to wear, but everything else in the picture was the photographer's choice. For the picture on the opposite page, he showed the model how to pose and asked for a wide-open stare. This was one of a series of photographs Newton took for the movie *The Eyes of Laura Mars,* in which his pictures were supposed to be the work of a woman photographer who had the uncanny ability to capture on film disasters that had not yet happened to her models.

For this photograph of a wide-eyed, elegantly dressed model running from the blazing lights of a hotel, Helmut Newton used a mixture of natural and artificial lighting. A long exposure and a moving camera turned the hotel's ordinary lights into a background as sinister as a house on fire, while electronic flash caught the woman in mid-stride.

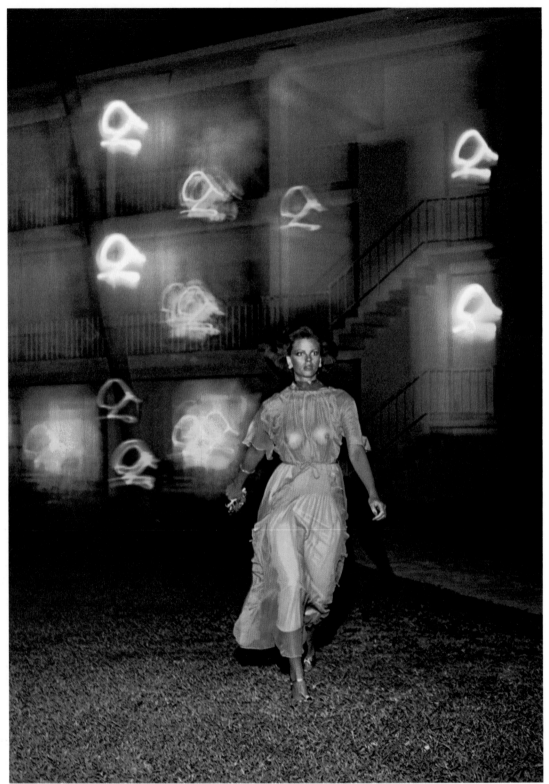

HELMUT NEWTON: *Lisa Fleeing, Key Biscayne, Florida, 1974*

A society murder is suggested by this shot of an apparently lifeless model crammed into a corner banquette overlooking a bridge on Manhattan's elegant East Side. In this location shot, the photographer made inspired use of available natural light to spotlight the model while at the same time surrounding her with mysterious shadows.

HELMUT NEWTON: *Lisa and the 59th Street Bridge*, 1978

SARAH MOON: *Liberty*, 1976

*At first glance this studio set-up seems to
represent a flowery meadow in Never-Never Land.
But gradually the true subject emerges: two
women with peaches-and-cream complexions
modeling print dresses. The even, natural light
helps focus attention on the pattern of flowers and
leaves, which is softened and romanticized in a
grainy enlargement from the 35mm original.*

Moon: Romantic Visions

SARAH MOON: *Beauty,* 1978

A mood of long ago and far away permeates the work of French photographer Sarah Moon. The focus is soft, the colors are pastel and muted, the women are dreamy and a little sad. Even the clothes often suggest another era, when life was sweeter than it is today.

In part, this romantic ambience is the result of a hard-headed business decision. "Fashion photography has to have charm. It is not meant to disturb people," says Moon, a former model who knows the business from the ground up. But partly it comes from Moon's personal vision. "I try to evoke feelings rather than describe clothes," she says.

In fact, Moon's vision happens to be myopic—but she puts her shortsightedness at the service of nostalgia and romance. Whether in the studio or on location she shoots whenever possible by natural light, avoiding the hard edges and exaggerated shadows of flash and flood lights. Like a turn-of-the-century art photographer, she uses filters and gauze and even smears petroleum jelly on the lens to soften her images. One of the trademarks of a Moon fashion shot is a grainy effect reminiscent of Impressionist painting. But the result is a deeply personal dream world in which print dresses are transformed into flowery meadows and even loneliness can be lovely.

Behind cracked glass, a picture of a beautiful woman in white hangs on an empty wall, its only company a pattern of sunlight from the blinds of a nearby window. In order to achieve this haunting effect, the photographer used tungsten fill to supplement the available natural light.

Bourdin: Calculated Surprise

Like Edward Steichen and Irving Penn, Guy Bourdin started out as a painter, and like Penn, he frequently takes his studio on location. But Bourdin's personal style is closer to tabloid-newspaper photography than to Old Master painting. One notorious shoe advertisement showed a chalk outline drawn on a sidewalk where a body had fallen after an accident. All that was left of the victim was a pair of elegant and expensive women's shoes. And in the *Vogue France* photograph at right, a young woman's privacy seems to have been violated not only by her maids but also by a spying photographer.

In Bourdin's pictures, however, what seems like a haphazard, candid-camera style of photography is transmuted into off-beat compositions of distinction and elegance; the sensational though never-quite-explicit story lines achieve the mystery of romantic poetry.

A fervently conscientious worker, Bourdin demands total artistic control over his pictures. The lengths to which he will go to get the perfect shot are legendary: He has spent as long as two months on location for a single advertising campaign, and he once opened 40 boxes of peas to find the right shade of green.

GUY BOURDIN: *Dress by Anne-Marie Beretta*, 1981

Two maids peek through a doorway as a young woman clad only in underwear walks through a pink-walled room toward an undisclosed destination. In a striking departure from the usual fashion photograph, the dress is shown not on the model but hanging on the wall. Harsh flash lighting heightens the aura of indiscretion, as if a prying paparazzo had captured a celebrity unawares.

Elgort: Moving!

With photographer Arthur Elgort, the casualness and down-to-earth realism of street photography invaded the fashion field. His pictures feature intelligent, active, modern young women—and their men—and they seem to have been taken on the run, as though an enterprising photojournalist just happened to be there at the right moment.

In fact, these seemingly casual shots are very carefully planned. Elgort works only with models who have the right look, and have the acting and dancing skills to follow his direction. He puts them in realistic settings and encourages them to move around naturally. Then he waits for the decisive moment.

Like other admirers of Henri Cartier-Bresson, Elgort prefers a "bad" picture that is full of life to a "good" one that is empty and dead. He carries a hand-held camera even when working with a tripod, and some of his favorite photographs are those he took for himself while on an assignment.

The attractive, healthy-looking young people in this snapshot-like picture for Vogue seem to be having a fabulous time. The photograph was taken just after sunset with both natural and artificial light. To achieve the casual look, the photographer warmed up the models with some preliminary fooling around and shooting. When he saw the moment he wanted, he used a 200-watt flash and a hand-held camera to capture it.

ARTHUR ELGORT: *Night in New York,* 1976

Chatelain: Impulsive Snapshots

In the fashion photographs of Alex Chatelain, the casualness of snapshot and street photography blends easily with an air of carefree romance. Born in France and raised in the United States, Chatelain is a former painter who learned the photographic trade in the studios of Avedon, Hiro and Guy Bourdin. Also influential in his development as a photographer is the work of Jacques-Henri Lartigue, whose pioneering stop-motion snapshots became a standard for photographic humor and fantasy.

An untiring traveler who often shoots on location, Chatelain relies heavily on chance and improvisation. "I try to make my models do crazy things," he says. Both of the photographs shown here, taken in the West Indies for *Vogue*, owe much of their impact to impulse. The scene at right was shot in an old whaler's house Chatelain happened upon while out walking. The whaler's friendly widow let him bring his equipment and models into her parlor and transform it temporarily into a studio. For the picture on the opposite page, Chatelain told the model to "do something impulsive" simply to show off the dress. But in capturing the view of the harbor and boat in the background, he turned an already off-beat picture of a dress into a romantic fantasy.

ALEX CHATELAIN: *Warm Afternoon Breeze*, 1980

In what might almost be a casual amateur snapshot, a young woman in a holiday mood poses with her boyfriend in a room washed with sunlight and balmy tropical breezes. Shooting by natural light on the West Indian island of Bequia, the photographer transformed an old whaler's house into the perfect setting for a romantic idyll—and a display for summer clothes.

On a hill overlooking a harbor in the Virgin ▶ *Islands, a young woman in a light summer dress clutches a straw hat to her head as she runs down the road leading to the waterfront and (one imagines) to the ship bringing her sailor home. Taken at noon under an overcast sky, the seemingly casual picture conveys an imaginary romance without ever departing from simple reality.*

ALEX CHATELAIN: *Running to Boat,* 1977

Pagliuso: The Intuitive Eye

Sharp edges, strong contrasts and bold graphic effects are the stylistic signatures of Jean Pagliuso, one of a growing number of women who have achieved success in fashion photography during the past decade. Sometimes her photographs suggest a story, like the one of the glamorously dressed woman at right, who seems to be swooning on the staircase of an elegant hotel. At other times, the emphasis is on strong design and striking color, as in the studio shot opposite of a model in Japanese clothes.

Pagliuso studied fashion design and illustration, and ran a boutique in her native California before taking up photography on a painting holiday in Mexico. Now her studio is in New York, but she travels to Italy each year to photograph the new collections for *Harper's Bazaar Italia,* finding that European magazines give her more freedom to experiment.

Pagliuso, who became successful as a fashion photographer before she had mastered the technical aspects of the trade, works intuitively rather than intellectually. "The best part of any shooting is surprise," she says, "and the less predictable it is, the more excited I get." The advice she once gave an assistant offers a clue to her own method: "When you go to sleep at night and images are going through your head," she said, "don't ignore them. You should pay attention."

JEAN PAGLIUSO: *Sala Le Maschere, Rome, 1978*

A striking contrast between old and new is provided by this hard-edged photograph of a modern model reclining on the staircase of a late-19th Century Roman hotel. The photographer used a ring-flash to highlight the model and tungsten fill to supplement the ambient light.

JEAN PAGLIUSO: *Evan-Picone Leg Fashions*, 1981

In this advertisement for pantyhose, a long-legged model was photographed from above. To get the flat, even effect of a Japanese print, Jean Pagliuso used a strobe in a "soft box" as the main illumination and two other strobes as fill.

Demarchelier: The Active Life

The dynamic athleticism of modern women invigorates the fashion pictures of Patrick Demarchelier, an American-based French photographer whose international work also includes celebrity portraiture and advertising. He prefers vital-looking models like Christie Brinkley *(right),* and his informal, often asymmetrical compositions possess a bounce and verve that match this preference.

In his approach to fashion photography, Demarchelier is typical of a post-World War II generation that eschews the formal poses and stilted classicism of the pre-War decades, as well as the excessive eroticism of some of today's photographers. Demarchelier's women pursue active, healthy lives, and they never become remote and inaccessible.

In this he reflects the changing fashion world itself. No longer is fashion only for a handful of very rich women who spend their lives at grand parties and resorts; it is, increasingly, for the woman next door: the working mother who must fit social engagements into the responsibilities of a job and a family, while finding time as well for relaxation and exercise.

Against the blue Mexican sky, model Christie Brinkley strides out in a form-fitting bathing suit that shows off her athleticism to perfection. The picture was part of a photo essay on resort wear that appeared in Life. Aiming for a natural look, Patrick Demarchelier shot this picture in late afternoon, a favorite time of day for photographers who work by natural light out of doors.

PATRICK DEMARCHELIER: *Christie Running*, 1981

Blanch: Down-to-Earth Sophisticate

The rich colors that Andrea Blanch favors in her photographs are part of her own style, but the realism she seeks to portray is a goal she shares with other photographers. Blanch avoids the complicated lighting and artificial settings of an older generation in favor of location work with a minimum of equipment, and she likes to put her models in believable situations.

"Women are not passive," says the Brooklyn-born photographer, "and in most of my pictures, even if they are quiet, they have an energy about them." When Blanch photographed a model in the rain *(right)* she reduced her "studio" to a camera, an assistant, a rain machine and one reflector card—and then told the model to "look uncomfortable." As a result of this down-to-earth approach, Blanch captures the sophistication that can color everyday life for women whose work fosters a new independence. □

At a flower market in Paris, a model under an umbrella holds a bunch of flowers upside down in a plastic bag to keep them from getting wet—a gesture the photographer once saw a woman make in real life. In this picture, taken on an overcast day for a story on raincoats, Blanch used natural light and a reflector to illuminate the model's face while a machine made the requisite raindrops.

ANDREA BLANCH: *It's Raining*, 1981

Inside the Modern View Camera 142

KEN KAY: *Still life as seen on the ground-glass screen of a view camera*, 1970

Inside the Modern View Camera

One of the things that cost money in a high-quality camera is precision. Consider, for example, the relation of film and lens: To ensure sharp overall focus, they must be lined up absolutely parallel, one squarely behind the other. If they are not—if the lens is the least bit out of line or if the film is not held exactly straight behind the lens—the photograph will be marred by soft, or blurry, spots that no amount of careful focusing can eliminate.

Why, then, pay a good deal of money (from $200 to almost $6,000 without lens) for a view camera whose film and lens can be purposely "unaligned"? Because in trained hands a view camera makes it possible to take pictures that a rigid camera, no matter how expensive, simply cannot produce. An obvious example is an attempt to photograph a tall building from across the street. Tip the camera up to include the top, and the entire building seems to fall over backward in the finished photograph. If it were possible to lower the film in the back of the camera so that it recorded a different part of the image projected by the lens, then much more of the building could be included within the frame of the picture.

This is only one of the adjustments that can be made by the view camera, whose back (film) and front (lens) can be independently twisted and moved in a number of directions: up, down or sideways, tilted forward or back, swiveled to either side. Each of these movements has a different effect on the negative. If properly

understood, they can impart extraordinary discipline and control to photography. They can eliminate or increase distortion, straighten walls, pull things into or out of focus, change perspective. How these movements are accomplished mechanically is shown in the diagram opposite. What they do photographically is explained on the next 26 pages.

In describing these movements the directions given relate, for consistency and clarity, not to the inverted image shown on the view camera's ground-glass viewing screen, but to the photograph that is actually taken.

Two basic movements that are possible with the front and back of the view camera are loosely known to photographers as swings and tilts. Swings are movements around the *vertical* axis of either lens or film—i.e., when either is twisted to the left or right. Tilts are movements around the *horizontal* axis of lens or film—i.e., when either is tipped forward or backward.

In addition to these two movements, many view cameras provide two others. One is sideways movement of lens or film to either left or right; this is known as shift. The other is raising or lowering of lens or film; this is known as rise or fall. These four movements can be used separately or in combination, according to the practical or esthetic need of the photographer. A camera that provides all of them is the most versatile instrument known to photography.

parts

A lens
B aperture scale
C shutter-speed scale
D lens board
E lens-board-adjustment thumbscrew
F front standard
G front-standard-adjustment thumbscrew
H shutter-release cable
J bellows
K tripod mount
L ground glass
M back-adjustment thumbscrew
N back
O back standard
P back-standard-adjustment thumbscrew
Q dark slide
R film holder
S film sheet

movements

1 back-rise
2 back-fall
3 front-rise
4 front-fall
5 back-shift left
6 back-shift right
7 front-shift left
8 front-shift right
9 back-tilt backward
10 back-tilt forward
11 front-tilt backward
12 front-tilt forward
13 back-swing left
14 back-swing right
15 front-swing left
16 front-swing right
17 front focusing
18 back focusing

This simplified cutaway of a view camera makes clear its basic relationship to all cameras: It is a box with a lens at one end and a sheet of film at the other. Unlike other cameras, however, the box is not rigid. The front face, to which the lens is fastened, can be moved independently —up or down, tilted forward or back —by loosening a pair of thumbscrews (E). A second pair of thumbscrews (M) permits similar movements of the back. Two other thumbscrews (G and P) permit front or back to be shifted, swung or focused. In addition, different-sized film can be used by substituting film holders and camera-backs that are designed for those sizes. Furthermore, the front end of the camera will accept different lenses, and extra bellows can be inserted between front and back to accommodate their different focal lengths and to provide extreme extensions for close-up work. Finally, if the focal length of the lens is so short that the regular bellows cannot be squeezed tight enough, it can be removed, and a special bag bellows substituted.

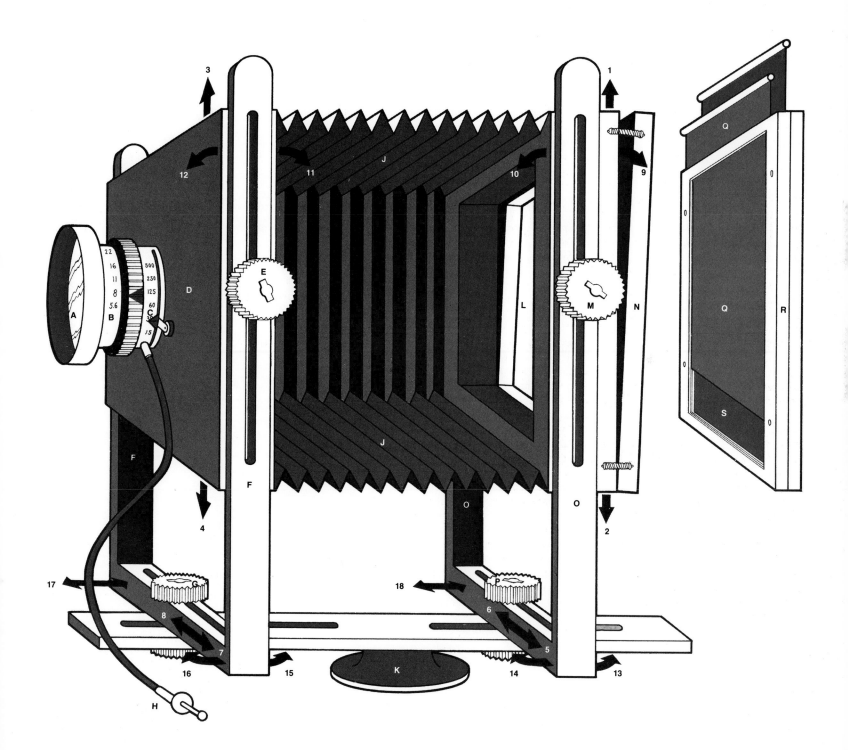

The View Camera's Limitations

Checking focus with a hand-held magnifier, the photographer does not place it squarely on the ground glass because the camera-back has been swung to the left and the lens tilted downward. Instead, he holds the magnifier at an angle to keep it lined up with the incoming light rays.

As a guard against manipulations that are too extreme, this Sinar camera shows a small circle of light at each corner of the ground glass when light coming from lens to film is not blocked by the camera bellows. The user must check the four corners of the ground glass one at a time.

In cameras, as in everything else, one does not get something for nothing. The flexibility that tilts and swings give the view camera comes at the expense of compactness and speed of use. This is a camera for slow, careful work, not for candid shooting. Furthermore, there is a limit beyond which the view camera's parts may not be twisted. Light normally travels in straight lines, and if the camera is swung or tilted too far, the bellows will interfere with the light traveling from the lens to the film.

Some cameras have devices to determine whether or not this problem is occurring. At each corner of the ground-glass viewing screen the corner itself has been cut away. Inspection of a corner will show a circle of light when rays are coming from the lens to that corner of the ground glass. If no such circle is visible, then the photographer knows that the bellows is cutting off the light.

Focusing is another problem encountered with swings and tilts. The view camera is capable of extreme sharpness, and the photographer ordinarily checks focus by placing a magnifier directly on the ground glass. This is easily done if the back and front of the camera are squared off. But if the back is swung at an angle or other adjustments have been made, as in the picture at left, the photographer must hold the magnifier at an angle to the ground glass. Finding the sharp point of focus under these conditions takes time and practice.

Finally, though the back of the camera can be used with film of various sizes, and the front with lenses of all types, match-ups must be made with care, or the photographer will obtain results like those shown at right.

The importance of matching film size with the proper lens is shown in these three pictures. Each was taken from the same spot with a camera containing 8 x 10 film, but with three different 135mm lenses designed for different film sizes. You can make a photograph with an 8 x 10 camera using a lens designed for a 2¼ x 2¼ camera, as the first picture shows. However, it is a waste of good film, since the lens can cover only a small section in the middle of the 8 x 10 film sheet. The same image could have been obtained, at lower film cost, by taking the 8 x 10 back out of the camera and substituting a 2¼ x 2¼ back.

By switching to a lens designed for a larger film size (here, 4 x 5), a much greater part of the 8 x 10 sheet receives an image. Note that the size of the fountain itself has not changed. It cannot; as long as the focal length remains at 135mm, the fountain parts visible in both pictures will be exactly the same size. All that the second lens has done is widen the field of view to include more of the fountain and use more of the 8 x 10 film sheet.

With a 135mm lens designed for still larger film, almost the entire film sheet receives the image. This demonstration makes several important points: Mismatches cost money in wasted film surface. They also cut down on the swings and tilts possible since, with a mismatch like the one at left, the shaft of light coming from lens to film is already a narrow one. In addition, the relationship between focal length, film size and lens characteristic is revealed. The first picture makes clear that a lens with a focal length of 135mm designed for small-sized film produces a telephoto effect with a narrow field of view. But the same 135mm focal length built to cover 8 x 10 film produces a wide-angle effect.

The Four Camera Movements: 1 Rise and Fall

To understand the effect each movement has on a negative, one must first look at a picture where no movement has been cranked into any part of the camera, where film and lens are both squarely lined up on an object. This has been done with the cube directly at right. Camera position was centered on the cube. All controls were set at zero. Focus was on the top front edge.

The result is an image that falls in the exact center of the picture frame. The cube's top front edge, being closest to the camera, is the largest. Being the focal point, it is also the sharpest. The two visible surfaces of the cube fall away in size and sharpness at an equal rate. With this "reference" cube as a standard, changes in its shape, sharpness and position—as a result of camera manipulation—can be explained.

The first manipulation is a rise or fall of the camera-back. This is simply an up-and-down movement of the film; it makes no change in the angular relationship of film plane to lens or cube, thus there is no change in the shape of the cube. All that happens when the back is raised (or lowered) is that the image on the film is raised (or lowered). If the front of the camera is moved up or down, the image on the film also moves —but in the opposite direction.

Does it matter whether the front or back is used to move the cube? Yes. Back movement changes only the location of the image, but does not affect its shape. Front movement does affect shape. This effect is too slight to be observed in these pictures, but changes in the relationship between one object and another can be seen if a second object is added to the picture—here, a small post placed in front of the cube.

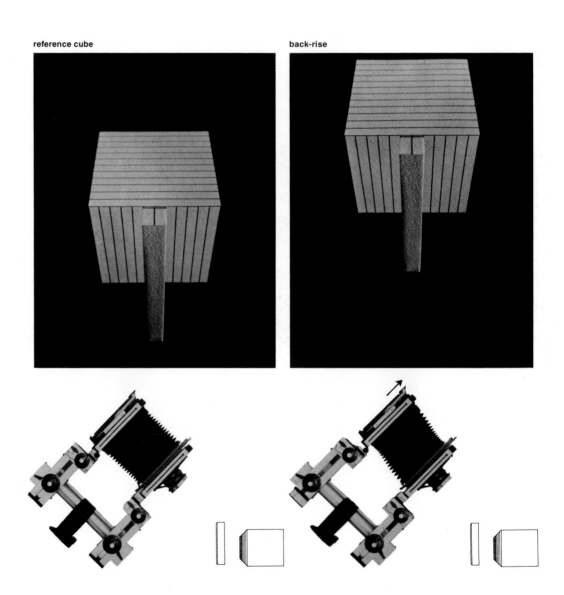

reference cube **back-rise**

The reference cube was shot with all camera adjustments set at zero position, looking downward, as the diagram shows, from an angle of 45°. This puts the cube in the center of the film, and produces a symmetrical figure. The next four pictures, although they move the cube around on the film through rise and fall of back and lens, apparently make no changes in the shape of the cube's image on the film.

Raising the back of the camera moves the cube higher on the film without changing its shape. Nor does this movement affect the position or shape of the small post that has been centered exactly in front of the cube, with its top in line with the cube's front edge—as comparison with the photograph of the reference cube will show.

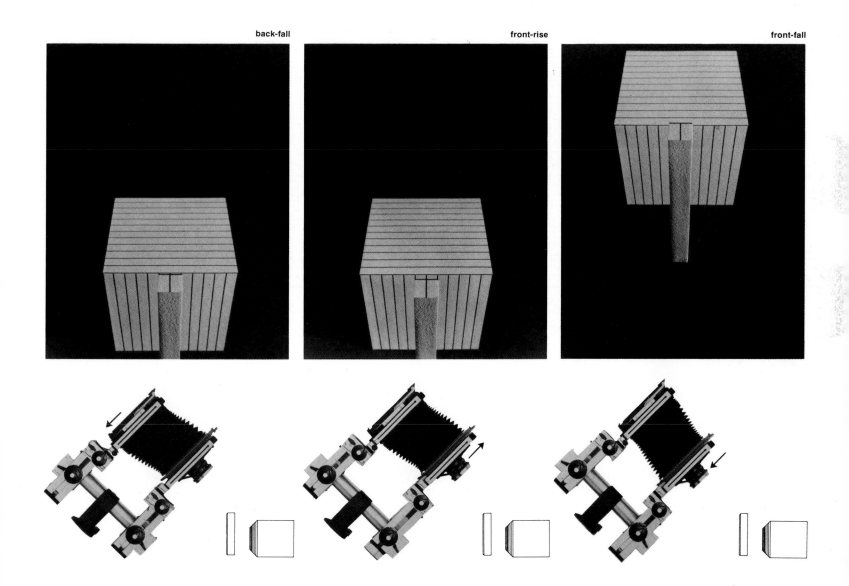

back-fall

front-rise

front-fall

Lowering the back of the camera lowers the position of the cube on the film. Otherwise, as before, there is no change in the shape of the cube or in its relationship with the post. This is because the film, though raised or lowered, is still getting the same image from the lens, which has not moved relative to the cube or post.

Raising the lens lowers the image of the cube on the film. In this its effect is the same as back-fall. However, lens movement causes a change that does not occur with back movement: It affects the relationship between cube and post because the lens is now looking at them from a slightly different position. Compare the apparent height of the post here with its height in the other pictures.

As expected, a drop in the lens has raised the image on the film. As expected also, lens movement has affected the space relationship between cube and post. Now the post top appears to have moved above the front edge of the cube, whereas in the previous picture it dropped below.

147

The Four Camera Movements: 2 Shift

Shift is a sideways movement of either the front or the back of the camera. Not all view cameras provide it because its function is actually the same as rise or fall: One needs only to lay the camera on its side and raise or drop the back. Presto, there is back-shift!

The reason that rise and shift are the same is that neither changes the angle between the planes of film, lens and object. And this is important enough to bear repeating: There is no change in the *plane* of film or lens, only in its *position*. Raise or shift the back of the camera, and the film is still squarely facing the lens; the only difference is that a different part of the film is now directly behind the lens.

Since shift is simply a sideways version of rise and fall, the reader should have no trouble in figuring out its effects. They are: Back movement to the left moves the image to the left on the film. Back movement to the right moves it to the right. Left or right lens movements have just the opposite results. Image shape does not change with back-shift, but does change slightly with front-shift.

But, again in common with rise and fall, shift of the lens does affect the spatial relationship of objects, because the lens is now viewing them from a different point. The examples at right illustrate these principles, with the reference cube included for comparison.

reference cube

back-shift to the left

To help establish the point that shift, like rise and fall, has no perceptible effect on the shape of an object, the reference cube is repeated here. Compare it with the four cubes to the right of it. It is clear that while they have been moved back and forth on the film, they continue to look the same.

A camera equipped with a back that can move the film from side to side, as well as up and down, can place an object wherever desired on a sheet of film. Here a shift of the camera-back to the left moves the cube to the left on the film.

A rightward movement of the camera-back moves the image to the right. Comparison of this picture with the previous one will reveal that there has been no change in the shape of either the cube or the post in front of it. Their spatial relationship has remained unchanged also, despite the movement of the image on the film.

Moving the lens to the left moves the image on the film to the right. It also changes the relationship of post to cube. This is logical. Since the lens actually moves to left or right, it views the two objects from a slightly different position, and one object appears to have moved slightly with respect to the other. Check the position of the post against the vertical lines on the cube, in this picture and the next, to confirm this movement.

By this time it should be clear that a rightward movement of the lens, as above, (1) moves the image to the left and (2) changes the relationships in space between objects. To summarize: If you want to move the image on the film but otherwise change nothing, raise or shift the back. If you want to move the image and also change the spatial relationship of objects, do it by raising or shifting the lens —do not move the back.

149

The Four Camera Movements: 3 Tilt

The preceding pages have shown that rise and shift have little or no effect on the shape of an object being photographed, because these movements do not change the angular relationship of the planes of film, lens and object. But what happens if the angle is changed by tilting the camera-front or -back?

Two things happen: (1) When the angle between film and lens is changed by tilting the back of the camera, the shape of the object changes. (2) When the angle between lens and object is changed by tilting the front of the camera, the focus on the object changes.

To understand why this happens, look again at the reference cube. In that picture the bottom of the film sheet was the same distance from the lens as the top of the film sheet. As a result, light rays coming from the lens to the top and the bottom of the film traveled the same distance, and the top back edge and the bottom front edge of the cube are the same size in the photograph. But change those distances by tilting —and the sizes change. The rule is: The farther the image travels inside the camera, the larger it gets. Since images appear upside down on film, tilting the top of the camera-back to the rear will make the bottom of the cube bigger in the photograph. All changes in size —and in shape—that are caused by back-tilt can be explained by this rule.

A front-tilt, by contrast, does not change distances inside the camera, and thus does not affect image size or shape, but it does affect focus by altering the lens's focal plane. Tilting the lens will bring the focal plane more nearly into parallel with one cube face or the other and thereby will improve the focus on that face.

reference cube

back-tilt of the camera-back

Checking the reference cube again, note that the 45° angle of view has produced an image that falls off in both size and sharpness at an equal rate on both the top and the front faces. As a result the two faces are exactly the same size and the same shape. Note also that the vertical lines on the front face are in a diminishing perspective downward; they are not parallel to one another.

When the back of the camera is tilted so that the top of the film is farther away from the lens than in the reference shot, this movement enlarges the bottom of the cube and tends to square up its front face, bringing its lines more nearly into parallel. At the same time this tilt has moved the bottom of the film closer to the lens than it was in the reference shot, shrinking the top back edge of the cube and heightening the perspective effect.

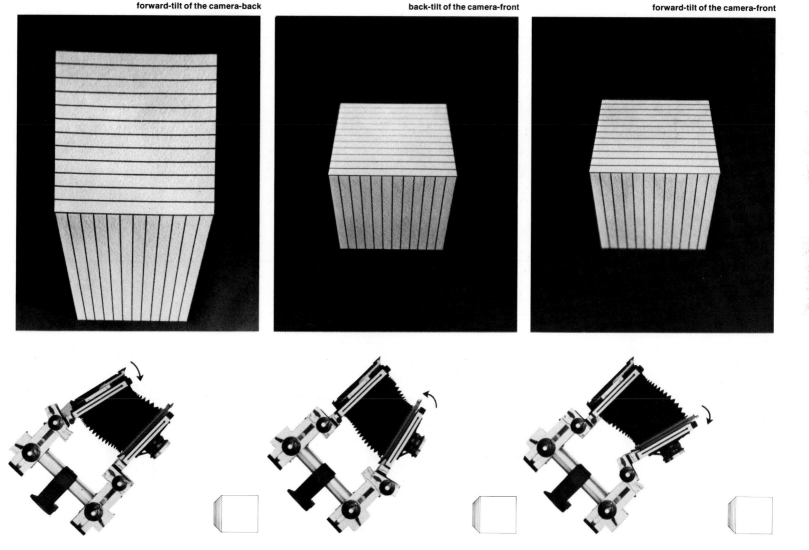

forward-tilt of the camera-back

back-tilt of the camera-front

forward-tilt of the camera-front

If the back of the camera is tilted the other way, so that the top of the film is forward and the bottom is moved away from the lens, the top of the cube tends to square up and the front falls into sharply diminishing perspective. Squaring up one face of the cube results in increasing light loss and increasing fuzziness toward the far edge of the squared face. In this case the back edge of the top face is so affected. In the picture at left the bottom edge of the front face is affected.

When the lens is tilted, there is no change in the distance from lens to film; thus there is no change in the shape of the cube. However, there is a change in focus. Here the lens has been tipped backward. This brings its focal plane more nearly parallel to the front face of the cube, pulling all of it into sharp focus. The top of the cube, however, is now more blurred than in the reference shot.

By tilting the lens forward, the top of the cube becomes sharp and the front more blurred. The focus control that lens-tilt gives can be put to excellent use when combined with back-tilt. Look again at the two back-tilt shots at the left; consider how much sharper their squared —and blurry —sides could have been made by tilting the lens to improve their overall focus.

151

The Four Camera Movements: 4 Swing

Swing is a sideways twisting of either the front or the back of the camera around the vertical axis. Like the three movements that have been discussed so far, it has different effects, depending on whether it is the back of the camera that is being swung or the front.

A back-swing—just like a back-tilt —moves one part of the film closer to the lens while moving another part farther away. These changes in distance —again, just as in a tilt—result in changes of shape in the image.

Front-swing, since it involves swiveling the lens to left or right, skews the focal plane of the lens to one side or the other. The general effect of this is to create a sharply defined zone of focus that travels at an angle across an object. A careful examination of the two right-hand cubes on the opposite page shows this. There is a narrow diagonal path of sharp focus traveling across the top of each cube and running down one side of the front.

The practical applications of the four camera movements are virtually endless. Some are subtle and complex, particularly when used in combination. Others are obvious. For example, assume that the reference cube is a house with a large garden in front of it. Raising the back of the camera *(page 146, second picture)* will raise the image on the film and permit more of the garden to be seen. Or, assume that you wish to make the reference cube resemble a very tall skyscraper viewed from above. Forward-tilt of the back *(first picture on page 151)* will give that effect. To see how swings, tilts, rises and shifts can be applied in real situations to solve specific photographic problems, see the next 13 pages.

reference cube

It is worth taking one last look at the reference cube to appreciate the distortions in shape that can be induced by changing the angle of film to lens. Compare the cube to the first two pictures to its right. It is hard to believe that these swing shots—or the two back-tilt shots on the previous page—are all of the same object, taken from the same spot with the same camera and lens.

left-swing of the camera-back

This movement of the camera-back swings the left side of the film away from the lens and the right side closer to it, making the left side of the cube smaller and the right side larger. (Remember, the image is inverted on the ground glass.) This effect is the same as tilt, but sideways instead of up and down. To grasp this better, turn this picture so that its right side becomes the top. Now it becomes an angle shot of a building, with the camera-back tilted forward to enlarge the top.

Here the right side of the film is swung away from the lens and the left side closer to it. The results are the opposite of those in the previous picture. In both of them it can be seen that there is a falling-off of sharpness on the "enlarged" corner of the cube. This can be corrected by swinging the lens or by closing down the aperture a few stops in order to increase the depth of field.

Since it is the lens that is being swung, and not the film, there is no change in the cube's shape. However, the position of the focal plane has been radically altered. In the reference shot it was parallel to the near edge of the cube, and that edge was sharp from one end to the other. Here the focus is skewed. Its plane cuts through the cube, on a course diagonally across the top and down the left side of the cube's face.

Here is the same phenomenon as in the previous picture, except that the plane of sharp focus cuts the cube along its right side instead of the left. This selectivity of focus, particularly when tilt and swing of the lens are combined, can move the focal plane around very precisely to sharpen certain objects and throw others out of focus. For a good example of this, see pages 156-157.

153

Combining Movements to Make a Still Life

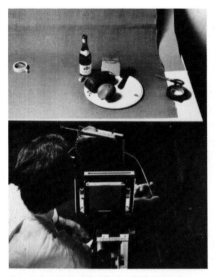

Here is the setup of Ken Kay's still life just before the final shot was made. Note the extreme right-swing of the front of the camera to get sharp focus on the bottle, the bread and the round cheese.

A still life consisting of a bottle, bread and a couple of cheeses was set up in his studio by photographer Ken Kay for a shot angled slightly downward at the arrangement. With his view camera in the right position, and with all settings at zero, Kay found several things wrong with the picture when he studied it on the ground glass of his camera. But by cranking adjustments into the camera one at a time, he was able to get an approximation of the picture he wanted. That shot *(fourth picture at right)* was, however, too far out of focus in some spots to satisfy him. Since he was working in a studio with control over his light, this was no problem. Simply by stopping his lens way down *(last picture)*, Kay was able to produce the degree of sharpness he was after.

As a starter, Kay placed his camera at the desired angle with all controls set at zero. Here he is interested only in the relationship of objects: how much of the label is visible over the top of the bread, how the cut in the cheese looks, whether the cork is located properly. The setup is off center on the film, but that is of no concern as yet.

Kay's first adjustment is to bring the still life into proper position on the film. He does this with a simple fall of the camera-back. Although he plans ultimately to have the cheese in the foreground touch the bottom edge of the picture, he does not move it quite that far down at this stage because he will enlarge it with his next adjustment.

The next movement straightens up the bottle, which was leaning because of camera angle. Kay does it by back-tilt of the camera-back, using the same principle that straightened the lines on the reference cube (page 150). Back-tilt also enlarges the foreground cheese and positions it properly. But this puts some things badly out of focus.

Now Kay addresses himself to focus. Having decided that he wants the sharpest emphasis to be on the left edges of bottle, bread and foreground cheese, he swings his camera-front to the right to bring the focal plane closer to that line. Then he stops down his lens to f/22 and takes a picture that satisfies him (above right).

Selecting a Point of Emphasis

Often a photographer wants to emphasize only one or two things in a picture by making them sharp and allowing the rest of the composition to go out of focus. This is easy enough to do if the singled-out objects are all the same distance from the lens; the photographer need only focus on them, open the aperture wide, and the depth of field will then be so narrow that the remainder of the photograph will become blurred.

But what if the objects are not the same distance from the lens? Only the view camera can handle this problem. From the lessons given on pages 152-155, it is clear that the solution is to swing the camera lens so that its focal plane is in line with the plane of the objects to be emphasized. The two pictures opposite make this point.

The aim of the photographer was to focus sharply on a pile of beans spilling diagonally across a picture, and to let some of the surrounding jars go out of focus, keeping emphasis on the spilled beans. Because some of the beans are much nearer the lens than others, a rigid camera would have to be stopped way down in order to hold all the beans in sharp focus. But this would bring the jars into focus too, as the top picture shows. By swinging the view camera lens and opening it wide, the photographer can create a narrow depth of field that follows the beans through the picture and leaves everything else blurred.

With camera-back and -front in zero position, a close-up shot of some spilled beans requires that the lens be stopped down to get both the foreground beans and those in the jar perfectly sharp. This also brings the other jars into focus.

A simple swing of the lens to the right brings its focal plane parallel to the receding pile of beans —all the way from the near-right foreground, back through the tipped-over jar. Now the photographer can focus on the beans and open up the lens to its maximum of f/5.6, which throws the other jars completely out of focus.

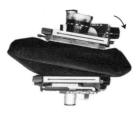

Manipulating Depth of Field

A common frustration experienced by beginning photographers occurs when the subject is something like a field of daisies. To photograph the daisies properly, the picture should be made from above, at an angle. But focusing on the daisies closest to the camera throws the ones in the background into a hopeless blur. A compromise focus, aimed at the middle of the daisy patch, might be all right if the lens is stopped down to increase the area of sharpness, or depth of field. But this would require a long exposure—which will not work with daisies on a breezy day.

The view camera can get around this problem. It permits sharp focus from here to infinity at maximum apertures by tilting or swinging the lens to alter the plane of sharp focus so that it coincides with the plane of the subject. This is demonstrated by the two setups at right. In the first, with the camera in normal position, the plane of sharp focus is parallel to the planes of the lens and the film. The area of sharpness falls in the middle ground: Most of the castle is sharp, but the near and far edges of the quilt are blurred.

In the second picture, the lens was tilted forward so that the plane of sharp focus coincides with that of the quilt. The area of sharpness now extends from near to far on the quilt itself. As usual, there is a price to pay, as the out-of-focus flags atop the castle towers reveal. However, a minor change in the lens's angle would shift the area of sharpness upward to include the flags.

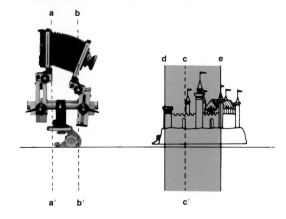

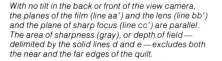

With no tilt in the back or front of the view camera, the planes of the film (line aa') and the lens (line bb') and the plane of sharp focus (line cc') are parallel. The area of sharpness (gray), or depth of field—delimited by the solid lines d and e—excludes both the near and the far edges of the quilt.

Tilting the lens forward causes line cc' to coincide with the plane of the quilt, extending the depth of field along the quilt's entire length. Adjusting the lens tilt to move the depth of field upward would sharpen the focus on the castle flags if that were desired.

Dealing With Distortion

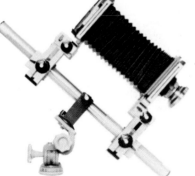

With camera settings at zero, a downward view of a book makes the upper part seem larger than the lower part—just as the top-front edge of the cube on page 150 was larger than the bottom edge. This also makes the book appear to be tipping to the left. The orange, on the other hand, a sphere seen straight on in the center of the picture, exhibits no noticeable distortion.

The book is straightened up by back-tilt and left-swing of the back, but the orange is forced out of shape. These back movements also have had a bad effect on focus; it has been necessary to back-tilt the lens and swing it to the left to bring its plane into better line with the book's face.

Every attempt to project a three-dimensional object onto a two-dimensional surface results in a distortion of one kind or another. Yet cleaning up distortion in one part of a photograph will usually induce a different kind of distortion in another. The book and orange in the two still lifes at right are examples of this. In the first picture, shot from above at a 40° angle with all camera adjustments at zero, the book shows two kinds of distortion. Since its bottom is farther away from the camera than the top, the bottom looks smaller. Also the book seems to be leaning slightly to the left. These effects would have been less pronounced if the camera had been farther away from the book —on the principle that the more distant an object is from a lens, the smaller will be the proportionate differences in distance from the lens to the center of the object and from the lens to the edge of the object. It is these differences that cause distortions in scale.

Can they be corrected? They can with a view camera, using a combination of tilts, swings and falls. Back-tilt of the camera-back straightens up the book's left edge. A left-swing of the camera-back squares up the face of the book. Fall of the back lowers the image—a necessity, since these tilts have enlarged the image somewhat.

A less distorted picture? That depends. The book is certainly squared up nicely, as if it were being looked at head on, but the spine is still visible. How can that be? Furthermore, the round orange of the first picture has now become somewhat melon-shaped. Moral: All pictures contain distortions; the photographer will have to manipulate them to suit his own taste.

159

Changing the Look of a Skyscraper

Tall buildings are such massive structures that it is impossible to photograph them from close at hand without distortion. An ordinary street-level shot of Lever House on Park Avenue in New York, for example, would look like the first of the four pictures at right. There would be a great deal of uninteresting sidewalk, and the top of the building would be chopped off. As every amateur skyscraper-shooter knows, tipping the camera up to include the top and eliminate the sidewalk does not help. The plane of the film departs from the vertical; it is no longer parallel with the face of the building, and the resulting picture will be one of a skyscraper that seems to shrink at the top.

The second picture, taken with the camera-front raised, pulls the top of the building into the film frame and gets rid of the sidewalk. However, this gives an exaggeratedly peaked angle to the top of the building. The top-near corner seems to jut up unnaturally sharp and high. The effect can be reduced in either of two ways. The back of the camera can be swung to the left *(third picture)*, which puts the film plane more nearly in line with the narrow side of the building, squaring it up somewhat. Or the back can be swung to the right *(fourth picture)*, which squares up the wide side of the building. None of these last three pictures is "better" than another. Each contains its own distortion. The choice depends upon which view best serves the photographer.

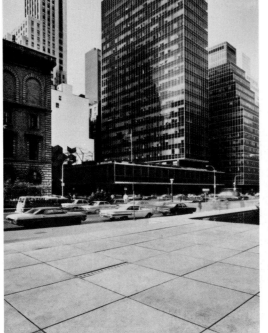

Standing at street level and shooting straight at a skyscraper produces too much street and too little building. Aiming the camera higher will not work—the lines of the building will no longer be vertical and it will seem to lean backward.

In this view, with the camera kept vertical to retain the vertical lines of the building, the roof can be pulled down into the picture by raising the camera-front. This produces an exaggeratedly sharp angle, often called the ship's-prow effect, at the top corner of the building.

A left-swing of the camera-back reduces the extremely sharp ship's-prow angle at the top of the building by placing the film plane more nearly parallel with the narrow side of the building. A left-swing of the camera-front is necessary to improve the focus on that narrow side.

Right-swings of front and back pull the wide side of the building around and further reduce the ship's-prow effect. The black areas in the upper corners of these last two pictures warn that the swings have been pushed too far; parts of the film have now been twisted so far out of line that they are outside the covering power of the lens.

Overlapping for a Wider Wide-Angle

To capture wide subjects the photographer has one obvious solution: a wide-angle lens. But while such a lens will fit more of a subject into a picture, its focal length is so short that it distorts depth relationships badly, making things seem very far away. The only way to get a wide picture that also seems close to the eye of the observer *(right)* is to use a view camera with a normal lens to make two shots of the scene from the same spot. The first is made with a back-shift to the right, the second with a back-shift to the left. The two can then be fitted together to form one picture. The composite at right has a much wider field (110°) and more dramatic closeness than the single picture, above, of the same scene.

The photograph at right consists of two overlapping pictures made from the same spot by shifting the camera-back (the bracket lines at top indicate the field of view encompassed by each). The photographer also raised the camera-front when making the two pictures. In this way he was able to include more of the skyscraper than appears in the picture above, which was made with the camera settings at zero— and to get rid of the car in the foreground.

Removing the Unwanted from a Picture

When the photograph immediately at right is studied, two awkward things become apparent about it. Both stem from the photographer's effort to get a formal, squared-up front view of a handsome Louis XV fireplace with its large mirror, flanking pilasters, mantel clock and candlesticks at the Metropolitan Museum of Art in New York.

The obvious way to get such a photograph is to place the camera squarely in front of the mirror. Unfortunately a large and distracting chandelier gets in the way, blocking the top of the mirror. Worse, a reflection of the photographer and the camera can be seen. Getting around these problems with an ordinary camera requires that the picture be taken from an angle—which produces a routine shot *(second picture)* that loses the desired frontal effect. The view camera, however, can get rid of the unwanted elements and still keep the frontal effect—by using shift.

As the earlier demonstrations with the cube made clear, a shift of the camera-back to the right will move the image on the film to the right. Shift of the camera-front to the left also will move the image to the right. A combination of the two will move the right-hand portion of the image off the film and replace it with another image that could not be captured (from that position) by an ordinary camera at all.

Back to the mirror: Aiming the camera straight at the wall at a point to the right of the mirror, the photographer then shifts both front and back of the camera. The planes of the camera-back, the wall and the mirror remain parallel—thus achieving the desired frontal effect with neither photographer nor camera in the picture.

A head-on shot that guarantees a squared-up picture of the fireplace and its mirror is made impossible by the chandelier hanging in the way, and also by the reflection of the photographer, who can be clearly seen in the mirror.

Moving to one side gets rid of the chandelier and introduces a different reflection, but it changes the perspective — the squared-up head-on effect the photographer wanted to achieve is lost entirely.

Aiming the camera directly at the wall a little to the right of the mirror squares up almost everything again. Then a right-shift of the camera-back and a left-shift of the camera-front pulls the image of the mirror back into the middle of the film.

Creating the Illusion of Motion

A sense of movement can be imparted to a stationary object with a stationary camera—if that camera has rises and shifts. All that is required is a series of exposures on the same sheet of film, introducing a little more fall and shift with each exposure, to move the image on the film. In the picture at right, five exposures were made of a glass bird against a dark background, the back of the camera being increasingly lowered and shifted left each time. This photograph, like all the others in this chapter including the eight pages of cube demonstrations, was made by the New York photographer Ken Kay. □

Falls and shifts, added in carefully graduated amounts for five successive exposures, produce a multiple-image shot of a glass bird that seems to swoop in a curve down through the picture. The only other help Kay gave the photograph was to dodge the bird's head to subdue its brightness. He did this with every exposure except the last.

HENRY WANTLAND: *Photo Studio in Stillwater, Oklahoma,* c. 1895

A Room of Your Own

At some point, practically every amateur photographer entertains the notion of setting up a studio. This will probably stem from a desire to work under more controlled conditions and with larger cameras than are convenient for outside work. Still-life experiments with varying light effects, such as those shown on pages 196-205, may become increasingly attractive. A photographer may want to try serious portrait work or may be stimulated by the opportunities for image control provided by the tilts and swings of the view camera *(Chapter 5)*.

Whatever the motivation, a day comes when the basement, the back hall or the garage suddenly takes on a new significance, and important questions just as suddenly arise: Exactly what is needed in a studio? How much space? What about plumbing and electric circuits? Must everything be set up all at once? Or can a small, inexpensive beginning be useful?

The answers depend entirely on what the photographer intends to do. A studio is really nothing more than a convenience. Some of the greatest pictures ever taken were made in ludicrously primitive studios — not because that was the way the photographer liked it, but because that was all he had for working space. Apartment bathrooms, even closets to which water must be lugged in pails, have made serviceable — if awkward — darkrooms. The one minimum requirement is enough space to use the camera and lights effectively. Other things can be improvised; but if your fancy runs to full-length portraits, you cannot operate properly in an eight-foot-square bedroom (although it would be adequate for tabletop work).

So, in terms of the pictures that are to be made, consider space first. Additional space will probably be needed for developing and printing, as well as for storing equipment and supplies. Obviously, these functions are best handled when they are located together, but they do not have to be. It is possible to do all the photography in the garage and all the processing in the basement — and get exercise walking between the two.

The space problem is often the simplest to solve. Good organization and ingenious photographic techniques permit making quite ambitious pictures in places that, at first glance, seem totally inadequate. There is no better illustration of this last point than the studio built by New York photographer Al Freni in minuscule quarters in a midtown-Manhattan skyscraper *(pages 172-175)*.

Freni's studio measures 9 feet by 30 feet, with an 8½-foot ceiling. A small darkroom is tucked in the back, leaving an area 22 feet long for taking pictures. However, not all of that is usable photographic space. In any studio, there must be room at one end for seamless-paper rolls — used for backgrounds — to hang from the ceiling behind the subject. The subject of a picture often has to be moved out into the room, several feet in front of the background, to permit backlighting. Also, the light stands must go somewhere, which cuts down on the usable width of the room.

One way that Freni managed to work so well in such a small space is that he gradually accumulated a good deal of specialized photographic equipment, thus increasing his flexibility. What another photographer could accomplish in one way in a larger studio, Freni managed differently in his with different props, a different camera or a special lens. This is not to say that the prospective studio builder should necessarily make up a shopping list from what Freni used and head for the nearest photo supplier; the bill would run to several thousand dollars. Freni himself started with two cameras, a couple of tripods, some seamless-paper rolls, a table and a few lights, adding equipment as he needed it and could afford it. Any aspiring studio photographer should follow the rule that guided him: Buy nothing unless there is a specific use for it; otherwise the precious working space will shrink away little by little, and the photographer will eventually find that the new studio has turned into a storage room.

Freni also saved space by putting pegboards and shelves on his walls, cupboards under all flat working surfaces: Everything has its place. And he gained some additional compactness in his darkroom by setting it up to process only black-and-white film, sending his color film—which is tricky and time consuming to process—to an outside firm.

Skimpiness in fundamental equipment, however, is false economy. An ample electric supply is a must, of course, since some studio lights drain a good deal of power. If a 220-volt line is installed, it can be wired to supply a large number of 115-volt outlets, so that the load can be evenly distributed among them without overtaxing any one. Hot and cold running water should be available for the darkroom. In most homes the best place to find easy access to utilities—along with working space and simplicity of light-proofing—is in a basement laundry, which may even have a pair of old laundry sinks already in place, almost begging to be used to process film.

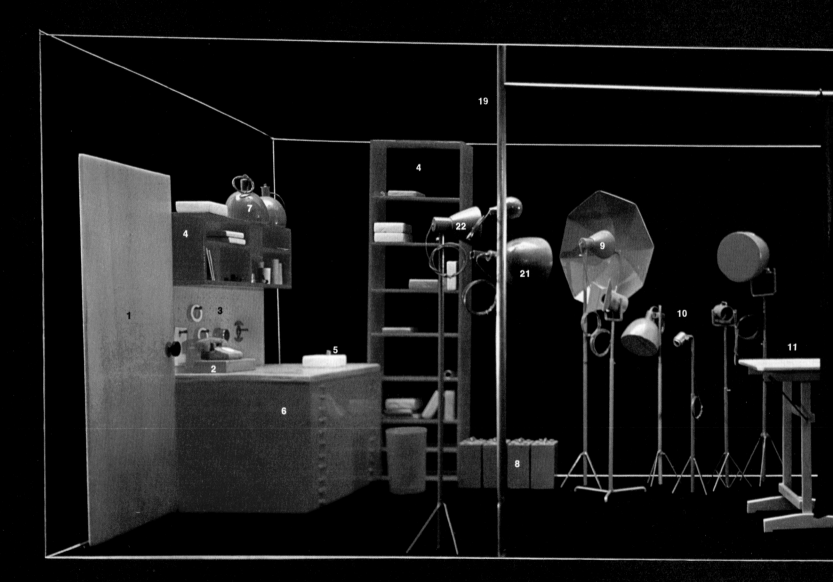

1 entrance door

2 telephone and telephone answering device

3 pegboard with tools

4 storage shelves

5 light box for viewing transparencies

6 cabinet desk

7 electronic flash heads and reflectors

8 electronic flash power packs

9 electronic flash unit with umbrella

10 floodlights and spotlights

11 table for still-life setups

Only 9 by 22—but a Complete Studio

In a space no larger than a one-car garage, Al Freni set up a studio that is shown in scale-model form at left. The entrance door is at far left. Next to it is a work desk with a light box for transparencies and a telephone. Drawers are underneath. Above the desk is a pegboard for masking tape and small tools. Above that: shelves for props as well as electronic flash heads and reflectors. More shelves are next to the desk. An assortment of lights, together with electronic flash power generators, is shown in the center of the picture. The rolls of seamless paper used to make plain backgrounds are stored on handmade racks under the ceiling at far right. The space underneath is not wasted: It contains filing cabinets and a print dryer.

Every studio needs adjustable surface space for setting up still lifes. Here the solution is a small drafting table whose top can be raised, lowered or tilted. If more working surface is needed, a large square of plywood that normally stands against a wall can be placed on the table. For still larger surfaces, there is always the floor.

Vital to the studio's function are three "pole cat" poles; their ends are under spring pressure so that they will wedge themselves securely between floor and ceiling anywhere they are placed in the room. They are located where they do not interfere with the photography but can be used for clamping lights or reflectors, or for suspending a seamless-paper backdrop. The two poles in the foreground are connected with a rod for hanging drapes to provide textured backgrounds.

12	seamless paper	18	radio
13	pegboard for extension cords	19	"pole cat" support poles
14	reflectors	20	black velvet curtains
15	door to darkroom	21	floodlight
16	print dryer	22	electronic flash unit
17	storage cabinets		

Only 9 by 8—but a Complete Darkroom

In the scale model pictured on the previous pages, there is a door in the far right background. The same door is seen at right rear of the model on the opposite page and is the entrance to the darkroom—a layout as economical of space as the studio. The darkroom is only nine by eight feet, but it is fully equipped to process black-and-white negatives and to make finished enlargements.

The "wet" side for developing film and making prints is at the left, with a large sink *(foreground)* that will hold two or three print trays and a wash tank. Under the sink are filing cabinet, wastebasket and storage space. Above are timers and clothesline with pins for holding wet film and prints. Higher yet, and going all around the room, are shelves for chemicals, paper and other supplies.

Along the far wall, next to the door, is a flat working surface with a paper cutter. Underneath are a filing cabinet and some vertical storage space. The near wall has another filing cabinet, whose top is used as a stand for the enlarger.

The right wall is the "dry" side of the darkroom. Its flat work space has a refrigerator under it (for storing color film as well as food products used as still-life subjects). Beyond the refrigerator is a lockable steel cabinet for storing cameras and lenses, and an open area for hanging clothes. Air conditioning outlets are not shown; it is important that a darkroom be adequately ventilated, by air conditioning or fans, to dispel fumes. □

1	entrance door from studio	9	storage cabinet
2	steel cabinet with lock for equipment storage	10	sink
3	storage shelves	11	print trays
4	refrigerator	12	timer
5	pegboard for tools	13	clothespins
6	enlarger	14	safelight
7	electric timer	15	folding table
8	enlarger easel	16	paper cutter

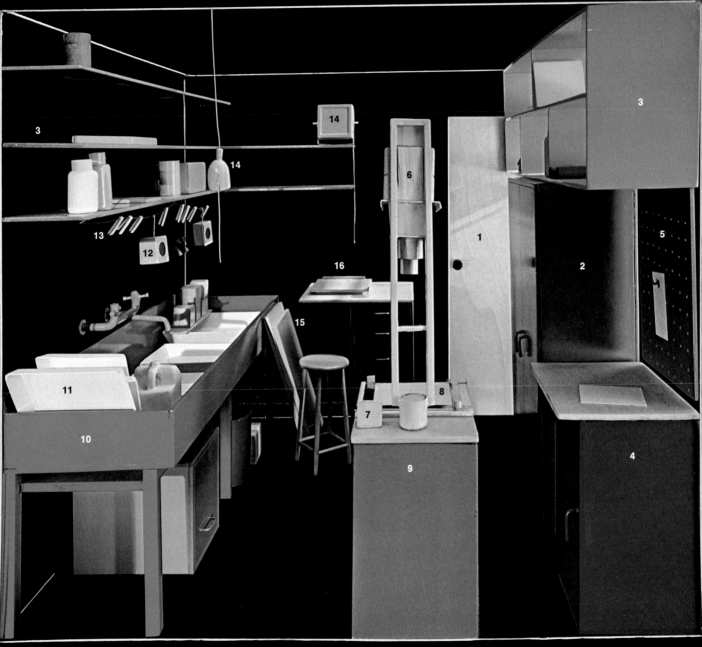

Choices of Cameras and Equipment

basic 35mm equipment

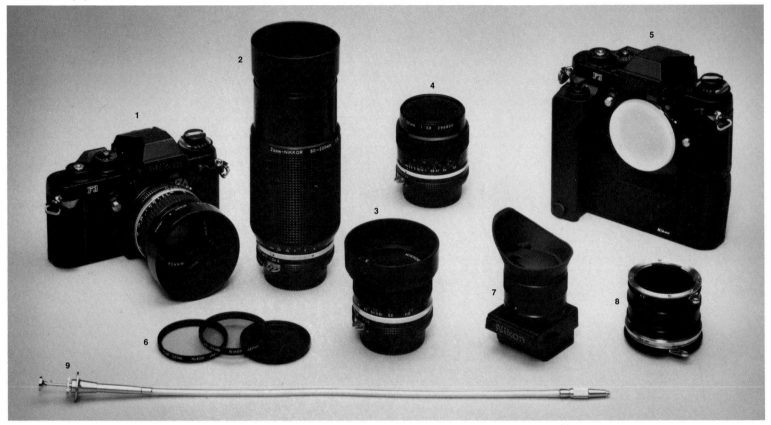

Probably a photographer about to set up a studio already has a 35mm camera. If so, it can be the studio workhorse until larger cameras are added. Shown above is the basic kit for a 35mm single-lens reflex (SLR) with a built-in light meter.

Lenses of four focal lengths will meet most of the needs of the small studio: the normal 50mm lens that comes with the camera; a zoom lens for backing off in order to make undistorted pictures (portraits, for instance) or to change the image size without having to move the camera; a 28mm lens for wide-angle shots and great depth of field; and a 55mm macro lens for extreme close-ups and great sharpness of detail. (For more normal close-ups, a set of extension rings will adapt the other lenses to making large pictures of small objects.)

A basic outfit would include three filters for black-and-white film (yellow, green and red), a cable release for long exposures, and a high-magnification viewfinder for close-up work and photomicrography. And finally, a second 35mm camera body with a motor drive is useful for shooting pictures in rapid sequence.

1 **35mm SLR body with built-in light meter and 50mm f/1.4 normal lens with lens hood**

2 **80mm to 200mm zoom lens**

3 **28mm f/3.5 wide-angle lens**

4 **55mm f/2.8 macro lens**

5 **second camera body with attached motor drive and power pack**

6 **filters**

7 **high-magnification viewfinder**

8 **extension-ring set**

9 **cable release**

basic 2¼ x 2¼ equipment

1 **2¼ x 2¼ SLR body with 80mm f/2.8 normal lens and lens hood**
2 **50mm f/4 wide-angle lens with lens hood**
3 **150mm f/4 telephoto lens with lens hood**
4 **interchangeable film backs**
5 **second camera body with built-in motor drive, battery power pack and electronic cable release**
6 **adapter ring for filters**
7 **filters**
8 **diffusion screen for soft-effect portraits**
9 **AC power cord for recharging power pack**
10 **Polaroid back**
11 **extension-ring set**
12 **cable release**

Many studio photographers prefer a 2¼ x 2¼ camera to the 35mm for its square format and also because its larger film size simplifies the making of big, grain-free blow-ups. Many such cameras are twin-lens reflexes, but 2¼ x 2¼ SLRs are increasingly popular; though more costly than the twin-lens, they are more versatile, hence preferable for studio work.

The necessary starting lenses for a 2¼ x 2¼ are wide-angle, normal and long. Because of the difference in film size, these lenses have focal lengths that are different from their 35mm counterparts: 50mm, 80mm and 150mm respectively. The kit should also include a cable release and three filters, with adapter rings that fit the filters to the larger lenses. Another useful piece of basic gear is a diffusion screen, its surface treated to soften the image in portrait and fashion work.

Interchangeable film backs let the photographer shoot more than one load of film without reloading, and permit easier switching from color to black-and-white film. Again, a second motor-driven body is needed for sequence shooting, and extension rings for close-ups.

Two Variations of the View Camera

basic 4 x 5 equipment

The 4 x 5 view camera is the ultimate studio instrument, capable of virtually complete picture control, with a film size large enough for almost any need. The four basic lenses suggested are extreme-wide-angle, wide-angle, telephoto and normal. Lenses for view cameras, like those for smaller cameras, can accept screw-on filters, but it is less expensive to use gelatin sheets. These require a filter holder and an adapter ring that fits the holder to the lens. Other basics include two cable releases (one with a small tip for recessed lens boards), a light meter, a

large black cloth to hood the viewing screen while focusing and a magnifying glass for critical focusing.

Film holders for 4 x 5 film sheets are required, as are two special film holders: a Polaroid back for test shots, and a 2¼ x 3¼ back that adapts the 4 x 5 camera to smaller, easier-to-use 120-size roll film. Lens hoods for larger lenses are often hard to find, but a bellows lens hood fits most larger and all smaller lenses and acts as an adjustable hood to block unwanted light from the lens without cutting off corners of the camera's field of vision.

1 **4 x 5 view camera body**
2 **4 x 5 cut-film holders**
3 **2¼ x 3¼ roll-film holder**
4 **4 x 5 Polaroid holder**
5 **black focusing cloth**
6 **cable releases**
7 **set of 3-inch filters**
8 **filter holder**
9 **light meter**
10 **magnifying glass**
11 **set of 4-inch filters for bellows lens hood**

12 **bellows lens hood**
13 **65mm f/8 extreme-wide-angle lens**
14 **90mm f/8 wide-angle lens**
15 **150mm f/5.6 normal lens**
16 **210mm f/5.6 telephoto lens**
17 **adapter rings for filter holder**
18 **standard lens hood**

1 **8 x 10 view camera body**

2 **4 x 5 revolving back**

3 **Polaroid processor**

4 **300mm f/5.6 normal lens**

5 **480mm f/8.4 telephoto lens**

6 **cut-film holders**

7 **Polaroid holder**

For the photographer who desires the maximum clarity and detail to be gained by using very large film, the 8 x 10 studio camera is the answer. Its images are four times larger than those made by a 4 x 5; but it takes up more room, it requires heavier tripods, and its film is more expensive. For these reasons it may be a less useful instrument—but for the same reasons, it may be a very good buy. Fewer people use 8 x 10s today, and it is sometimes possible to pick up a used one at a bargain price.

Standard recommended lenses are a normal and a telephoto. (Note that with this huge film size, normal focal length is 300mm.) Also needed are 8 x 10 film holders, a set of gelatin filters and the same kind of filter holder shown for the 4 x 5 view camera opposite.

Another very useful item is a 4 x 5 revolving back for adapting the 8 x 10 to the smaller, cheaper film. It also offers another advantage: Rotating the back allows the angling of the image on the film to any desired degree. A Polaroid back and processor for 8 x 10-inch test shots completes the basic kit.

Tripods and Lights

Choosing a studio tripod is simple. The tripod will not be lugged into the field, so a good, heavy model is best. The larger tripods have extension arms that can be attached to the lower part of the center post so that cameras can be clamped to it for low-angle shots. Clamps are also useful for holding lights and reflectors.

Selecting the lights is a more complex matter. Cheapest and easiest to use are photofloods, which come with reflectors and stands. The floods generate heat, change the color of their light as they age, and die early. A quartz floodlight is more expensive but it gives more consistent light than a photoflood of the same wattage, and it lasts longer. A small spotlight is essential for highlighting particular areas. A larger spotlight has "barn doors" to keep light off surfaces where it is not wanted.

Electronic flash is even more expensive, but long-lived, heat-free and unsurpassed for stopping motion. A good studio unit should handle up to six separate lights from its power pack and deliver 400 watts to each when operating at full power. In the bottom picture on the opposite page is a professional six-light power pack with two standard electronic flash heads and other necessary equipment, including an electronic flash light meter. When in use, the power pack is connected to the camera by the synchronizer cord and cable.

The flash heads are mounted on the folding stands or at the unweighted end of the boom assembly, which clamps onto a light stand and gives the photographer more freedom in moving the flash heads horizontally, out of the camera's field of view. Each additional head requires its own stand, reflectors, extension cord and flash tube covers. □

1 **extra-heavy studio tripod for 8 x 10 camera**

2 **extension tube to raise head of studio tripod**

3 **arm bracket for extra-heavy tripod, for low-angle shots**

4 **medium-weight tripod for 4 x 5 or 8 x 10 cameras**

5 **arm bracket for medium-weight tripod**

6 **tripod for 35mm and 2¼ x 2¼ cameras**

7 **handy clamp, small (several needed)**

8 **handy clamp, medium (several needed)**

9 **handy clamp, large (several needed)**

10 **angle clamp, adjustable (several needed)**

11 **angle clamp, plain (several needed)**

12 **3-inch "C" clamp (several needed)**

13 **5-inch "C" clamp (several needed)**

1 studio light with 12-inch reflector and 500-watt photoflood
2 studio light with 16-inch reflector and 1,000-watt photoflood
3 1,000-watt quartz floodlight with barn doors
4 200-watt spotlight
5 750-watt spotlight with barn doors

1 boom assembly on light stand
2 flash head with 11½-inch reflector
3 flash head with 7-inch reflector
4 umbrella
5 electronic flash power pack
6 power synchronizer cord
7 power synchronizer cable
8 electronic flash light meter
9 flash tube covers

Processing Large-Format Film

Sheet film in the 4 x 5- or 8 x 10-inch sizes is processed in a different way from roll film. Until the image is fixed, the entire procedure must take place in total darkness, and the method of agitation is especially tricky.

Some photographers use shallow trays to hold the chemical solutions, agitating the film by continually moving the bottom sheet in the stack to the top. However, film agitated this way is easily scratched. A better method is to use hard-rubber tanks and stainless-steel film hangers. (Tanks also come in stainless steel, but the rubber ones are better at maintaining the chemical solutions at a constant temperature throughout the processing.) The hangers keep the sheets of film separate, reducing the risk of scratching and providing a more even distribution of the chemical solutions over the surface of each sheet. With tanks and hangers, up to six sheets can be safely processed simultaneously.

Before trying to develop exposed film, the photographer should practice every step of processing with the lights on. The main steps of large-format film processing with tanks are shown at right. The photographer should follow manufacturer's instructions for timing each step. ☐

1 remove the film from holders

After turning off all darkroom lights, remove each sheet of film from the film holder. If film packs are used, open the pack in the dark and detach each sheet from its protective backing.

2 load the hangers

Open the top of a stainless-steel hanger. Then slide a sheet of film into the hanger until it touches bottom. Close the top, locking the film into place. Stand the loaded hanger upright against the wall.

3 position hangers for agitation

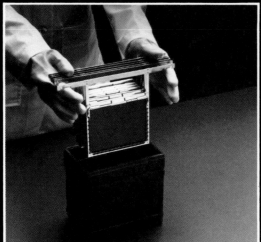

When all hangers are loaded, pick up the stack between forefingers and thumbs as shown, and lower it vertically into the tank, taking care that film does not touch other film or the sides of the tank.

4 agitate

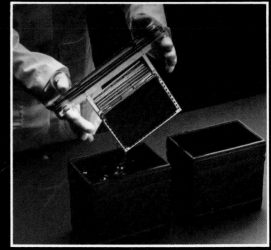

To agitate, raise hangers from the tank and tilt them at a 45° angle to one side. Reimmerse and repeat, tilting to the opposite side. The same method is used for developer, stop bath and fixer.

5 transfer to the wash

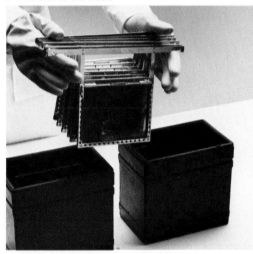

When the image is fixed, turn on the lights and transfer the hangers to the wash tank. Wash them according to manufacturer's instructions, changing the water by emptying and refilling the tank.

6 dry

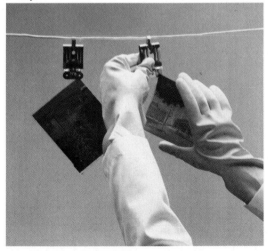

After washing, remove the film from the hangers and hang it up to dry, attaching each sheet by one corner to weighted film clips. Hang the sheets far enough apart to keep them from sticking together.

two methods of temperature control

lowering the temperature

To cool a warm solution to 68°, the normal temperature for processing, briefly submerge a plastic bag of ice cubes in the tank. Make sure the bag is waterproof, to avoid contamination.

raising the temperature

Use an immersion heater coil to raise the temperature of a cool solution to the required 68°. Warning: To avoid shock, always unplug the coil before putting it into or removing it from the solution.

In 6,000 Square Feet, Room to Expand

The dream of countless studio photographers is to have enough space to easily accommodate any picture-taking challenge. Arthur Tilley, a successful Atlanta photographer who specializes in advertising illustration, realized this dream. After several years of working out of his apartment and then out of a rented studio, he bought a roomy industrial building and turned it into 6,000 square feet of tailor-made studio, darkroom and offices.

The building itself was not prepossessing: a leaky, abandoned icehouse in a rundown neighborhood far from Atlanta's business center. Architects and contractors who looked it over advised him not to buy. But Tilley envisaged studios in the building's large, unobstructed interior, and he believed—correctly, as it turned out—that the neighborhood soon would attract other professionals.

Tilley's first priority was a new roof and a fence around the property, but except for some modest planting and a gleaming brass door, he left the outside untouched. To reduce costs, he scavenged for discards such as flooring ripped out of old railway cars, which he used to make the back fence. He also used amateur workers, employing professionals for electrical work, heating and air conditioning, and sheet-rock finishing.

The renovation proceeded by fits and starts, but it took Tilley just one year to turn the derelict icehouse into the fully equipped, modern studio shown on the following pages. Now when the job demands it, Tilley has space to expand in. He is able to bring in extra assistants and models to work unhampered in a room with a 20-foot ceiling, where he can even re-create outdoor settings. It is a long way from the days when he crammed his "studio" into the corner of his living room.

Flowering shrubs and a shiny brass door dramatize the entrance to Arthur Tilley's Atlanta studio, but otherwise the building retains the industrial look of its former days as an icehouse. The brass was one of the lucky finds Tilley made in the course of his do-it-yourself renovation. He came across it while searching for a name plate and bought it cheap. But its gleam perks up the building's nondescript façade —and hints at the wonders within.

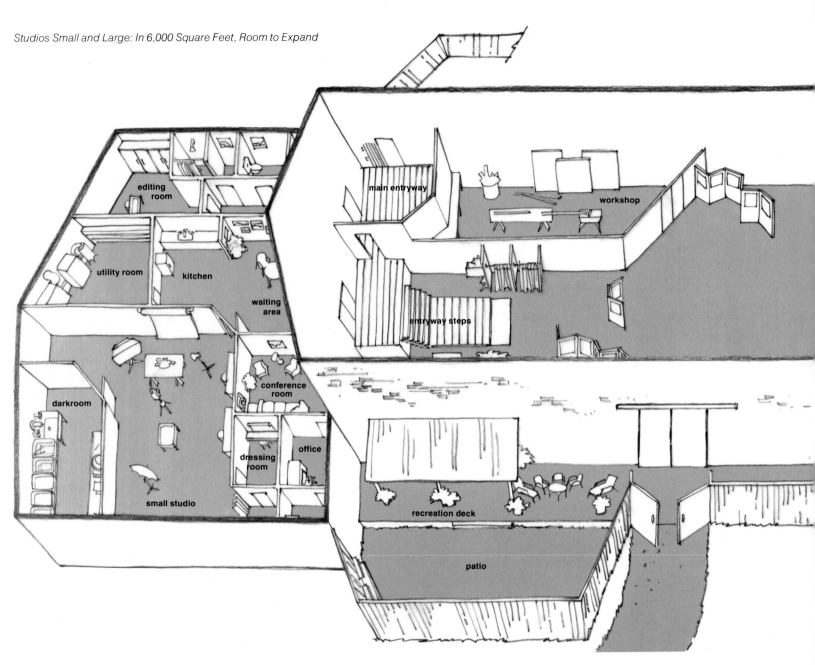

Inside his former icehouse, Tilley has installed two studios, enabling him to work on more than one assignment at a time. The main studio measures 112 x 38½ feet, with skylights that let Tilley shoot with natural as well as artificial light; its 12½ x 12½-foot doorways permit passage of even the largest subjects. Adjoining it is a workshop for making props and settings. The smaller, windowless studio is used for still-life photography under controlled artificial lighting. Next to it is a fully equipped darkroom.

A separate area for clients and other visitors includes a reception area, a conference room, two offices and a kitchen. A main entrance with a distinctive brass door gives access to the complex, and at the rear of the building is a recreation deck and patio.

main studio

main entryway

waiting area and kitchen

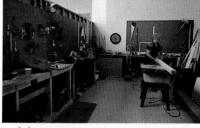

workshop

small studio

conference room

main studio

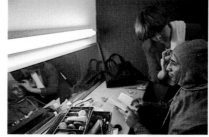

darkroom

dressing room

recreation deck and patio

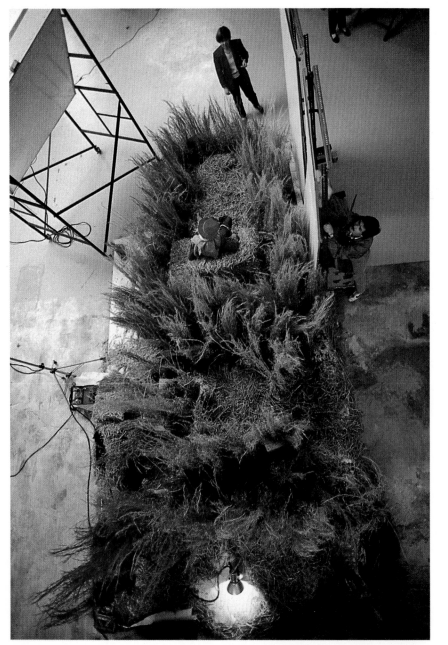

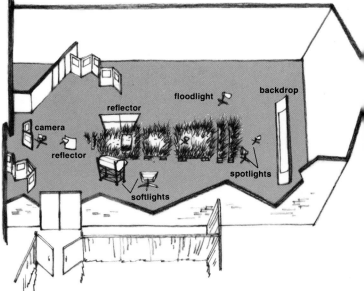

As the sketch above and the pictures on these pages demonstrate, Arthur Tilley's main studio is large enough to hold a 31-foot-long artificial wheat field — or any similar re-creation. Even with camera, sky backdrop and lights, the setup is far from cramped. By using the studio for such projects, rather than shooting on location, Tilley can obtain greater control over lighting and setting.

Seen from above, an indoor wheat field is surrounded by lights and reflectors as Tilley and his assistants prepare to make test shots of a model dressed as a scarecrow for this demonstration of his studio's versatility. In addition to the wheat, the project called for 20 bales of hay and an array of costumes that included two basic outfits and five changes of hat for the scarecrow.

A stuffed crow and a girl wrapped in a blanket
have joined the scarecrow in the wheat field, which
now has a painted sky behind it. Natural light
from the skylights in the 20-foot ceiling is reinforced
and modified by floods, spots and reflectors,
and a smoke machine softens the atmosphere as
Tilley makes ready for the final shot.

In the final shot, the scarecrow reads to the little girl, both of them oblivious to the crow perched nearby. Every element of this picture is realistic, but an air of fantasy is fostered in the studio that would be difficult to achieve outdoors.

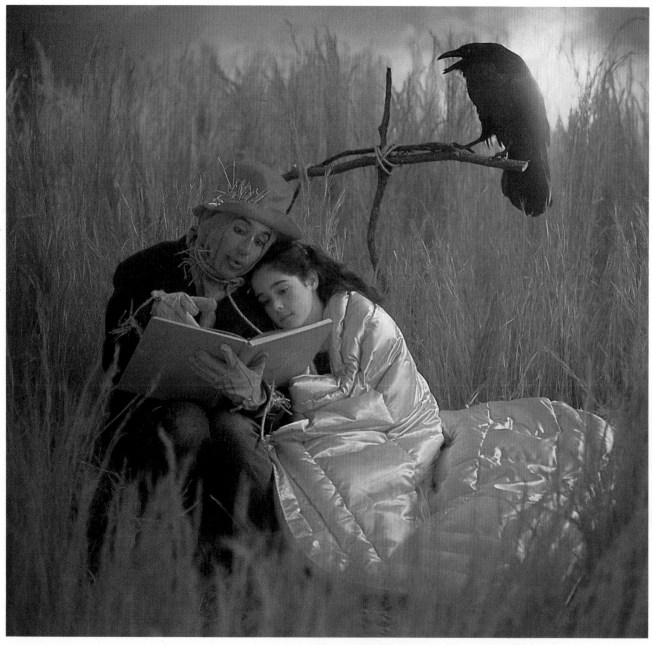

The Art in Everyday Objects 7

PHIL MARCO: *Rubberbands*, 1977

Coping With the Problems of Still Life

Many beautiful and arresting studio photographs are created from inanimate objects. Some are classic, familiar portraits — pears and wine bottles, seashells and fish — and some are abstract arrangements, such as matchsticks, bottle caps and paper clips. They may show one flower, one teacup, one china figurine, or elaborate assemblages of almost anything from a meal set out on a kitchen table to a pile of children's toys. Ordinary household objects often make the best, and certainly the handiest, subject matter. With a bit of imagination, the photographer can transform them into fascinating pictures that transcend the everyday nature of the subjects. For example, where a less discerning eye might have seen only some school supplies and a child's faltering attempts at lettering, Phil Marco found a bit of abstract art and, with some diffuse lighting, compressed his elements into the jaunty, evocative still life reproduced on the preceding page.

When shooting inanimate things, photographers enjoy a unique advantage. More than with any other kind of studio photography, they have unquestioned control over the subject. There are no live models to squirm and fidget, no chance shadows to disturb the appearance of a face or figure. Time is under their control too; they can take as long as necessary to arrange the subject and balance the lights before tripping the shutter. Such total control is also a necessity, for many ordinary objects present obstinate technical problems. How do you show the shape and indicate the volume of a wine glass, which is almost totally transparent? How do you illuminate a pottery vase so as to bring out its sheen and texture and at the same time avoid the glaring reflections from light sources? Shiny, metallic objects, such as silverware, copperware and stainless steel, have a way of mirroring things from all over the room — spotlights, tripods, cameras, furniture, the photographer — and some, such as curved musical instruments, can even pick up reflections of themselves.

Commercial photographers face these problems daily, for many of their studio pictures are shot as advertisements for just such standard household products. To overcome the problems, they use a variety of techniques and equipment. Deft use of lighting is usually the key. One obvious lighting arrangement is a pair of strong floodlights or electronic flash units set up on either side of the subject. They will provide evenly balanced, although somewhat flat, overall illumination. To create shadows and highlights that bring out an object's shape and texture, the photographer may omit a flood and add a spotlight, or place a reflector behind the subject to backlight it and give its outline sharper definition. Another spotlight is often used for calling attention to particularly important areas of the composition. The lenses on some spotlights are adjustable, and their beams can be focused into a shaft that the photographer can aim at the exact point needed for a highlight.

But good photographers never rely exclusively on standard lighting tech-

niques. To give themselves greater control and flexibility, they shift and vary their lights, and often turn to a number of ingenious accessories to help adjust the shape and quality of light. By covering light sources with diffusing material, they can soften the borderline between light and shadow. The opposite effect is accomplished by fitting lights with metal beam directors called barn doors. These devices for trimming down the beam of a spot or flood are attachments borrowed from the theater. Each pair consists of two hinged metal flaps whose name describes how they work: When the barn doors are swung wide open, the spot or flood emits a full, round flow of light. When they are partly closed, they cut off the edges of the beam, giving precise control of the area illuminated. Their principal purpose is to keep light away from places where it is not wanted: blocking it from illuminating an undesirable feature, such as a highly reflective surface, or preventing it from shining directly into the camera lens.

Other simple devices help ensure the photographer's control. Reflectors of white paper or metallic foil on a cardboard backing help to bounce light into shadowy areas. A light table, essentially a box with a translucent top, allows him to photograph the subject on an illuminating surface. He arranges the subject on the light table and places a spotlight or flood lamp underneath it, aiming the light up at the subject from below. To eliminate distracting backgrounds, the photographer often uses a sheet of seamless paper: By setting up the still life on one part of the paper and curving up the other part to form the backdrop, he eliminates the horizon line that would otherwise appear where the tabletop meets the backdrop, and gives the impression that the subject is suspended in unlimited space.

To solve the problem of unwanted reflections when shooting glassware, crockery and silverware, the photographer may shield the subject with an ingenious contraption known as a light tent *(pages 196-197, 203)*. It consists of an enclosure — fashioned out of white seamless paper and a translucent material such as fiberglass, plastic sheeting, a light cloth or even tracing paper — in which the subject is placed. The white paper forms the floor of the tent and usually its back; the translucent material makes up the sides and top. By aiming light through the walls of the tent, or by bouncing it around inside, the photographer surrounds the subject with diffused, glare-free illumination. At the same time, the tent blocks off any images of studio equipment that might otherwise be picked up as distracting reflections. The front of the tent is left partially uncovered to allow entry for the camera.

It takes only a bit of practice to learn how to use such versatile studio devices as barn doors and light tents. The basic principles of their application are relatively uncomplicated, and the devices themselves are almost indispensable when photographing the everyday, around-the-house articles that are chosen as the subjects of most object-photographs.

Shadows That Separate White from White

One attractive subject for the still-life photographer is the family's pure white china, but one of the most interesting ways to shoot it may be less than obvious—on a white tablecloth. Although a dark background provides a dramatic contrast, white is more subtle. Besides, a dark background may cast dull or distorting reflections.

In shooting white on white there is a risk, of course, that the china will simply disappear against the linen. The solution is in the careful use of lighting. Properly lighted, the white background can impart interesting shadows to the white cups and saucers: strong, sculptural shadows; soft, even shadows; diagonal shadow patterns that permit the simplicity of the objects to emerge. In most cases, indirect rather than direct lighting is preferable, for glare, distortion or harsh reflections are often produced by head-on illumination. On these pages Erich Hartmann has demonstrated ways to use reflected light to create striking white-on-white pictures.

Deep shadows cast by backlighting lend the photograph above a sculptural quality, bringing out the form of the cups and silhouetting the handles sharply. For this contrasty white-on-white picture, a high-intensity 800-watt floodlight was directed against a white seamless-paper background (left).

The softened shadows around the cups and saucers at right, above, result from the reflection and diffusion of the floodlamp's beam. To achieve this effect the cups were placed in a translucent light tent (right) and the light was aimed at the studio ceiling. The reflected light then passed through the fiberglass walls and top of the tent.

Diagonal lighting makes more obvious the hollowed shape of the cups and saucers (above, left). The slanted shadows are produced by placing two small spotlights on either side of the light tent (left). One light penetrates the tent from left center; the other is placed toward the rear. The spread of each light beam is limited by adjustable metal shields known as barn doors.

Pale, barely perceptible shadows are the only element of contrast in a photograph that shows off the purity and simplicity of the white porcelain (above). For this picture four lights were set up, as shown at right. Two small spots were trained on the light-tent ceiling; a large spotlight was angled downward onto white paper. The fourth light was bounced off the ceiling of the studio.

Tracing the Delicacy of Glassware

The qualities that draw the eye to fine glassware are the same ones that make glassware a challenge to photograph. Crystal is cherished for its capacity to capture light and take on the subtlest glow within a room, from the sparkle of a chandelier to the guttering flame of a candle. However, that very evanescence demands careful photographic planning, for it is easy to lose the delicate translucence, shape and symmetry of glassware against the background.

Fil Hunter, who made the photographs on these pages, has two basic tactics when he is shooting crystal: He strives either to set off the edges of the glasses in black against a white backdrop *(right)* or to define the edges in white against black *(opposite)*. "The single most important principle," Hunter says, "is to follow one approach or the other. When both happen simultaneously, the edges of the glassware disappear and the photographer will have the problem of 'invisible' glassware."

Hunter's techniques take advantage of the fact that glassware transmits light— except when the light rays strike its surfaces at oblique angles, which results in reflection. By carefully controlling light and color with setups and backdrops like those shown below the two photographs here, and by positioning the glasses until their reflections are precisely as he wants them, Hunter—or any photographer— can make a picture that expresses all the crystalline beauty that made him reach for his camera.

Two glasses are dramatically outlined in black against white in the photograph above. Fil Hunter obtained the striking effect by arranging the glasses on a white surface against a frame-filling white backdrop *(right)*. Behind the backdrop he placed a single floodlight, bright enough to illuminate the screen but not the glasses. The light from the white background passed through the glasses to the lens and was also reflected off the bases of the glasses, thus defining the goblets in stark outline.

This photograph of two glasses, their silhouettes traced in white against a black background, emphasizes the graceful lines of the crystal. Hunter placed the glasses on a dark surface (left), in front of a black backdrop that exactly filled the frame of his picture. Behind that backdrop and protruding around it —out of view of the lens—he placed a white backdrop, lighting it from behind. The edges and bases of the glasses, acting like mirrors, reflected the white light into the lens.

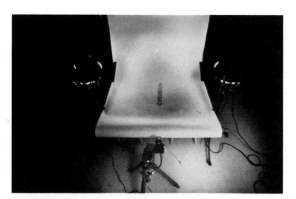

A colonnade of crystal (left) is softly backlighted by two large spotlights whose joined beams bounce off a sheet of seamless white paper, as shown above. The shadow that surrounds the bases of the glassware provides contrast with the brilliance cast by the reflected light source and lends an air of cool elegance to the photograph.

Two solid crystal figurines, a penguin and a porpoise, glow in the light of a pair of 200-watt spotlights covered with colored gelatin sheets. The spots were placed behind the translucent white seamless-paper backdrop (right), and the bright orange and blue beams they projected were narrowly confined by barn doors to bathe both penguin and porpoise in eerie hues.

Keeping Ghosts out of Metalware

Much of the visual allure of metal objects lies in their gleam and glitter—the dazzle and flash of a musical instrument, the satiny finish of heirloom silver, the burnished glow of antique iron. But to capture that charm, the photographer must confront and solve the problems of distracting reflections and glinting highlights. Flat metal surfaces can be shot without a camera reflection by manipulating the controls on a view camera or by using a polarizing filter to eliminate or dampen glare and reflections. A matte powder or spray also can be applied to the metal to mute its mirror-like quality—but only at the cost of the brilliance that made it so attractive in the first place.

With extravagantly curved metal objects such as musical instruments, antique timepieces and even automobiles, the only satisfactory way, short of retouching, to eliminate reflections and hot spots caused by lamps is to construct a light tent around the subject. The material of the tent, either gauzy muslin or thin paper, isolates the subject and blocks reflections. The tent also serves to diffuse the light, softening and distributing it evenly, thus helping to dissolve shadows while subtly defining the curves and shape of the subject—and revealing its lustrous beauty.

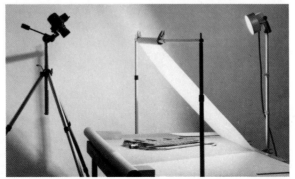

To photograph the gleaming curves and planes of a glockenspiel while avoiding harsh shadows and glinting reflections from his floodlamp, Fil Hunter rigged a simple diffusing screen (left). Two light stands were set up in front of the flood and used to support a metal rod that, in turn, held up a sheet of tracing paper. The paper transmitted light from the flood while diffusing it and eliminating glare.

This photograph of a cornet might have been a jumble of glare and reflections of surrounding objects as well as the instrument's own sinuous tubing. But Fil Hunter lighted the cornet evenly and diffusely with two spotlights, isolating the horn inside a light tent (below). The camera, looking in through the opening in the tent from the shadows outside, stays out of the picture —as do any other potentially distracting reflections.

Catching the Freshness of Fruit

Each photographer develops his own favorite tricks for making fruits and vegetables glisten and appear fresh and appetizing. Some professionals use a dropper or paint brush to apply glycerine or glycerine mixtures to the food; the viscous liquid clings to the surface of the fruit and gives the impression of dewlike moisture. Alternatively, mineral oil may be applied in a thin layer to a vegetable or a piece of fruit, providing a surface on which drops of water will collect. In the center picture at right, still a third technique was employed: Mist from a household spray bottle filled with water provided just the right amount of wetness.

With such tricks some form of backlighting is preferred, since it silhouettes the droplets, adding dimension to the surface texture of the fruit. The light almost always comes from electronic flash equipment. Unlike hot floodlights, which will dry out and discolor vegetables or fruit and dissolve ice cream or aspics, the powerful flash units deliver bursts of intense light so briefly that the food is not affected. □

Conveying the desired effect of moisture and freshness, juicy halves of fruit (above) glisten under light reflected from an umbrella placed over an electronic flash positioned almost directly above the subject (left). Since it shows no shadows, the black-paper background concentrates attention on the rough pulpy texture of the fruit.

A close-up study of rough-textured oranges, smooth-skinned apples and a single grape (above) is enhanced by back-lighted water droplets applied to the fruit with a spray bottle. An electronic flash with a fiberglass diffuser faces the fruit and its black backdrop, while another flash unit towers over the arrangement from the rear to provide the necessary backlighting (right).

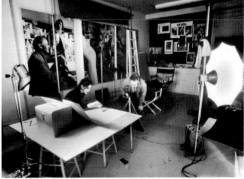

Suspended over a lemon half, a delicate, pearl-like drop of juice emphasizes the succulence of the fruit and even manages to convey a sense of tartness. The effect was created with two electronic flash units: One, a fill-in light at the camera's left, was directed into an umbrella; the other, partly shielded by a piece of cardboard, served as the predominating backlight.

The Professional Approach

At its best, a picture of an object is a still life in the classic sense: a work of art that, in revealing the character of the subject, arouses fresh appreciation of its qualities. This high goal is the aim of professional studio photographers. How well they achieve it—despite unusual limitations on artistic freedom—can be seen on these and the following pages. Only occasionally can photographers choose their subject matter and work with traditional objects such as flowers or fruit. More often they must create to order an image of beauty from commercial products or other objects not usually associated with serious works of art—a pot, an electric lighting fixture, a piece of cloth.

To promote a line of earthenware, Henry Sandbank, a New York photographer, spent several days juxtaposing various items, searching for an austere but esthetically pleasing combination of sizes, shapes and colors. His final shot, strongly sidelighted, dramatically utilizes color, light and shadow.

The picture on the opposite page is the work of Aldo Ballo, a former architecture student who specializes in interpreting the avant-garde industrial design for which his native Milan is renowned. His photograph, commissioned by a furniture firm in Milan, clearly defines the lamp and table, but includes a pattern of reflections that makes it an effective object-portrait.

Brilliant lighting accentuates the shiny surfaces of a coffeepot and jug. A 1,000-watt flood was set to the left of the subjects while two angled pieces of white cardboard—one only slightly larger than the jug, the other slightly smaller—were placed out of camera range at the right and at the rear to guide a minimal reflection around to the right side, defining the shape of the earthenware.

HENRY SANDBANK: *Earthenware Utensils with a Spoon,* 1967

Surface sheen characterizes the red plastic of
this lamp and table, illuminated from one side by
two 900-watt banks of floodlights. The lamp was
suspended only a foot above the tabletop in order
to place it near the center of the frame, and
a plate of dried fruit was so placed as to relieve
the severe lines of the molded plastic objects.

ALDO BALLO: *Molded Plastic Furniture*, 1969

Fabrics in Close-up

At first glance the two pictures on these pages seem not to resemble each other. They show different things and were made by different photographers using radically different techniques. And yet both achieve the same purpose: They convey the idea of fabric without showing fabric as it is ordinarily seen.

For the greatly enlarged view of Orlon at left, Manfred Kage set up an optical bench: a guide rail to which he attached a small lamp to backlight the fabric, a condenser lens to focus the light, a filter, the fabric sample and a view camera. The subtly colored remnants of thread in the composition at right were photographed by John Ellard in an English mill. Meticulously framing the subject with his 35mm camera, manipulating it and the lighting angle, he achieved a result as precisely controlled as Kage's.

Many times larger than life, this photomacrograph of an Orlon swatch was backlighted so that wispy, dark strands of thread would be clearly visible. Frontlighting made the light-colored strands show up and revealed the pattern of the weave.

MANFRED KAGE: *Orlon magnified 20X, here enlarged to 45X, 1969*

The balls of thread at right look like yarn from ▶
grandmother's knitting basket but are "thrums"
—waste from the warp section of a loom. Daylight
from a nearby window illuminated them.

JOHN ELLARD: *Warp Waste in a Spinning Factory*, 1969

Bringing Out the Character of Cloth

Cloth appeals to our senses with a barrage of simultaneous delights: Its color, pattern, heft, whether sensuously heavy or ethereally light, and even its characteristic whisper or rustle, are qualities that demand every bit of wizardry the photographer can conjure up.

The key is light. The creative photographer, aware of how cloth and light interact, carefully manipulates the two. Crosslighting can throw the texture of a weave into a striking bas-relief or, by enhancing the folds of a material, help convey the body of the cloth, suggesting an airy delicacy or a rich heaviness. Backlighting can further dramatize this effect.

When the picture is not to be a close-up but a portrait, the inclusion of supporting elements can help define the quality and personality of the cloth. For example, the eye-catching and whimsical scene at right suggests that with the tasteful application of elegant material, shown draped over frosted-glass doors, even a fusty, old-fashioned steam-heated flat (actually a set built in the photographers' studio) can take on some *haut monde* chic — mice or no mice.

To illustrate the gossamer elegance of this diamond-patterned Dralon curtain material, photographers Ambrogio Beretta and Giancarlo Maiocchi—who collaborate as Occhiomagico— used a mundane setting as counterpoint. They crosslighted the cloth with a flash aimed from above left to highlight the pattern, and used just enough backlighting to emphasize the material's translucence. Then they set loose four furry models (rented from a pet shop) to lend the portrait just the right note of playfulness.

OCCHIOMAGICO: *Rented Mice*, 1980
211

Jewelry on Display

Jewelry is one of the most difficult subjects to photograph effectively. It can be as transparent as glass and as full of reflections as silverware or cut crystal, posing a complex of problems. Small and delicate, jewelry must be photographed with utmost precision to reveal the details of workmanship. Most often it is shown in life-sized, or larger-than-life-sized, close-ups, adding to the difficulty of producing needle-sharp pictures—the nearer the camera to the subject, the more restricted the depth of field and the smaller the area of sharp focus.

Cut gems are particularly demanding subjects. Because their brilliance is a result of the way light glints across their facets, the photographer must adjust the lighting to make as many facets glow as possible. Photographers often cope with the technical difficulties of gems by using a light tent *(pages 196-197, 203)* and carefully balancing the illumination. Also, to hold sharp focus in a tight depth of field, they usually limit the composition to a single vertical plane, as in the arrangement of brooches and pendants at right.

Beyond its artistry and palpable worth, however, jewelry is an accessory to an illusion, a prop in a fantasy the lucky owner can slip into as easily as strapping on a watch *(opposite)*. To convey that possibility—and perhaps obtain an image that is itself a gem—the photographer must remember to allow for the dream.

CHARLES R. COLLUM: *Arrangement with Opals*, 1969

An antique nutmeg grater provides an unusual foil for a sparkling display of opal jewelry set with cut diamonds and other gems (above). For maximum clarity, the photographer placed all the gems at the same distance from his 8 x 10 view camera.

A man's wrist watch glows with elegance and ▶ desirability in this portrayal by Parish Kohanim. To create an atmosphere of mystery, Kohanim set the watch amid an abstract assemblage of a black sphere and shiny corrugations against a deep-blue screen. He toplighted the grouping with a diffusing light box, and backlighted the screen with a strobe.

PARISH KOHANIM: *Wristwatch,* 1981

Liquids in Suspension

A Leitz Aristophot, an elaborate close-up apparatus, allowed the photographer to catch this strange magnified view of a blue-dyed drop of water poised near the edge of a nylon curtain. Since the curtain was water repellent, he had ample time to experiment with lighting, subject and camera angles. He placed the drop on the curtain edge, beneath the lens of the Aristophot. Two floodlights, equipped with heat-absorbing glass filters to guard against evaporation, illuminated the subject from above. A small spotlight aimed at an angled mirror below the material provided backlighting to define the sharp edges of warp, woof and water droplet.

MANFRED KAGE: *Water Drop on a Curtain,* 1970

As an illustration for a promotional calendar, ▶ photographer Osamu Hayasaki concocted this suspenseful image of soda and lemons. First he built a tiny catapult to loft the glass and lemons in perfect sync with each other. Next he rigged an infrared beam that, when interrupted by the hurtling glass, would trigger his strobe—a 2,400-watt flash shielded by tracing paper. Then he set up a water tank and floated a plastic cushion in it to catch the falling glass. Finally, with the strobe firing at 1/50,000 second each time, Hayasaki catapulted the glass and lemons again and again until he got precisely the kinetic image he was looking for.

OSAMU HAYASAKI: *Soda and Lemons*, 1979

The Radiance of Flowers

A tumbled profusion of thistles and wildflowers glows ▶
with fading loveliness in this portrait by Murray
Alcosser, who made the photograph in his kitchen.
He took the picture with a single-lens reflex 35mm
camera and a tabletop tripod, his illumination only
"lots of afternoon light, beautiful, subdued and soft."

Flower photography is an art in itself. Every variety of blossom has its own visual personality, its own pictorial characteristics—which a good photograph can bring out. There is a kind of elegance in the convoluted petals of roses, and a cheerful, down-to-earth aspect to a bunch of yellow daisies; imaginative photographers take advantage of these individual qualities when they use flowers as subjects for still lifes.

One sensitive portrayer of nature is Paul Caponigro, who caught the character and beauty of a fragile thistle puff in the picture at right. "Things in nature," says Caponigro, "radiate a being of their own." Another photographer who seeks the essence of plants—and who occasionally finds that essence indoors—is Murray Alcosser; he says, "I love to arrange objects in such a way that they become so real they are almost abstract."

*The cobweb delicacy of a Scottish thistle ready
to broadcast its seeds becomes all the more
apparent when shown in silhouette. "I found a
paint-spattered window drape against a window
with diffuse light coming through," Caponigro
noted. "It made a fine background against which
to place my thistle." The contrast with the
massive shadow of the window sash emphasized
still further the fragility of the thistle.*

PAUL CAPONIGRO: *Scottish Thistle*, 1958

MURRAY ALCOSSER: *Wildflowers*, 1981

Exploring the Beauty of Food

In no other field of still-life photography does the process of simulating reality depend more on illusion than in capturing the fleeting essence of food. Successfully picturing a tempting repast requires the services of an army of assistants who make the fruit sparkle with dew and the meat smoke with heat waves, and who replace the greens when they droop under the heat of the lights.

Beyond the perishable nature of the subject matter, other considerations confront the photographer. The crystal must be positioned so that it neither disappears into the background nor sparkles with gaudy glints. The crockery must enhance, but not dominate, the food. And the main course must be arranged and lighted to perfection. Small wonder, then, that specialists in the field of culinary photography—as complex a studio production as photography can offer—often work with view cameras and use Polaroid backs to test exposures and composition before they shoot the final takes. The result is a visual white lie that conveys the truth: a picture that looks as good as the feast would taste.

Assigned to photograph the striking tablecloth at right, Christopher Broadbent found himself reminded of 17th Century still-life painting. In his Rome studio he set about arranging a composition that, to him, evoked a similar feeling. On the tablecloth he set an antique wineglass and an apple upon a plate. Suspended above the cloth from an unseen boom was a head of lettuce—he tried no fewer than 15 before he found a satisfactory prop. Aiming his flash down from the left at the tabletop, Broadbent shot the picture with a 4 x 5 view camera, using a 135mm lens set at f/32. A soft filter gave the scene its subdued intimacy.

CHRISTOPHER BROADBENT: *Still Life with Lettuce,* 1980

FRANÇOIS GILLET: *Cheese from Sweden*, 1978

Two halves of a tomato, on two halves of a plate, become abstract elements in this photograph by Jean Bernard Aegerter. Depth was added by placing one of the halves nearer to the camera than the other. Aegerter set up his camera on a tripod and shot straight down; his studio was in darkness until the strobe fired. The light was aimed from below and behind the camera, illuminating the plates except for the shadow of the tripod at top and bottom—which resulted in a dramatic break in the image.

JEAN BERNARD AEGERTER: *Tomato Halves*, 1980

The milk is as unappetizing as chalk, and the fried ▶ egg looks as hard and shiny as china; but this picture, with its strong patterns and strange perspectives, is immensely powerful. "By pure design and composition," notes photographer Henry Sandbank, "I was able to create a surrealistic photograph using these generic food objects." He suspended his view camera above the table, but slightly ahead of its forward edge, to take the picture from an angle rather than from squarely overhead. A single spotlight was located below the camera to cast the dark shadows of the bottle and glass against the light backboard.

HENRY SANDBANK: *Egg and Milk,* 1968

As simple and as artful as a haiku poem, this photograph depicts a replica of a vegetarian meal served to bonzes, or monks, in a Buddhist monastery. Photographer Reinhart Wolf took the picture with a 35mm camera and a 55mm lens. Working indoors on an overcast day, he shot with natural light and used a white napkin as a reflector. The form of the lighted area of the still life was made by a crescent-shaped piece of black cardboard set between the light source (a window) and the plate of food. Because he used Kodachrome 25 film and a small aperture (to increase depth of field), Wolf needed a long, 6-second exposure to capture all the subtle colors of the Zen meal. To keep it fresh during shooting, he moistened the food with water from a brush.

REINHART WOLF: *Zen Food, Still Life*, 1980

An Electric Composition

As electrifying as the op art that it echoes, this still life, done for a magazine spread on wall and flooring material, moves in tight on a power cord snaking across dotted tiles and into an outlet. Marirosa Ballo constructed a set using wallpaper that simulates rough plaster, and selected an industrial fixture for mood. She lighted her set with a 2,000-watt spot filtered through canvas — then added the cord to give the picture a jolt.

MARIROSA BALLO: *White Cord, Blue Floor*, 1980

The supply of delightful photographs lying hidden in ordinary objects all around us is limitless. To transmute the everyday into photographic art, the studio photographer must first be on the lookout for a promising subject, then be able to compose the elements both on the set and in the camera. Here, durable tile, rough plaster and an electrical conduit — ingredients that might be found in the humble corner of an industrial building — serve as the makings of a striking still life. □

Bibliography

General

Avedon, Richard, and Truman Capote, *Observations*. Simon and Schuster, 1959.

Ballard, Bettina, *In My Fashion*. David McKay, 1960.

Beaton, Cecil:
The Glass of Fashion. Doubleday, 1954.
The Wandering Years. Little, Brown, 1961.

Blum, Daniel, *A Pictorial History of the Silent Screen*. Grosset & Dunlap, 1953.

Chase, Edna Woolman, and Ilka Chase, *Always in Vogue*. Doubleday, 1954.

Devlin, Polly, *Vogue, Book of Fashion Photography 1919-1979*. Simon and Schuster, 1979.

Di Grappa, Carol, ed., *Fashion: Theory*. Lustrum Press, Inc., 1980.

Feininger, Andreas, *Darkroom Techniques*, Vol. 1. Prentice-Hall, Inc., 1974.

Giebelhausen, Joachim, ed., *Manual of Applied Photography*. Verlag Grossbild-Technik, 1966.

†Grimm, Tom, *The Basic Darkroom Book: A Complete Guide to Processing and Printing Color and Black-and-White Photographs*. New American Library, 1978.

Hall-Duncan, Nancy, *The History of Fashion Photography*. Alpine Book Company, Inc., 1979.

Hedgecoe, John, *The Photographer's Handbook*. Alfred A. Knopf, 1979.

Holloway, Adrian, *The Handbook of Photographic Equipment*. Alfred A. Knopf, 1981.

Horst, Horst P., *Photographs of a Decade*. J. J. Augustin, 1962.

†Lahue, Kalton C., *The Darkroom Guide*. Petersen's Photographic Library, 1980.

Levin, Phyllis Lee, *The Wheels of Fashion*. Doubleday, 1965.

MacGowan, Kenneth, *Behind the Screen*. Delacorte, 1965.

Marcus, Adrianne, *The Photojournalist: Mary Ellen Mark & Annie Leibovitz* (Masters of Contemporary Photography). Thomas Y. Crowell Company, Inc., 1974.

Newhall, Beaumont, *The History of Photography*. The Museum of Modern Art, 1964.

Newton, Helmut:
Sleepless Nights. Congreve Publishing Company, Inc., 1978.
White Women. Stonehill Publishing Company, 1976.

Penn, Irving, *Moments Preserved*. Simon and Schuster, 1960.

Pollack, Peter, *The Picture History of Photography*. Harry N. Abrams, 1958.

Ray, Man, *Man Ray, Self Portrait*. Little, Brown, 1963.

Snow, Carmel and Mary Louise Aswell, *The World of Carmel Snow*. McGraw-Hill, 1962.

Stroebel, Leslie, *View Camera Techniques*. Hastings House, 1967.

Taft, Robert, *Photography and the American Scene*. Dover, 1938.

Taylor, Deems, *A Pictorial History of the Movies*. Simon and Schuster, 1943.

Trahey, Jane, ed., *Harper's Bazaar, 100 Years of the American Female*. Random House, 1967.

Wahl, Paul, *Press/View Camera Technique*. American Photographic Book Publishing, 1969.

Periodicals

American Photographer, Image Nation Co., New York City.

American Publications, CBS Publications, New York City.

Aperture, Aperture Inc., New York City.

British Journal of Photography, Henry Greenwood and Co., London.

California Living, Los Angeles Herald Examiner, Los Angeles.

Camera, C. J. Bucher Ltd., Lucerne, Switzerland.

Camera 35, U.S. Camera Publishing Co., New York City.

Creative Camera, International Federation of Amateur Photographers, London.

Famous Photographers Magazine, Westport, Connecticut.

Harper's Bazaar, Hearst Magazines, Inc., New York City.

Holiday, Holiday Publishing Co., Indianapolis.

Infinity, American Society of Magazine Photographers, New York City.

Modern Photography, The Billboard Publishing Co., New York City.

The New York Times, New York City.

The New York Times Magazine, The New York Times, New York City.

Newsweek, Newsweek Inc., New York City.

The Photo 49, Marshall Cavendish Ltd., London.

Popular Photography, Ziff Davis Publishing Co., New York City.

Rolling Stone, Straight Arrow Publishers, Inc., New York City.

Travel & Camera, U.S. Camera Publishing Corp., New York City.

U.S. Camera World Annual, U.S. Camera Publishing Corp., New York City.

Vogue, The Condé Nast Publications Inc., New York City.

†Also available in paperback

Acknowledgments

The index for this book was prepared by Karla J. Knight. For the assistance given in the preparation of this volume, the editors would like to express their gratitude to the following individuals and institutions: Mehemed Fehmy Agha, Malvern, Pennsylvania; Billy Arce, Sinar Bron, Inc., Carle Place, New York; Jerry Arena, Production Manager, Color Unlimited, Inc., New York City; Richard Avedon, New York City; Paul Bonner, The Condé Nast Publications Inc., New York City; Steve Bronstein, Big City Productions, New York City; Zenja Cary, Cary Kitchens, New York City; Walter Clark, Rochester, New York; F. Van Deren Coke, Deputy Director, Eastman House, Rochester, New York; Arnold Crane, Chicago, Illinois; George Cukor, Hollywood, California; Louise Dahl-Wolfe, Frenchtown, New Jersey; Kimberly S. Dyckman, Atlanta, Georgia; Louise Effron, New York City; Bea Feitler, Art Director, *Harper's Bazaar,* New York City; Ludovico Ferraglio, Ferraglio-Newbery Associates, Inc., New York City; Al Freni, New York City; George Fry, Manager, Electronic Flash Department, Willoughby's, New York City; Stanley Glaubach, New York City; Professor L. Fritz Gruber, Cologne; Lowell Hocking, Director, Jacksonville Museum, Jacksonville, Oregon; Jocelyn Kargére, Art Director, *Vogue France,* Paris; Max Keizerstein, Manager, Studio Equipment, Willoughby's, New York City; Richard A. Lange, Calumet Photographic, Bensenville, Illinois; T. J. Le Comte, Sinar Product Manager, Ehrenreich Photo-Optical Industries, Inc., Garden City, New York; Phyllis Lee Levin, The Condé Nast Publications Inc., New York City; Eaton S. Lothrop Jr., Editor, *Photographic Collectors' Newsletter,* Brooklyn, New York; Patricia McCabe, Irving Penn Studio, New York City; Yvonne McHarg, New York City; Sue Moseson, Big City Productions, New York City; Ute Mundt, *Vogue France,* Paris; Tomas Newbery, Ferraglio-Newbery Associates, Inc., New York City; Irving Penn, New York City; Kenneth M. Raskin, Atlanta, Georgia; Charles Reiser, Professional, Commercial and Industrial Markets Division, Eastman Kodak Company, Rochester, New York; John H. Reynolds, National News Director, University of Southern California, Los Angeles, California; Mark Rosoff, Penn Camera Exchange, Washington, D.C.; Steve Steigman, Big City Productions, New York City; Joyce Tenneson, Washington, D.C.; Paolo Viti, Olivetti, Milan; Harry Warnecke, New York City; Beth Watson, Atlanta, Georgia; Robert W. Wescott, Atlanta, Georgia; Max Zweig, Penn Camera Exchange, Washington, D.C.

Picture Credits
Credits from left to right are separated by semicolons, from top to bottom by dashes.

COVER: Arthur Elgort, courtesy *Vogue.*

Chapter 1: 11: Edward Steichen, courtesy The Museum of Modern Art, New York. 18: © Karsh of Ottawa from Rapho Guillumette. 19: © Arnold Newman. 20, 21: Richard Avedon, copyright © 1970 The Condé Nast Publications Inc. 22: Roddy McDowall. 23: © Barbara Morgan. From *Martha Graham,* Sloan & Pearce, 1940. 24, 25: © Philippe Halsman. 26: Gregory Heisler. 27: Annie Leibovitz. 28: Irving Penn, copyright © 1948 The Condé Nast Publications Inc. 29: © Starr Ockenga. 30, 31: Guy Bourdin, courtesy *Harper's Bazaar;* Art Kane. 32: Peter Knapp, Paris, for *Vogue Italia,* Milan. 33: © Oliviero Toscani, courtesy *Esprit.* 34: Georges Tourdjman, Paris. 35: © Henry Wolf, courtesy *Town & Country Magazine.* 36: Guy Powers. 37: © 1982 John Neubauer, courtesy Gourmet Grafiks, Inc. 38: Ernie Friedlander. 39: Gary Perweiler. 40: © 1981 Tom Weigand. 41: Gabriele Basilico/Olivetti, Milan. 42: Lionel Freedman.

Chapter 2: 45: Courtesy Anna C. Gossner. 48, 49: Evelyn Hofer, courtesy Jacksonville Museum, Jacksonville, Oregon. 50, 51: Evelyn Hofer, courtesy Henry Ford Museum and Greenfield Village, Dearborn, Michigan. 52: T. C. Marceau, copied by Paulus Leeser, courtesy Eastman Kodak Company. 53: Copied by Paulus Leeser, courtesy Eastman Kodak Company. 54-57: Culver Pictures. 58: Wilton Tifft; drawing by Herbert H. Quarmby. 59: Wilton Tifft; courtesy *Daily News,* New York. 60: Drawing by Lois Sloan. 61: Michel Tcherevkoff, courtesy AT&T. 62: © Elizabeth Hathon—drawing by Lois Sloan. 63: Michel Tcherevkoff. 64-66: John Senzer. 67: Rudy Muller. 68-71: Rogier Gregoire. 72: Reid Miles.

Chapter 3: 75: Arthur Elgort, courtesy *Vogue.* 85: Y. R. Okamoto, courtesy Lyndon Baines Johnson Library. 86, 87: © Arnold Newman. 88: Louise Dahl-Wolfe. 89: Louise Dahl-Wolfe, courtesy *Harper's*

Bazaar. 90-92: John Senzer. 93: John Senzer; Rudy Muller. 95: Keith Trumbo for Irving Penn Studios. 96: Per Boije for Irving Penn Studios. 97: Irving Penn, copyright © 1967 The Condé Nast Publications Inc. 98: Irving Penn, copyright © 1970 The Condé Nast Publications Inc.

Chapter 4: 101: Edward Steichen, courtesy The Museum of Modern Art, New York. 104: Baron de Meyer, copied by Paulus Leeser from *Camera Work,* courtesy The Museum of Modern Art, New York. 105: Top left, Baron de Meyer, copyright © 1921 The Condé Nast Publications Inc.—Baron de Meyer, courtesy Louise Dahl-Wolfe and George Eastman House (2). 106, 107: Edward Steichen, courtesy The Museum of Modern Art, New York. 108: George Hoyningen-Huene, copyright © 1931 The Condé Nast Publications Inc., courtesy Horst. 109: George Hoyningen-Huene, copyright © The Condé Nast Publications Inc., courtesy Horst. 110: Cecil Beaton, copyright © 1934 The Condé Nast Publications Inc. 111: Cecil Beaton, copyright © 1949 The Condé Nast Publications Inc.; Cecil Beaton, copyright © 1937 The Condé Nast Publications Inc. (3). 112, 113: Martin Munkacsi, courtesy *Harper's Bazaar* and Joan Munkacsi Hammes. 114: Toni Frissell, courtesy *Harper's Bazaar* and Library of Congress. 115: Toni Frissell, copyright © 1938 The Condé Nast Publications Inc. 116, 117: Louise Dahl-Wolfe, courtesy *Harper's Bazaar.* 118: Horst. 119: Horst-*Vogue France,* Paris. 120, 121: Irving Penn, copyright © 1947 The Condé Nast Publications Inc.; Irving Penn, copyright © 1950 The Condé Nast Publications Inc. 122: Richard Avedon. 123: Richard Avedon, copyright © 1968 The Condé Nast Publications Inc. 124, 125: Helmut Newton, Paris. 126, 127: Sarah Moon, Paris. 128, 129: *Vogue France*-Guy Bourdin, Paris. 130, 131: Arthur Elgort, courtesy *Vogue.* 132, 133: Alex Chatelain, reproduced from *British Vogue,* © The Condé Nast Publications Ltd. 134: Jean Pagliuso © 1978. 135: Jean Pagliuso © 1980. 136, 137: © Patrick

Demarchelier. 138: Andrea Blanch, courtesy *Vogue,* copyright © 1982 by The Condé Nast Publications Inc.

Chapter 5: 141: Ken Kay. 143: Drawing by Nicholas Fasciano. 144-157: Ken Kay. 158: Fil Hunter, Castle courtesy John Davy Toys, Quilt by Virginia Suzuki, drawings by Frederic F. Bigio from B-C Graphics. 159-166: Ken Kay. 164, 165: Hôtel de Varengeville, Wrightman Galleries, The Metropolitan Museum of Art, New York. 166: Bird by Lalique for Nina Ricci Parfums, courtesy Jacqueline Cochran, Inc.

Chapter 6: 169: Courtesy Robert E. Cunningham. 172-175: Models by Nicholas Fasciano, photographs by Neal Slavin. 176-179: Fil Hunter. 180: Al Freni. 181: Al Freni—Fil Hunter. 182, 183: Fil Hunter. 184, 185: Thomas S. England. 186, 187: Drawing by Lois Sloan—Thomas S. England— © Arthur Tilley 1982; Thomas S. England, except second from top, © Arthur Tilley 1982; Thomas S. England, except middle, © Arthur Tilley 1982. 188: Thomas S. England; drawing by Lois Sloan. 189: Thomas S. England. 190: © Arthur Tilley 1982.

Chapter 7: 193: Phil Marco. 196, 197: Erich Hartmann from Magnum, China courtesy RMH International, Inc. 198, 199: Fil Hunter. 200: Erich Hartmann from Magnum. 201: Erich Hartmann from Magnum, Crystal courtesy Steuben Glass. 202, 203: Fil Hunter. 204, 205: Erich Hartmann from Magnum. 206: Henry Sandbank. 207: Aldo Ballo. 208, 209: Manfred Kage from Peter Arnold; John Ellard. 210, 211: Occhiomagico for *Casa Vogue,* Milan. 212: Charles R. Collum, courtesy Glenn Advertising for Fine Jewelers Guild. 213: Parish Kohanim. 214: Manfred Kage. 215: Osamu Hayasaki, Tokyo. 216: Paul Caponigro. 217: Murray Alcosser. 218: Christopher Broadbent, Milan. 219: François Gillet. 220: Jean Bernard Aegerter, Milan. 221: Henry Sandbank. 222, 223: Reinhart Wolf, Hamburg. 224: Marirosa Ballo, Milan.

Index *Numerals in italics indicate a photograph, painting or drawing.*

Printed in U.S.A